BASEBALL
IN SPRINGFIELD

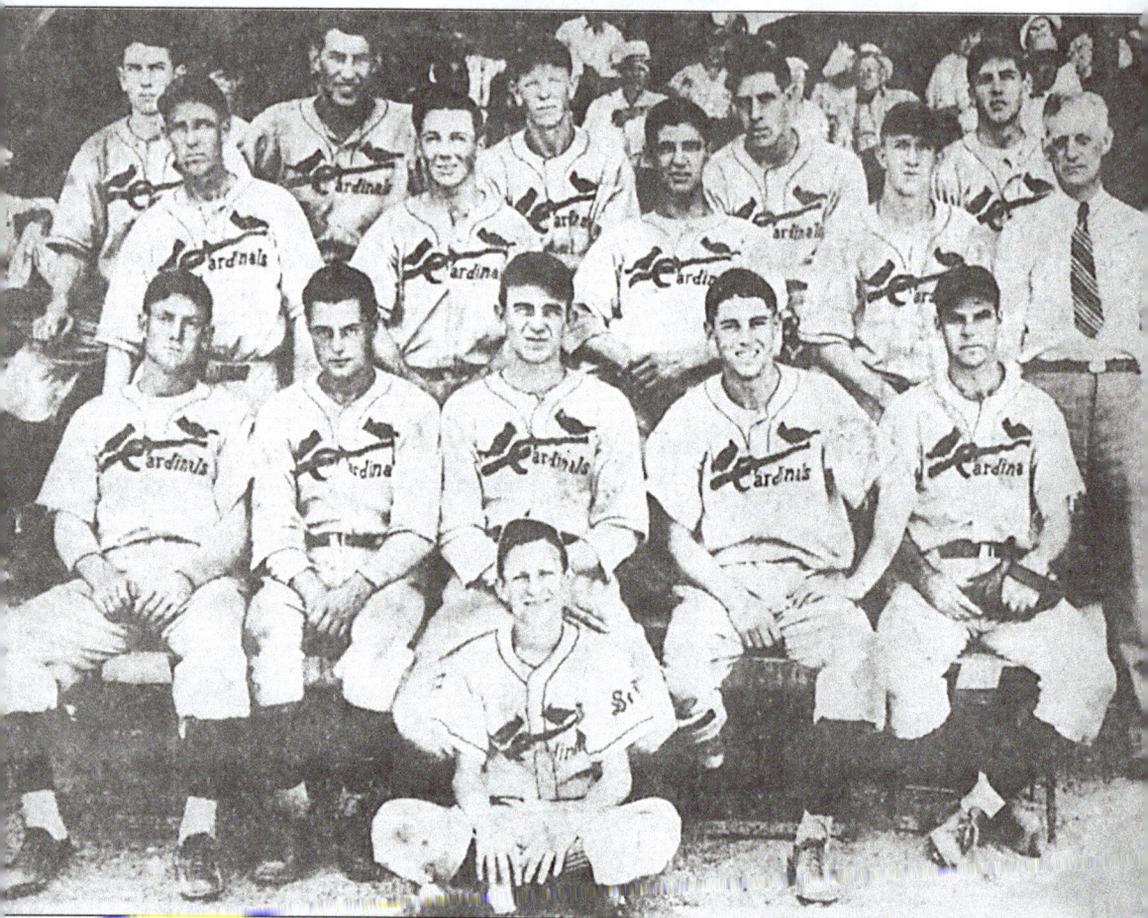

1935 Springfield Cardinals. As local heroes at the pinnacle of professional baseball in Springfield in the mid-1930s, the 1935 Springfield Cardinals captured the admiration of the hometown fans. Like most Springfield squads, they were a colorful bunch that drew thousands of fans out to White City Park. Led by George Payne (back row, center), the team included: a crooning outfielder, John Kyler (front row, far right); two of the league's top pitchers that year, right hander Bob Ross (front row, middle) and major league-bound lefty Tom Seats (middle row, far left); the captivating and speedy base-stealer Lyle Judy (middle row, second from right); along with the hard-nosed future National League All-Star catcher, Arnold "Mickey" Owen (back row, far left). (Courtesy of *Springfield Magazine*.)

BASEBALL
IN SPRINGFIELD

Rusty D. Aton

ARCADIA
PUBLISHING

Published by Arcadia Publishing
Charleston, South Carolina

Library of Congress Catalog Card Number: 2005920612

For all general information contact Arcadia Publishing at:
Telephone 843-853-2070
Fax 843-853-0044
E-mail sales@arcadiapublishing.com
For customer service and orders:
Toll-Free 1-888-313-2665

Visit us on the Internet at www.arcadiapublishing.com

Front Cover photos: Herschel Bennett. (Courtesy of Bob Bennett); Mickey Owen. (Courtesy of Charlie Owen.)
Back Cover photo: Hammons Field on opening night (Courtesy of SMSU Photo Services/ Kevin White.)

CONTENTS

ACKNOWLEDGMENTS

Dozens of people helped out on this project, but broad recognition can not begin without saying the biggest thanks to the members of my graduate school committee at Southwest Missouri State Univerity: Dr. George Hummasti, Dr. Wayne Bartee, and Dr. Jim Giglio. All of these men contributed in helping me to produce a master's thesis ultimately deserving of publication. I will forever be the most grateful, however, to Jim Giglio for generously aiding me in accessing primary sources and then guiding me through the long and tedious process of producing a scholarly written work. Although this book aimed to reach a wider audience through its focus on images, the spirit of that earlier scholarly effort is still apparent.

Others who gave their time and attention to my four year long obsession with baseball research and writing include: the office faculty and staff of the history department at Southwest Missouri State University—Dr. Marc Cooper, Dr. Michael Sheng, Margie von der Heide, Jean Thomas, and Lynn Young; the staff of the Springfield Greene-County Library local history department—Michael Glenn, John Rutherford, and Sharol Neely; Bob Newman of the Greene County Archives; Steve Gietschier of the *Sporting News*; the staff of the Springfield-Greene County History Museum; Bob Glazier of *Springfield Magazine*; and the staff of the National Baseball Hall of Fame Museum and Library in Cooperstown, New York.

A great thanks also goes out to those many individuals who provided information and photos for this project: Duff McCoy, Bob Bennett, Bus Harless, Larry Lipscomb, Allen Casey, Charlie Owen, Katherine Lederer, Charley Talley, Hank Billings, Patricia Ryba Hoover, Cheryl Tuckely Williams, Sally Lyon, Mike Vincent, Glenn and Harold Barclay, Bob Duncan, Denny Melton, Jerry Hogan, John Hall, Bob Speake, Jim Jacobs, Jack Hamlin, Roy Gilmore, Al Billingsley, and Jerry Lowther.

Only through the generosity of all these people was it possibility to accumulate the amount of knowledge and images necessary to create this book. Unfortunately, even this failed to achieve the number of "quality" pictures desired. It was with great misgivings that lower quality images were used at some points. Still, it is my firm belief that this work presents readers with the most accurate representation possible of the evolution of baseball in Springfield from its earliest forms to where it stood entering 2005.

PROLOGUE

Over fifty years after the last minor league team played in Springfield, Missouri, construction of Hammons Field in the downtown area has the Queen City of the Ozarks again ready for professional baseball. However, the average person today has little or no knowledge of the city's historic connection with the top levels of the national pastime. Team names such as the Reds, Midgets, Cardinals, Creamers, Stars, and Generals, along with White City Park and Memorial Stadium, remain merely footnotes in the reminiscent articles of retired Springfield journalists. Gone are memories of the long struggle to field successful minor league and semi-pro baseball teams in Springfield. The story of this long journey began during the nineteenth century, flourished at the turn of the twentieth century, culminated in the 1930s with a string of minor league championships, ended in the post-World War II period with a semi-pro national championship runner-up, and reemerged finally in the early 1990s.

This book does what no other writing has comprehensively or accurately done; it traces the long and storied path of Springfield professional and semi-professional baseball. By illustrating the joy and heartbreak experienced by Springfield fans from 1886 to 2004, a more complete understanding of 118 years of baseball emerges. As with all sports teams, Springfield area interest in baseball exploded and then waned throughout the years, usually in line with the performance of the local team. For this reason certain seasons stand out in terms of all-around success and therefore receive greater attention. Beginning with the earliest semi-pro and professional team of 1886, and detailing the first established semi-pro and professional teams in 1901 and 1902, respectively, an understanding of the sustained baseball tradition of the first half of the twentieth century surfaces. The single championship season of the 1920s, and the dominating ones of the early 1930s as a farm club of the St. Louis Cardinals receive their deserved credit. The 1935 season, however, stands out as the most crucial in Springfield professional baseball, when the future success of the franchise was jeopardized by critical ill-fated decisions within the Cardinal organization. Before final explanation of the events of the post-war period, which ultimately decided the total collapse of professional baseball in Springfield by 1951, the last winning season in 1941 all but concludes the Cardinal era. The grand era of baseball in Springfield ended during the mid-1950s with semi-pro baseball reaching its pinnacle of success and popularity, only to soon die away. As with nearly all entrants into American professional sports, Springfield teams struggled with the desire to win and the need to satisfy fans, while concurrently dealing with the economic realities of self support. The origins of this long and often tedious struggle toward successful baseball operations began with baseball's early development in Southwest Missouri during the late-1860s.

BIBLIOGRAPHY

Due to the comprehensive nature of this book, a broad range of sources were used. Primary sources became the overwhelming majority, in large part because of the limited amount of scholarly work previously done on the subject of baseball in Springfield. Naturally, newspapers from the 1860s through 1954 formed the majority of primary sources, and included the *Carthage Weekly Banner*, *Springfield Leader & Democrat*, *Springfield Republican*, *Springfield Daily News*, *Springfield Leader*, *Springfield Press*, *Springfield Leader & Press*, *Springfield News-Leader*, and *Springfield Daily Herald*. Also utilized were the *Sporting News: 1886–1950*, numerous U.S. Censuses, and turn of the twentieth century Springfield city directories and insurance maps. In terms of baseball statistics and information, the well known baseball guides *Spalding's*, *Lajoie's*, *Reach's*, *the National Association's*, *Commissioner's Office*, and *Sporting News*—stretching from 1902 to 1951—proved invaluable. The files of both the *Sporting News* in St. Louis and the Baseball Hall of Fame in Cooperstown provided document after document giving information on teams, leagues, and players, most of which cannot be found anywhere else. Finally, personal interviews of those few living individuals who experienced the local baseball past rounded out the most important parts of the research.

In terms of secondary sources, no minor league baseball researcher can correlate all the contradicting facts, dates, and statistics without Lloyd Johnson & Miles Wolff's, *Encyclopedia of Minor League Baseball 2nd ed.* (Durham: Baseball America.1997), Peter Filichia's *Professional Baseball Franchises: from the Abbeville Athletics to the Zanezville Indians* (New York: Facts on File. 1993), or Benjamin Sumner's, *Minor League Baseball Standings* (Jefferson, NC: McFarland. 1999). Robert Obojski's *Bush League: A History of Minor League Baseball* (New York: Macmillian. 1975) is still definitive as an overview of nineteenth century minor league baseball, while other works such as Donald Anderson's "Branch Rickey and the St. Louis Cardinals Farm System" (PhD. Dissertation: University of Wisconsin. 1975), John Hall's *Majoring in the Minors* (Stillwater: Oklahoma Bylines. 1996), Jerry Hogan's "Angels in the Ozarks: The Annals of a Hometown Minor League Club in the 1930s" (*Mid-America Folklore*, Fayetteville: University of Arkansas press. Summer 2002), Jeffery Aulgur's "Depression Era Minor League Baseball: The Arkansas State League 1934–1935" (Masters Thesis: University of Arkansas. 1991), and James Giglio's "Prelude to Greatness: Stanley Musial and the Springfield Cardinals of 1941" (*Missouri Historical Review*. July 1996) provided insight into the minor leagues of the 1930s and 1940s. For a general historical overview on Springfield's past, Harris and Phyllis Dark's *Springfield of the Ozarks* (U.S.A.: Windsor. 1981) provides the only comprehensive look, while various articles during the 1980s and 1990s in *Springfield Magazine* provided additional clarity. For a look at the movement of people in and out of Missouri, see Russel Gerlach's *Immigrants in the Ozarks* (Columbia: University of Missouri Press. 1976), and *Settlement Patterns in Missouri* (Columbia: University of Missouri Press. 1986) offers an excellent overview; while identification of broad historical events in Missouri is still best made with Duane Meyer's *The Heritage of Missouri* (Hazelwood, MO: State Publishing Co. 1970).

INTRODUCTION

Baseball first appeared in Southwest Missouri sometime after the Civil War. Although it is impossible to determine the exact date of its arrival, several towns apparently became serious about the game in 1867. That summer, Carthage, Neosho, Granby, and Springfield all fielded amateur teams, and all vied for bragging rights. The Springfield newspapers of the day, however, indicated that Springfield's collective interest in baseball remained low compared to other area towns. This trend changed little over the next 30 years.

Despite lack of rail service and inlet roads, baseball grew and prospered on a small scale in Springfield during the late 1860s for a variety of reasons. Settlement of the area had centered on two paths: the Springfield Road and overland passages through the Ozark Mountains. The old Indian trail that became the Springfield Road followed the highland area between St. Louis and Springfield. The road became the primary route of settlement into Southwest Missouri soon after Missouri became a state in 1821. The other route through the Ozark Mountains was utilized by groups of Scotch-Irish, who had slowly traveled west after arriving in America. These Scots-Irish crossed the Appalachian Mountains and came up from the southeast, some settling in Tennessee and Kentucky, before crossing the Ozark Mountains to settle in Springfield and other parts of Southwest Missouri. This ethnic group formed the basis of the northside neighborhoods that became the foundation for fan support for a professional team in Springfield, which was incorporated in 1838 but still remained a small town in 1865, with a population of under 2,000.

Springfield mirrored St. Louis closely in its development during this same time period. St. Louis began booming in the 1840s as numerous eastern travelers stopped through on their way west. Many were from New York and Boston and stayed, moved west, or returned to the East only after instilling in St. Louis "a continuous infusion of the latest eastern prescriptions and the most fashionable Yankee reforms." Well into the 1880s, St. Louis was considered "a Yankee outpost in a Southern province and a Northern city in a slave state." Therefore, it was hardly surprising that St. Louis developed the same kind of baseball tradition as New York City, Washington D.C., and Philadelphia. With a road, and later railroad, connecting St. Louis and Springfield, the Queen City of the Ozarks simply followed in the Gateway City's footsteps.

Springfield's slow but steady population growth (less than 5,000 in two decades) noticeably accelerated after the railroad arrived in 1870. The railroad brought progress, not only to Springfield, but to many other nearby towns. It also took some control of society out of the hands of locals, bringing an initial influx of Lutheran German immigrants who, along with Irish and German Catholics, worked in the yards of the adjoining railroad town of North Springfield, adding to the population of the Springfield area. The desire for new and better things, which often directly came from the East, placed westerners at odds over what was most important: autonomy or progress. Progress meant the tried and true methods of the East, which as it turned out, went against western opinion, especially when dealing with the development of the national game. Significantly, the 1870s witnessed baseball, on the national scale, move from its amateur beginnings to a widely popular professional game.

By 1877, three minor leagues had formed in the United States. By 1879, professional baseball first reached the American West with the creation of the Northwestern League. With teams in places like Omaha, Nebraska, and Davenport, Iowa, the Northwestern League brought professional

baseball closer to Springfield. The 1880s found more sophisticated teams around the country; some of these structured and organized teams played in professional leagues, but more were semi-professional. Springfield's first brush with truly competitive baseball came during this period. Semi-professional (semi-pro) teams came into vogue in nearly all areas of the country. In the natural progression from amateur to fully professional teams, towns and individuals who could not yet support the expenses of a minor league team could more easily afford semi-pro baseball. While not the exact equivalent of a minor league team in terms of players or competitiveness, semi-pro teams drew enthusiastic support from their communities. They offered a highly competitive team environment that featured talented players. The owners scheduled games based on economic considerations, which included playing on Sundays, the day when almost everyone was off work. Players in semi-professional baseball began as locals, although over time serious teams paid players more, and thus could recruit better players from other areas. The trend toward serious semi-pro action took hold in Springfield during the mid-1880s.

By 1886, Springfield fans yearned for more competitiveness from their semi-pro team: the Leader Cigar Baseball Club. Albert G. Fischer, a cigar maker, owned and managed the mediocre team, known to fans as the Springfield Reds. Despite Springfield's rapid growth during the 1880s (from population 5,555 in 1880 to 21,850 in 1890) the Reds received poor fan support. An early-season 18-1 loss to the Prickly Ash Nine team from St. Louis confirmed Springfield's weakness both on the field and at the gate. Naturally, fans want to watch winners, and Springfield increasingly found it hard to field skilled players. The *Springfield Daily Herald* and Fischer each shared the view that the team's poor play resulted from player raids by the Western League to the north. The only viable solution was for Springfield to join some "regularly organized ball association." The Western League offered the only potential option. In its fourth year of operation, in 1886, the Western League had teams in Nebraska, Kansas, Colorado, and as close as St. Joseph, Missouri. Detailed report of the requirements for Springfield's future entry indicated serious local consideration. Community members dedicated to the idea responded by quickly drafting a letter that circulated around town drumming up support for people to buy stock in the new team. At $25 a share, 120 shares were needed to raise the $3,000 in capital required to secure a franchise. Springfield's grasp of the requirements necessary to field a team in the Western League failed to acknowledge the reality of its geographical remoteness to Colorado and Nebraska. Supporters also underestimated the difficulty in towns like Springfield fielding less expensive and more flexible semi-pro teams, but playing in an organized minor league such as the Western, which required better facilities, financing, and fan support.

The Reds' poor performances, pitifully small crowds, and apparent failed stock drive all contributed to the death of the Western League proposal. Although rumblings over entry continued into the 1900s, 47 years actually passed before Springfield finally fielded a team in the Western League. The money raised from the 1886 stock drive may have been refunded to those few who supported the venture, but more likely it was contributed to what developed in the following year.

The year 1887 turned out to be a big one in Springfield on many levels. Springfield's population grew overnight in April of that year when an election merged the railroad-oriented city of North Springfield with its neighbor to the south. Economic expansion continued with the completion on the city's first elevator-serviced large office building, Baker Block, while recreational activities expanded with the opening of the first YMCA building. Little over a month after the two Springfields consolidated, a minor league in Southwest Missouri and Central Arkansas officially formed, and Springfield entered their former semi-pro team in the new Southwestern League as the Springfield Indians.

Springfield was better situated geographically in the Southwestern League, than it would have been in the Western League. With teams in Fort Smith, Pine Bluff, Hot Springs, and Little Rock, Arkansas, and in Webb City, Missouri, Springfield's travel distances seemed manageable. Though less serious than the risk of entering the Western League, a risk of failure still existed. Use of the recently installed railroad through Springfield allowed more efficient player transport,

but only regular patronage from the local fans could sustain the venture. On May 28, 1887, the Springfield Indians inaugurated the Southwestern League's schedule in Arkansas against the Hot Springs Blues.

Springfield lost their league opener, 11-2, before coming back the next day to beat the Blues in a wild, error-filled game, 21-17. The Springfield players, the majority recruited from the St. Louis area, struggled as they played on the road the first three weeks of the season. Only team captain and second baseman Al Tebeau and center fielder Tom Matthews played well. A little over a week into the season Springfield was playing .500 baseball, while the Fort Smith Indians opened with seven straight victories and Webb City went 5-4, claiming first and second place in the league, respectively.

Springfield continued playing on the road and remained in the middle of the pack heading into their first home game of the season on June 20. The excitement of the first professional game in Springfield, which, like other area events, probably opened with a performance by the popular Springfield Military Band, was offset by two losses to the Pine Bluff Infants. Small crowds spelled the doom for a club likely still reeling from accrued travel expenses. By early July both the Springfield team and league had folded. The disbandment of the Springfield club ended with the more talented players being absorbed by Joplin, Missouri's mid-season first attempt at professional baseball in the neighboring Kansas State League.

Semi-pro and amateur baseball involving the Fischer name carried on in Springfield after the collapse of the Indians. Springfield, along with the other teams new to professional baseball, learned the hard way that determination to field a professional team was not enough. Other outside influences were necessary for survival.

Professional baseball during that year in other parts of the country faired little better than it did in Springfield. As minor league baseball historian Robert Obojski noted, many minor leagues had trouble getting started during this period. The creation and disbandment of numerous leagues and teams demonstrated not only that Springfield was normal in its attempt at minor league baseball in 1887, but also that the phenomenon of failure was predictable and linked by a common cause—poor financial backing and infrastructure.

However, minor league baseball grew rapidly in the early 1890s. The Southwestern League even reappeared in 1891 with some of the same teams, although Springfield continued to stay out of the professional fold, preferring instead to focus on the numerous semi-pro and amateur teams that sprung up in the period.

Springfield's apparent reluctance to join a minor league during the 1890s sprang from factors other than baseball's lack of popularity in the city. The burgeoning young community, with a population in the low twenty-thousands, seemed satisfied with its current level of baseball. The economic outlook remained shaky throughout the decade, as the depression of the 1890s created a cautious air throughout Springfield. Even with construction of buildings such as the $100,000 Springfield High School in 1893 and the Federal Building a year later, the economic downturn made a direct hit in 1893 when five of Springfield's twelve banks closed their doors. As would be the case many times over, the high percentage of steadily employed railroad workers offset the effects of a poor national economy and allowed the city's continued growth throughout the decade. During this time, play began out at the Old Fair Grounds, a small, rickety park situated on property in a square block between Division Street, Campbell Street, Lynn Street, and Boonville Avenue. Springfield's baseball tradition remained strong throughout the decade, although Springfield remained outside the minor league craze that emerged during the 1890s.

The minor leagues continued to grow and shrink in that decade. Eastern leagues typically survived longer than those in the West, where no amount of effort and determination could keep many afloat. Indeed, development of manufacturing precipitated minor league success, whereas limited capital and industrial organization in small cities like Springfield decreased viability. Increased industry created good paying jobs, which enabled people to afford ball games. No team survived without fans, and lack of fans ultimately doomed Springfield's first brush with minor league baseball.

ONE

The League At Last

Around the turn of the twentieth century Springfieldians again began to itch for professional baseball. With little else to do and still desperate for anything to take their mind off the deadly smallpox epidemic of 1899–1900, Springfieldians frequented Doling Park, an amusement facility at the city's northern edge. The Springfield economy blossomed with even more railroads jobs, in addition to abundant mill and factory work. By 1901, the city of 23,267 inhabitants possessed the capabilities to support professional baseball. Fourteen years had past since the Springfield Reds were transformed into a professional team, and Horatio S. (H.S.) Fischer, a Springfield traveling salesman and brother of former team owner Albert Fischer, controlled the Springfield team. H.S. Fischer, perhaps acting on his brother's experience and advice, wanted no part in the expense and frustration of fielding a team in a professional league. Fischer felt that a new league would fail, just as the Southwestern League had previously. He had only to consider all the teams and leagues that had failed during the previous decade; losing considerable sums of money on professional baseball was still very much a reality in 1901. After the completion of the Reds' very successful 1901 season, in which sizable crowds attended the semi-pro team's bi-weekly games, Frank "Shorty" Hurburt spearheaded Springfield's return to professional baseball.

The squat, round-faced, and mustachioed Hurlburt arrived in Springfield sometime in the mid-1890s and within a few years began a co-proprietorship called Shorty's Livery and Transfer, located at 310 Boonville Avenue. By 1901, Hurlburt co-owned the Baker Arcade, a popular billiards parlor and saloon on the northwest corner of the public square. He spent the winter of 1901–1902 actively campaigning for local support of a Springfield team in a new professional league, while undoubtedly dodging encounters with the city's very active and leading prohibitionist, Aunt Libby Osburn. The cantankerous Osborn sought to put an end to use of the alcohol and tobacco products that Hurlburt counted on to help fund his team. Hurlburt's perseverance persuaded towns in the region that had previously attempted professional baseball or that currently fielded successful semi-pro teams to commit to a league. He collaborated all winter with his partner, August "Gus" Bennert, a homely looking bachelor who owned the Queen City Restaurant on College Street, to get the team and league idea going. Hurlburt's and

Bennert's labor resulted in the new Class D Missouri Valley League and its member team, the Springfield Reds. Not coincidently, this new league was formed using the rules established by the new National Association of Professional Baseball Leagues (National Association).

The National Association had formed the previous fall in Chicago at a meeting of the presidents of the country's largest minor leagues. The National Association, operating out of Albany, New York, established for the first time a set of guidelines for minor league teams. The Missouri Valley League joined the National Association and therefore followed its guidelines for creation and operation. Stipulations such as leagues establishing a mandatory deposit of forfeit money were employed as safeguards against the volatility of nineteenth-century minor leagues. The National Association provided the structure and security that any group or individual investing money in a team would want. With this foundation in place, Springfield set itself up for successful operation as a minor league city.

With the league's second and most important meeting at Fort Scott, Kansas, looming, H.S. Fischer sold his team to Hurlburt and Bennert on April 15, 1902. Hurlburt assumed the role of field manager, while Bennert became team president, and Ott Morris became secretary and assistant manager. Eight clubs from Springfield, Joplin, Sedalia, Jefferson City, and Nevada, in Missouri, and Fort Scott, Coffeyville, and Iola, in Kansas, attended the April 15 meeting. Dr. D.M. Shively, the former sports editor of the *Kansas City Star*, became league president and secretary. Opening day was set for May 6, with a nearly four-month long schedule of 126 games. Additionally, each team paid ten dollars to register with the National Association and agreed to deposit $100 forfeit money with the league by May 6, thus guaranteeing completion of the season. To keep expenses low, a $400 per team monthly season salary limit, well below the National Association limit, was instituted, with each team receiving $25 travel money for road games. Finally, the league settled on the widely used Spalding ball for use in games. With Hurlburt's successful return from Fort Scott, the *Springfield Republican* gleefully decreed, "The League at Last."

The excitement over professional baseball in Springfield grew. The *Springfield Republican* commented that "greater interest was taken in the national game than was ever before evidenced in the city." This renewed faith in professional baseball owed itself as much to the uniformity and structure introduced through the National Association, as to the grand popularity of the game in Springfield. Success appeared eminent. Mere weeks before opening day, an enthusiastic drive began to clean up the Old Fair Grounds ballpark. Although the *Republican* claimed that the park would be "equal to best ball parks in this section of the country," even leveling the infield, and installing cushioned reserve seating in the small, approximately 2,000-seat wooden grand stand, left the playing field in poor condition. Springfield players would learn to deal with a rocky infield as well as ruts and holes left in the outfield grass from circus and carnival use. Still, Springfield's field shone when compared to some others in the league. The Nevada club played its games on a tattered field at the state mental hospital grounds, giving rise to their name, the Nevada Lunatics. The other clubs' sub-par facilities (some totally lacking formal seating), combined with quirky team names, only contributed to a well-deserved initial reputation as a bush league. With teams like the Sedalia Gold Bugs, Fort Scott Jayhawkers, Iola Gasbags, and Jefferson City Convicts, it was little wonder that by 1903, Shivley himself, writing for the *Spalding Guide*, called the Missouri Valley League "the little brush organization of the Middle West." The St. Louis-based *Sporting News* showed little confidence in the league and quit covering its games after late May. More traditional names like the Joplin Miners, Coffeyville Indians, and Springfield Reds failed to provide the league with initial respectability.

In his first move as the new Springfield manager, Hurlburt revamped the team roster. The Reds of 1901 featured several quality players destined to return. Foremost were infielders Harry Gross and Ted Schipke, and pitcher Ed "Red" Craig. On April 18, John Perrine, the "famous kid shortstop," arrived, the first of many of Hurlburt's players imported from Kansas City and St. Louis. Hurlburt hurriedly scheduled exhibition games, played partially with Fischer's assembled bunch. The Springfield management also ordered new red jerseys and held its first practice that

same day. Players slowly trickled into town and the Springfield club played several exhibitions against St. Louis area teams. Fifteen hundred "wild and excited" fans turned out on April 20, to watch Springfield lose in 13 innings to a St. Louis Friscos team that the *Republican* (totally discounting the existence of the American League's Browns) repudiated to be the best team in St. Louis next to the National League's Cardinals.

Two days later, George Ehle arrived from St. Louis, with the catching position reportedly locked up. Not satisfied however, Hurlburt continued to solicit players, inviting a former Southern League catcher to challenge for the job. The catching job seemed filled. But, during the last week of April, a young man from Arkansas named Charley Schmidt journeyed northward through the rugged Ozark hills after hearing about the new Springfield club. After a rigorous session, he impressed Hurlburt enough that when the other catcher failed to arrive, Schmidt was signed.

Following two more exhibition wins and the let down of an opening day rainout, Springfield mayor J.E. Mellette again declared May 7 to be "baseball day" in Springfield and threw the traditional first pitch. Hurlburt and Bennert also orchestrated an hour-long pre-game concert on the square, performed by the Hobart Military band. Afterward, the band loaded up street cars and proceeded down brick-lined Boonville Avenue to the fair grounds. Businesses all over Springfield shut down that afternoon so that Springfield's many blue-collar workers could attend the weekday game. A packed grandstand watched Springfield commit five errors to lose 11-6 against Joplin. Because of the small primitive gloves and poor playing conditions, high error totals became a hallmark of the league, just as rowdy crowds would later.

Springfield played inconsistently the first week of the season, but with an even record they stayed close to red hot Nevada and Fort Scott. Just days after the opener, a surprising second professional team, the Springfield Independents, announced its formation. The Independents pooled together the remaining Springfield area players, including the recent Hurlburt cast off, McAfee, for the purpose of barnstorming against a wide range of teams. The Independents' schedule of two or three games per week produced surprisingly good crowds. As the season passed its second week and the Reds began to win, the additional team little affected the Missouri Valley League team's attendance. The bigger problem for the Springfield Reds became the predicted league instability. On May 18, with Springfield was in third place at 5-6, neither Jefferson City nor Sedalia had paid the $100 deposit due by May 6. Small crowds at Sedalia had already nearly bankrupted club owner Dr. J.W. Furgison, who sustained his team on road trips solely by using the $25 paid to visiting teams. Both Jefferson City and Sedalia managed to continue operation, shrugging off Shively's hollowed threat of immediate removal from the league. With league business settled temporarily, Hurlburt focused on a heated early season pennant race, wheeling and dealing to put the finishing touches on a championship caliber team.

The only teams hotter than Springfield in late May were Nevada and Fort Scott who continued one-two in the standings, with Springfield close in third place. Springfield reeled off eight straight wins during May 19–28 to raise their record to 13-6. With Joplin in fourth place, and the poor quality of the remaining four teams obvious, the league's second division took shape. On June 4, Springfield finally played Nevada for the first time. The Reds woke up at 4:26 in the morning to catch the early train to Nevada for a three-game series, starting that afternoon. After a rainout, Springfield split the remaining two games against the "Loonies," as many papers around the circuit had begun calling them. Hurlburt continued to experiment with new pitchers, funneling in cast offs from bordering leagues, includingt a pitcher from the Memphis club of the Southern League. As was the case all season, Hurlburt searched for the pitcher who might propel Springfield into first place. The Southern Leaguer lasted less than a week under Hurlburt's physically taxing, money saving, three-man pitching rotation. Another win in front of the "largest crowd that ever witnessed a game in the Missouri Valley League" in Fort Scott crept Springfield even closer to the Jayhawkers for second place by early June.

The Fort Scott-Springfield series resulted in a season-long animosity toward Fort Scott fans, which gave birth to the Springfield team's future nickname. Jayhawker fans, unlike the

almost non-existent Nevada fans, turned out in force and were often exceptionally rowdy. Both Springfield players and fans soon learned to watch what they said and did while in Fort Scott. The *Fort Scott Monitor*, reflecting the hostilities of the railroad town's working class, many of whom experienced the border land fighting of post-Civil War Kansas, joined several other papers around the league in referring to the Springfield club as "runts." The term poked fun at the exceptionally small physical stature of some of the Red's players, but the Springfield papers took the term to heart and transformed it into the "Midgets." The name slowly gained acceptance as the season continued and eventually became one of the most well-known and beloved names in Springfield baseball history.

Springfield returned home on June 9 for a needed day off before hosting Nevada for the first time. Springfield fans joined others around the league in detesting the league leader's tendency toward unsportsmanlike play. Gamblers played on the anticipation of the series by placing bets days before. Some gamblers even portrayed themselves as "businessmen" who followed the Reds around the circuit to monitor play. Good weekday Springfield crowds witnessed their Reds lose two games to the Lunatics. A 12-1 victory gave some hope as Springfield blew out Nevada in the series finale. Even winning the next two of three against Fort Scott moved Springfield no closer to Nevada as the Lunatics continued to dominate. Springfield, however, stayed with the league leaders, finally pulling to within one game of second-place Fort Scott on June 17.

The Missouri Valley League nearly suffered its first casualty of the season when last-place Coffeyville set out to play in Springfield on the morning of June 22. At 9-28, Coffeyville easily fielded the worst team in the league, had little prospect for improving, and enjoyed little fan support as a result. The Indians came in route to Springfield, as far as Mound City, Kansas, then inexplicably turned around. Hurlburt speculated publicly that Coffeyville had probably disbanded, and then scrambled to fill that afternoon's game with a scrap against the Springfield Independents, whom the Reds easily defeated 6-1. Coffeyville finally arrived in Springfield a day late, and the Reds handled the Indians easily, sweeping the three-game series including one by forfeit. By June 24, Springfield had overtaken Fort Scott for second place with a record of 26-13, but still remained four and a half games behind Nevada. Two days later Joplin ended a seven game Reds winning streak, as the Coffeyville Indians became the Chanute Oilers.

By late June, Hurlburt felt first place finally within his grasp and began wheeling and dealing to further strengthen the club. Hurlburt worked a deal with Joplin for their 18-year-old rookie outfielder Harry "Dick" Bayless. Bayless, a Joplin native, impressed the Reds skipper so much that he surrendered a starting pitcher and "cash boat" of money for the outfielder. Hurlburt justified the loss of one of his few pitchers by claiming an ace in the hole was on the way. In mid-June Hurlburt began negotiating with one of the San Francisco area's best pitchers, Harry Kane. Hurlburt rationalized Kane's expense to the Springfield club and agreed to meet all monetary demands, including prepaid transportation to Springfield, largely because the Reds continued to draw well at home and therefore made money. Kane's asking price, however, pushed Springfield far above the monthly league salary limit. His first outing on June 30 proved a disappointment, as the Reds lost to Joplin, 3-2. Kane's next outing turned out little better, as the umpires' calls, which could be very inconsistent at times, so enraged the recent California League player that he induced the entire Springfield team to follow him off the field while leading 11-9 in the sixth inning. Kane recouped the forfeit loss on two days rest in a no-hit win over Iola on July 7. Still, Springfield remained in second place, three and a half games behind Nevada.

In mid-July Springfield began their long march to overtake Nevada, who at 43-14, were only two and a half games ahead. Nevada rolled into town on July 19 to face a red-hot Springfield club just off a three-game sweep of Fort Scott. Kane faced-off against "King" Morton, considered the best pitcher in the league before Kane's arrival. To the amazement of a sizable crowd, the two hurlers dueled for 20 long innings before Springfield scored a run in the bottom of that final inning to win 2-1. The next day, before a large and vocal crowd of 3,500, Springfield fell behind early before a disputed call in the fourth inning resulted in the Lunatics player manager James Driscoll being ejected. Driscoll's subsequent refusal to leave ended with him removing his

16

team from the field. Fearing a riotous crowd, the Springfield management reluctantly requested Driscoll's reinstatement. After the teams retook the field, Springfield scored to take a 4-3 lead, before Driscoll became upset again in the fifth and officially forfeited the game. The Reds missed an opportunity to pull within half a game of first place when Nevada hit Jones hard and won the series finale, 10-4.

The next day Hurlburt released Jones out of disgust over the pitcher's performance. Soon rumors also began to spread about a possible trade of Kane to the St. Louis Cardinals for 25-year-old right handed pitcher, Willie Popp. Although Hurlburt ignored any offers for Kane, realizing that he could hardly afford to trade or sell the most dominant pitcher in the Missouri Valley League, the realization soon set in that the marathon outing of July 19 affected both pitchers. Both Morton and Kane were noticeably ineffective in subsequent starts the following week and the Nevada starter never seemed to fully recover. While Hurlburt experimented by signing a new pitcher from Lebanon, Missouri, to further strengthen his staff, Kane took the possibility of moving up to the majors to heart.

Once again, Springfield nearly caught Nevada, pulling to within one game of first place at 46-21 late in the month. Springfield played a Sedalia team on July 30 that had won eleven straight games and advanced to fourth place by importing several former major leaguers, as well as future St. Louis Cardinals scout Charlie Barrett. A reported record weekday crowd witnessed Springfield take a double header from Sedalia, led by Kane's ten strikeouts in the first game, leaving the Reds only half a game behind Nevada and prompting Sedalia's ace and game-one-losing pitcher, Paul "Premier" Curtis, to comment to Hurlburt that, "you have the fastest team I have ever seen."

The league's most consistent team during the month of July finally completed its march to first place on July 31, when Springfield defeated Sedalia, and Nevada did not play. Springfield's taste of first place was short lived, however; the next day, Sedalia defeated the Reds in the final game of their series, and Nevada split a double header with Chanute. Nevada should have won both games, pushing their lead back to one full game, but again forfeited a game when a Nevada player fought umpire Charles Collins. Nevada's reputation for winning through intimidation was by then well known throughout the league, prompting the *Fort Scott Monitor* to label the Nevada team "a bunch of howlers."

Springfield regained the league lead on August 6, and held it for a week, but never by more than one game. Springfield led by a miniscule .005 percentage points in the standings before a loss to Sedalia on August 13 knocked the team out of first. Three days later Springfield had slipped to three games out, following their fourth straight loss. Some believed the down slide owed itself to the loss of Kane, who on August 6, illegally jumped to the St. Louis Browns, after apparently convincing the American League club that he was free to do so. Kane pitched in four big league games over a three week span, one of them an unsuccessful start. The loss of Kane meant less, at least initially, than the temporary loss of Springfield's only other effective pitcher, Ed Craig, who quit after complaining that he was overworked and, above all, underpaid. Unfortunately for Craig, league rules forbade negotiating raises during the season. By the time Springfield played Jefferson City in a special game played in the northern Arkansas community of Monte Ne, Craig had returned.

The Reds rebounded to play well the remainder of August but lost ground to a Nevada team that still rarely lost. When St. Louis finally decided to turn Kane loose, he returned to Springfield. Normally suspension came to a player committing Kane's act, but Hurlburt needed him too much. The matter was likely never turned into the league office, and Kane returned just in time to help Springfield overtake Nevada one last time by .004 percentage points on September 1.

Springfield then fell permanently back into second place after losing three of five games to Nevada during the first week of September. Teams around the league continued to despise Nevada so much that rumors began to circulate that teams like Iola (who had picked up the discarded James Driscoll) were colluding to allow Springfield to win the pennant. The rumors

proved false, and Springfield fell back to four games out of first place by mid-September, due in large part to Nevada remaining nearly unbeatable. The final blow to Springfield's pennant hopes came when both Perrine and Schmidt were lost for the season to injuries with barely two weeks left. Sid Zoellers, who became the starting centerfielder shortly after the start of the season, led the team in batting with a .351 average, while the rookie Schmidt impressed many around the league with his steady defense and hitting. The rookie outfielder Dick Bayless, who briefly made it to the majors with Cincinnati in 1908, hit .312 after coming from Joplin.

After the league meeting in late September, a 1903 return of the Missouri Valley League became assured. The league raised the salary limit to $550 a month per team, while the teams' deposit to insure completion of the season grew to $300. Despite widespread displeasure during the past season over his lax enforcement of league rules, D.M Shively was reelected president. And Hurlburt assumed a more active role in the league by replacing Don Stewart of Joplin as vice president. As was expected, the league eliminated its two weakest teams—Jefferson City and Chanute—and added new teams in Pittsburg and Leavenworth, Kansas. All other teams returned for 1903.

Soon after the 1903 season began on May 2, it became obvious that Nevada's winning ways would not continue. The Lunatics' sparse crowds in their inaugural season caused team owners Harry Mitchell, C.M. Duck, and A.B. Cockrell to lose money, just as all the teams in the league had except Springfield. Money issues left the defending league champion a shell of its former self; its quality players were either sold to teams with higher classifications or unwilling to return for offered salaries. Less than two months into the 1903 season the Nevada franchise moved south to Webb City, Missouri, before it folded a week later. With its arch nemesis of 1902 uncompetitive from the start, Springfield jumped to the lead in the 1903 Missouri Valley pennant race.

In early July, the Springfield Midgets, with a 35-13 record, held a four and a half game lead over the second place Joplin Miners. Hurlburt returned most of his team from the year before, with key players Perrine, Schmidt, Bayless, and Kane leading the charge. Hornaday's Fort Scott club continued in their 1902 position of third place, while Iola and Sedalia brought up fourth and fifth places. By the season's midway point on July 16, Springfield's lead had been reduced to two and a half games by second place Iola, after a sudden and unexpected charge. But Iola's rise paled to the one made during the second half by then fifth place Sedalia.

Springfield began the second half of 1903 at 43-20 and in first place in the Missouri Valley League. The Sedalia Gold Bugs entered the second half with a record of 33-29, stuck in fifth place, nine and a half games out. Team owner J.W. Furgison's sudden move to stock his team with high-priced talent had initiated Sedalia's second half run in 1902. That move, however, pulled the Gold Bugs no closer than fourth. When E.N. Harrison took over ownership early in the 1903 season, it appeared little had changed, aside from the club picking up veteran second baseman James Driscoll to round out a squad led again by ace pitcher, Paul Curtis. Paced by the league's leading hitter, catcher J.H. Schrant, Sedalia stunned Springfield fans by going 51-18 during the second half of the season. Springfield's steady play during the second half of the season left them tied for second place with 38 wins, but the Midgets still lost the pennant by two and a half games. Despite leading the league in hitting at .296, Springfield fielded poorly for the second straight season, recording the second worst percentage in the league at .930. Springfield's downfall came when they failed during the second half to dominate any team completely, while Sedalia beat up on the league's worst remaining teams, Joplin, Fort Scott, and Pittsburg. (Leavenworth and Webb City both folded on July 16.)

For Springfield fans, little changed in 1904. Leavenworth returned to the league, and Topeka, Kansas, replaced Nevada's former franchise. Hurlburt stepped aside as manager and allowed infielders T. Smith and John Perrine to each take turns running the team. The season began in April with a well received spring exhibition game at the Fair Grounds against the Chicago White Sox, but the Midgets finished in second place for the third straight year. The revamping of a team that only returned Zoellers and Schmidt to the Springfield lineup actually failed to win 80 games for the first time in franchise history. Iola won its only league championship that

year, winning 83 games and dominating Springfield in head-to-head play, eleven games to six.

Prospects for the Missouri Valley League looked very good after the 1904 season. Most of the teams in the league had made money, but in order to further consolidate, the two smallest market teams, Pittsburg and Iola, were voted out. The more attractive communities of Okalahoma City and Guthrie in Indian Territory were then added. The big news during the off-season meeting came from the decision to change the Missouri Valley League's name to the Western Association (W.A). Three times before, the last coming in 1901, a league had operated under that label. Shively explained the use of the name by claiming that the "managers deemed it advisable to give the organization a more pretentious title." In truth though, Shively himself pushed for the name change because it made his league "appear far more important." Ultimately, the name change made some sense because of the expansion into Indian Territory. In addition to the new name, the collective population of the cities allowed the league to move up to Class C standing, as well as to increase their games from 126 to 140. This fourth and final edition of the Western Association turned out to be longest running one, as the new W.A. lasted, with several brief interruptions, until 1954.

The *Spalding Guide* called the 1905 Western Association season "the most prosperous season of its history." The apparent "positive" changes for the league left Springfield at a disadvantage in 1905. Springfield had been the most successful team in the three years of the Missouri Valley League with an overall winning percentage of .644, but failed to compete with the three new large metropolitan areas of Oklahoma City, Topeka, and Wichita in players or attendance. The Springfield president and manager, Hurlburt changed the team name to the Highlanders but failed to drum up much enthusiasm for a team that finished in last place. The club's sudden collapse from 77 wins in 1904 to 54 wins in 1905 (with more games played in 1905) caused Hurlburt to lose considerable money for the first time. After the season, the "founding father" of modern professional baseball in Springfield cut ties and left to manage the league's new team in St. Joseph, Missouri.

The 1906 season represented a slight turn around for the Springfield club. Gus Bennert, with little if any managerial experience, began the season as the club's field general in addition to regaining his former position of club president. Although the team played competitively, before the season ended both Springfield native and starting catcher J. Warren Seabaugh and team secretary and treasurer John Shinn had shared the duties of managing Springfield to a fourth place finish at 72-67. Springfield finished ten and a half games behind first-place Topeka— more successful than Hurlburt's attempt to transfer J.D. LeBolt's ex-Guthrie franchise north to the former Western League city of St. Joseph. On June 12, after suffering the same poor play and attendance as Springfield the year before, the St. Joseph Packers moved to Hutchinson, Kansas, leaving Hurlburt jobless and temporarily out of baseball. While the former St. Joseph franchise was on its way to an overall last place finish in the league, Springfield's poor start in the league race shifted by mid-summer, and for a two-week period in mid-July the team, now again called the Midgets, caught fire and surged to the front of the Western Association pack, only to again slump and permanently fall back by late in the month.

The 1906 season also proved to be the last good year during Springfield's early period of professional baseball. Due to St. Joseph's financially positive move to the baseball hungry community of Hutchinson, Kansas, no team in the circuit lost money. Springfield management, likely anticipating further financial success, paid its annual guarantee to the league for the 1907 season. Springfield never stood a chance in 1907, however, as the entire league ran up against the Wichita Jobbers, the second greatest team in the history of the Western Association. The Jobbers led wire-to-wire in capturing the pennant, going 98-35, compared to Springfield's worst record to date at 46-92. Only Leavenworth finished worse than Springfield, with a 29-108 record. New manager "Dad" Pierce took the blame for poor decision making early in the season, but actually the Midgets suffered more from injuries and general poor play. Leading hitter and defending league batting champion Warren Seabaugh missed most of the season, and no Springfield regular batted as high as .270.

The highlight of the 1907 season turned out to be the opening of one of Springfield's greatest landmarks—White City Park. The three owners of the United Amusement Company built the new amusement park on the same square block (Division, Lynn, Boonville, and Campbell) as the Old Fair Grounds, by then commonly known as Central Park. Referred to by a local paper as the "Baghdad on Boonville" for its Middle Eastern décor, the White City Park opened in May and featured a penny arcade, billiards room, bowling alley, skating rink, roller coaster, theater, restaurant, dance hall, and grandstand. Although the grandstand, like the one it replaced, was intended for multiple uses (circuses, for example), the main use remained baseball. The White City Park opened during the panic of 1907, an economic downturn that hurt its first-year business as well as that of the ball team. The Midgets' terrible record only made the situation worse. By the next season, the White City owners gave up on professional baseball, and the Midgets temporarily moved north to Doling Park.

Displeasure with the Springfield club's showing on and off the field went beyond Springfield during the winter of 1907–1908. Off-season meetings revealed that some club owners favored removal of Springfield and Leavenworth from the league. In the end, only Leavenworth got the ax, and Springfield returned for another fruitless season. Springfield management tried in vain to resurrect the fallen Springfield club. They even brought in the well-traveled veteran minor leaguer Dud Risley to manage the Midgets. Neither Risley's return, or the return of Hurlburt, to the organization's management prevented Springfield from again finishing seventh in the eight-team W.A. pack. Their poor record resulted in Tony Vanderhill replacing Risley before the 1908 season ended with a 50-87 showing. In addition to playing in smaller and less-accommodating Doling Park, Springfield struggled that season under a considerable population disadvantage.

Springfield had been one of the largest cities in the Missouri Valley League. By 1908, Springfield was one of the smallest in the W.A. and was barely able to compete. The limited finances of its local small business owners prevented Springfield from attracting top players. The cause of the money problems ultimately came with the league's move up to Class C standing. With the move came an increase in the salary limit. When the Springfield club slumped, and attendance dropped accordingly, it became extremely difficult to cover monthly salaries that, at $1,500, were over three times those of the Missouri Valley League's first season in 1902. The only solution was to employ less talented players who commanded lower salaries. As with many financially strapped ball clubs, the Springfield club usually sold its one or two good prospects to a higher classification after the season ended to make up budget shortfalls, and thus, had to start over again, playing the next season with unproven talent. An example of this came during the 1908 season when Springfield's team captain led the W.A. in batting average at .322. One year later he was no longer with the team.

Under the renewed managerial leadership of Frank Hurlburt, Springfield returned to the W.A. for its eighth season in 1909. The team also returned to playing at White City Park after the White City owners decided that it was better to gain the added attraction for the struggling amusement park. Improving competitiveness and consistency within the league had enhanced its reputation for producing quality talent. After the 1909 season, Springfield sold its two best players directly to major league clubs. The move produced much needed revenue, but again left the roster depleted for the following year. The accomplishments of a few players meant little to the overall record of the Midgets, as the team again failed to crack 60 wins, even after returning to the 126 game schedule. Springfield looked promising in 1909, coming out of the gates running, and even leading the league for the first six weeks of the season, before the club faded when eventual champion Enid overtook them in June. An improved winning percentage of .444 (56-70) failed to regenerate any interest in baseball in Springfield, and Hurlburt decided he had lost money for the last time. After the season the Springfield team withdrew from the W.A., and Hurlburt broke ties with Springfield professional baseball for good. Perhaps foreseeing more bad times ahead, D.M. Shively also resigned as league president after the 1909 season.

Hurlburt's decision to stay out of the Western Association in 1910 had been a wise one, as the league struggled badly and finished with only four teams. T.C Hayden became the

new league president, relieving vice president J.H. Shaw who oversaw the league in 1910. Longtime W.A. owner and manager Larry Milton attempted to revive a team in Springfield in 1911 when he entered the Springfield Jobbers in a reorganized Class D Western Association. Milton's entry became one of eight teams to start the 1911 season. Despite a favorable initial response in Springfield to the new team, financial problems within the league persisted, and within a week into the season the Joplin club folded after it failed to pay its $500 franchise guarantee. Representatives from the other teams decided that without Joplin as part of a road trip Springfield was too far removed from the rest of the league and voted Milton's Springfield club out of the league. Milton, claiming displeasure over poor attendance in Springfield (crowds ranged from 300 to 1,200 per game), symbolically handed over the leagueless team to former Joplin team captain Tony Anderson. Despite Anderson's aspiration to take over the Springfield club, the team folded on May 10. A little over a month later the Western Association folded for the first time in its history, not to return until 1914. Thus, Springfield remained teamless through 1915, when an eight team circuit called the Continental League was planned by D.M. Shively, purposely to included Springfield and to be affiliated with the outlaw Federal League. However, the Federal League folded after the 1915 season and Springfield ultimately remained teamless for the decade.

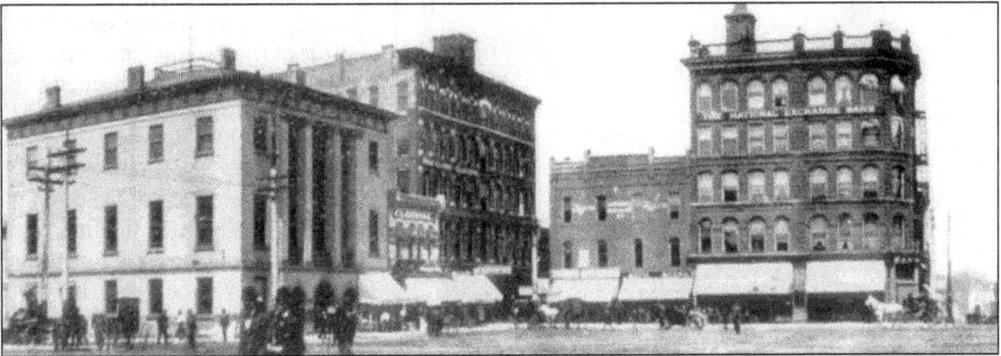

Springfield Public Square. In grand old style, the 1902 Opening Day for professional baseball in Springfield began with a band playing on the city square, before the group paraded north up Boonville Avenue, to the Old Fair Grounds Park where they continued to perform. Ultimately, this scene, complete with the ceremonial throwing out of the first pitch by the city mayor, played itself out many times over the years in opening the minor league season. (Courtesy of the Springfield-Greene County Library.)

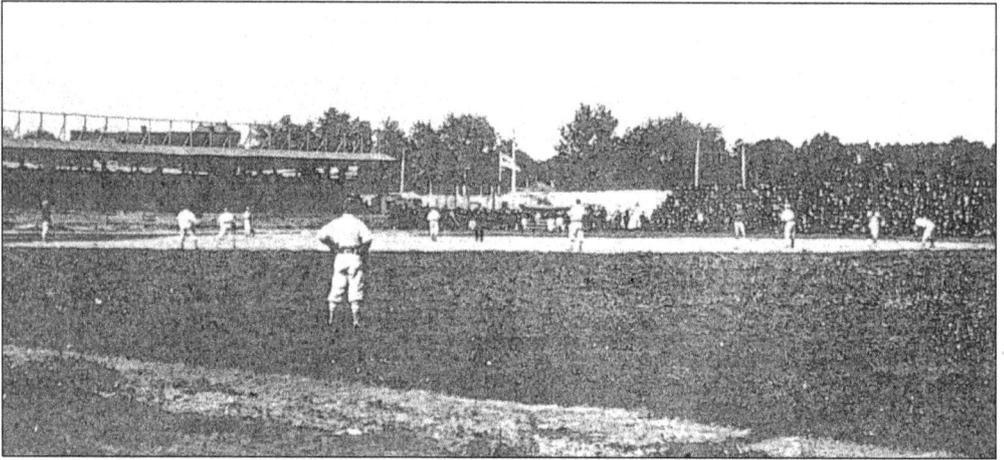

Old Fair Grounds Park. It became the Opening Day home of Springfield's new minor league franchise, the Reds, in the Class D Missouri Valley League of 1902. The ballpark had received few renovations to improve its condition during the last decade of the nineteenth century, prompting organizers to refurbish its approximately 2,000-seat grandstand and roll the infield dirt, thus making it easily the best facility in the early years of the Missouri Valley League. Soon after that initial season, the ballpark and surrounding property became more commonly known as Central Park.

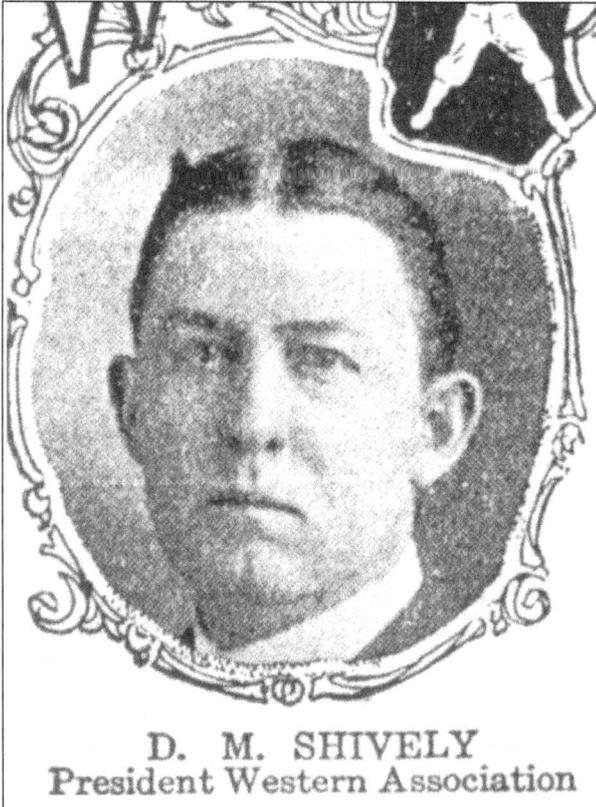

D. M. SHIVELY
President Western Association

Dr. D.M. Shively. Dr. D.M. Shively was the former sports editor of the *Kansas City Star* when he became the president of the new Class D Missouri Valley League in 1902. From the start, complaints frequently blossomed, as Shively often overlooked violations of league rules. His lax enforcement apparently hurt some team's ability to compete, but not Springfield's, who took advantage early on by routinely eclipsing the league monthly salary limit. Shively led the circuit as both the Missouri Valley League and Western Association through the 1909 season, when further discord finally forced his resignation.

1902 Season Opening Ad. In early May 1902, professional baseball returns to Springfield for the first time in 15 years. Team owner/manager, Frank "Shorty" Hurlburt, who had purchased the former semi-pro team in April, ran this ad in the *Springfield Republican* advertising the May 6 opening of the inaugural season of the Missouri Valley League.

Base Ball !

Old Fair Grounds

Opening of

League Season,

Tuesday,
Wednesday,
Thursday.

**Joplin vs.
Springfield.**

**Big League
...Games...**

*Wednesday, June 11,
Thursday, June 12,
Friday, June 13.*

Springfield vs. Nevada.

1902 Games vs. Nevada Ad. The Springfield Reds were stuck in third place behind league leaders Nevada and Fort Scott when the first-place Lunatics rolled into town. The Nevada series of June 11–13 became not only the first big series of the year but demonstrated why Springfield became the only team in the league to make money when crowds of around 3,500 packed the grandstand, bleachers, and areas all around the field.

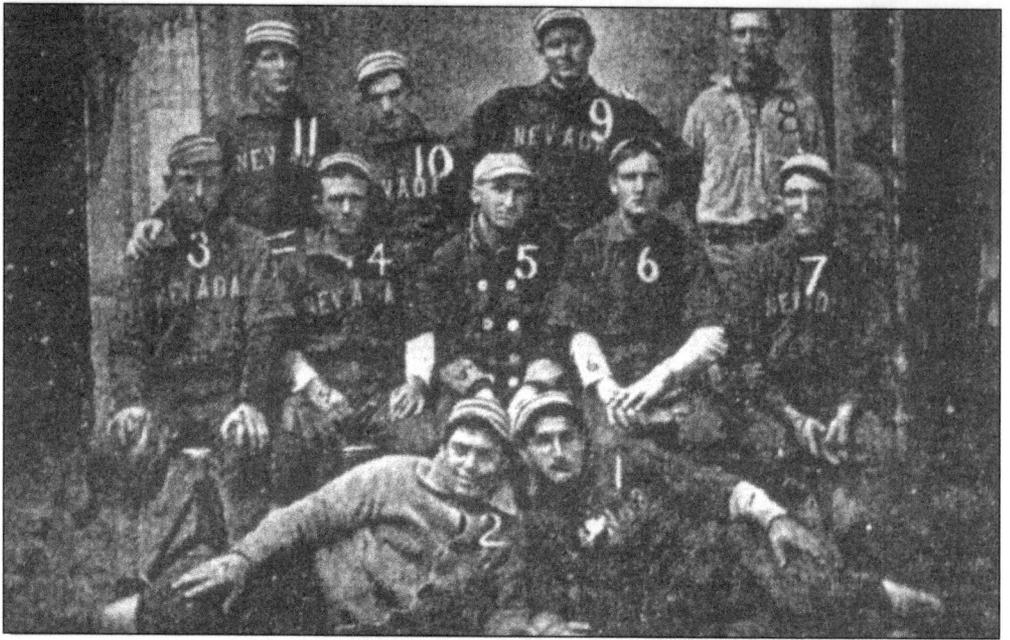

1902 Nevada Lunatics. Only Springfield managed to wrestle first place from the dominant Nevada Lunatics during the inaugural season of the Missouri Valley League. The Lunatics held first place for the entire first half of the season, before second place Springfield finally caught fire during July behind the pitching of the hard throwing newly acquired lefty, Harry Kane. The Reds dropped permanently into second place in August, when Kane bolted to the pennant chasing St. Louis Browns of the American League. Injuries to several key players in mid-to-late August kept Nevada permanently two and a half games ahead of Springfield.

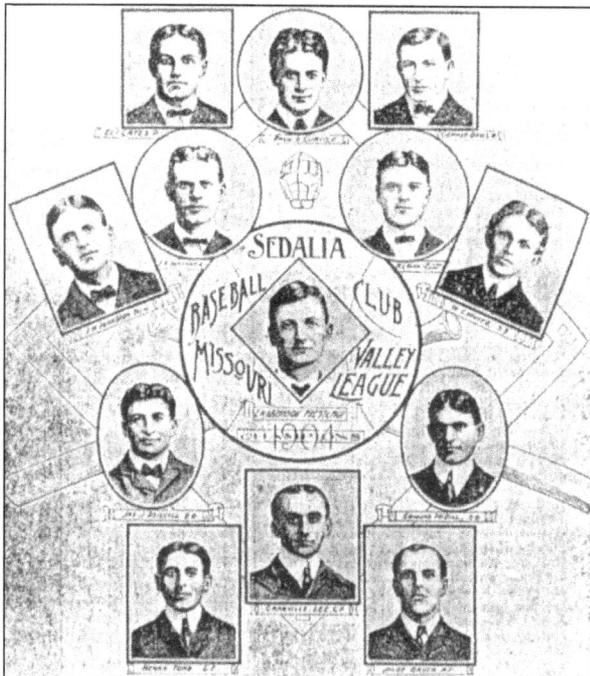

1903 Sedalia Gold Bugs. Despite being the most financially secure team in the league, which allowed Springfield to circumvent the salary limit and attract better players, the club again lost the championship of the Missouri Valley League in 1903. Featuring the same solid line up of Perrine, Kane, Schmidt and Bayless, Springfield raced out to the league lead. Consistent play from the "Midgets," as they became know to fans, failed to hold off the incredible performance of early season underachievers, the Sedalia Gold Bugs. Sedalia's remarkable 51-18 second-half record left Springfield (82-48) again in second place.

Charley "Boss" Schmidt. Pictured in his Detroit Tigers uniform, toward the end of three straight American League pennants, Charley Schmidt played three years in Springfield. As a rookie in 1902, the 21-year-old switch-hitting catcher hit .329 and helped lead Springfield to a close second-place finish in the Missouri Valley League. Often described as having a natural boxers build, the former coal miner, who Springfield fans knew as "Big" Schmidt, arrived from his home town of Coal Hill, Arkansas, looking to become a professional ballplayer. Schmidt won a platoon spot at catcher/first base in 1902 and remained with the Springfield club for two more years. By 1906, Schmidt was in the majors, playing his entire big league career with Detroit, and starting on the Tigers three consecutive World Series teams (1907–1909). He became famous for fist fighting, whipping Ty Cobb a reported two or three times, and then for fighting an exhibition with heavyweight boxing champion Jack Johnson. But he also gained the dubious distinction in 1907 and 1908 of being the only player in World Series history to make the final out in consecutive Fall Classics.

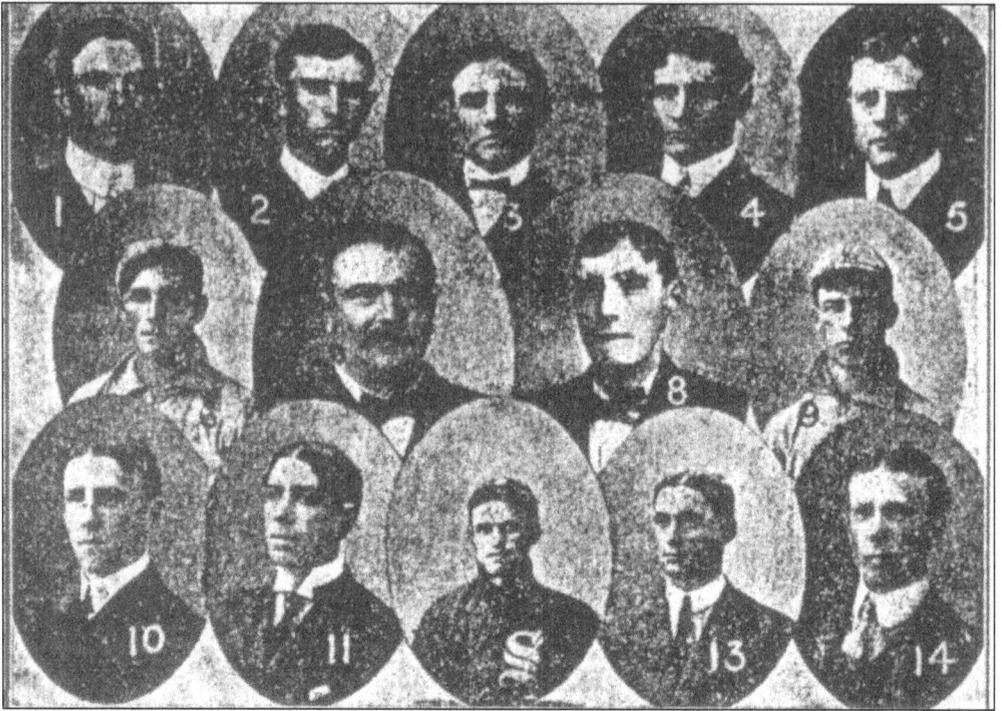

1905 Springfield Highlanders. The transition of the Missouri Valley League in 1905 to a Class C league called the Western Association added exposure for the league and its teams, thus producing this earliest known photograph of a Springfield club. The league name change gave Hurlburt the opportunity to deal with his apparent disenchantment over the "Midgets" nickname, by changing to the Highlanders. Neither that, nor new players added to the roster, turned out many fans to witness Springfield be dominated by the league and finish 54-80 in 1905. The resultant financial losses temporarily drove Hurlburt from the Springfield baseball scene.

Bob Groom. Perhaps the sole bright spot on the 1905 Springfield team was Bob Groom. The St. Louis native posted a 21-21 record with 225 strikeouts in 1905 and a 20-18 record in Springfield's rebound year of 1906. The hard throwing but wild right hander landed in the majors with Washington in 1909, setting the then major league record for consecutive loses at 19, while leading the American League in loses with 26. Following two seasons (1914–1915) with Phil Ball's St. Louis Terriers team in the Federal League, Groom shifted to the Browns when Ball purchased the club in 1916.

26

1906 Western Association Officials.
Following the 1906 season, Frank Hurlburt left the Springfield team solely to Gus Bennert (bottom, middle), who used his experience as the team's first president to again assume most of the club's off-the-field duties. Bennert's aptitude for maintaining a top Class D ball club failed to translate in into success up against D.E. Breese's emerging juggernaut in Wichita.

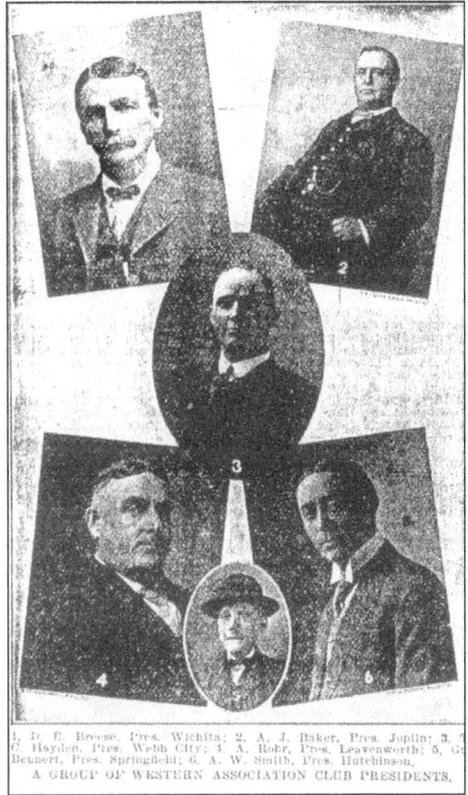

1. D. E. Breese, Pres. Wichita; 2. A. J. Baker, Pres. Joplin; 3.
C. Hayden, Pres. Webb City; 4. A. Rohr, Pres. Leavenworth; 5. Gus
Bennert, Pres. Springfield; 6. A. W. Smith, Pres. Hutchinson.
A GROUP OF WESTERN ASSOCIATION CLUB PRESIDENTS.

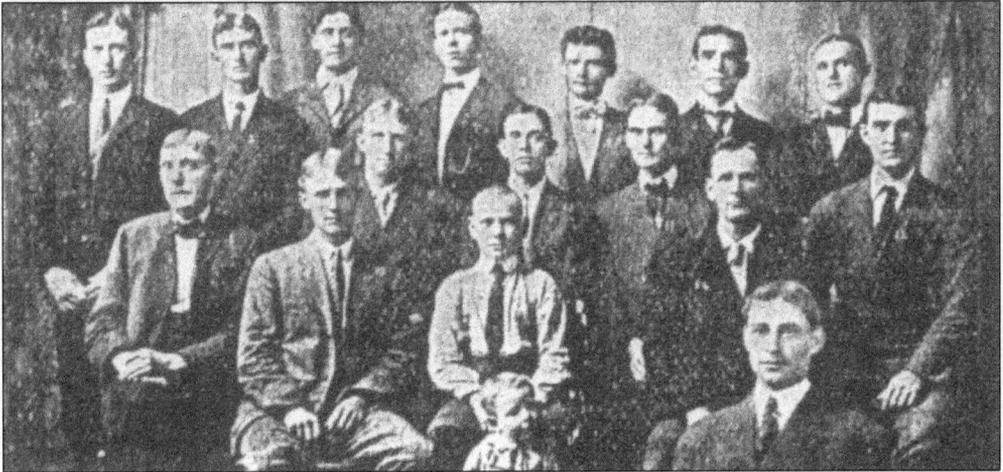

1906 Springfield Midgets. With Hurlburt away, managing in St. Joseph, Gus Bennert began the 1906 season as both president and manager before inexperience likely forced him to temporarily hand over the managerial responsibilities to catcher J. Warren "Doc" Seabaugh, before another shift of team secretary and treasurer John Shinn into the position. The 1906 club faired better than in 1905, finishing in fourth place with a respectable 72-67 record, but economic woes persisted.

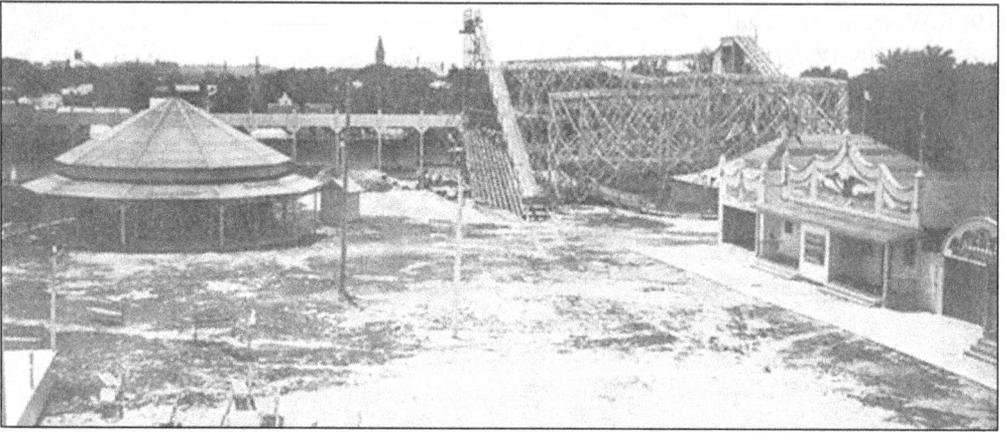

1907 White City Amusement Park. In the spring of 1907, the property that encompassed the Old Fair Grounds (or Central Park as it became known) came under the ownership of the United Amusement Company. Company owners James Neville, R.C. Stone, and F.W. Diemer took control of the property and quickly constructed a large amusement park, calling the new facility that included the original baseball field White City Park. While the amusement park lasted only until 1912, the ballpark's new name stuck, and White City remained in operation, used for all levels of baseball, into the mid-1940s. Although the White City Amusement park was created to promote fun, some religious groups—particularly the Baptists and Assemblies of God—took offense to the activities promoted on the grounds. Various Protestant denominations were vocal opponents of all activities—including baseball—on the property, because the amusement park introduced dancing, billiards play, and even a palmist, all of which were suspected of promoting gambling and other corrupt activities in an area bordered by several churches. Baseball played into the picture primarily through its historic connection to drunken rowdy behavior, particularly that of the Irish Catholics living north of the ball park. Banded together, the protestant church groups heavily influenced the amusement park's ruin by 1913, and put a temporary end to most baseball on the property in the form of a later ordinance outlawing the playing of baseball within 1,000 feet of a church. By the early teens, the churches had prevailed and the property temporarily became nearly useless for even traditional Sunday semi-pro ball games. (Courtesy of Springfield-Greene County Library.)

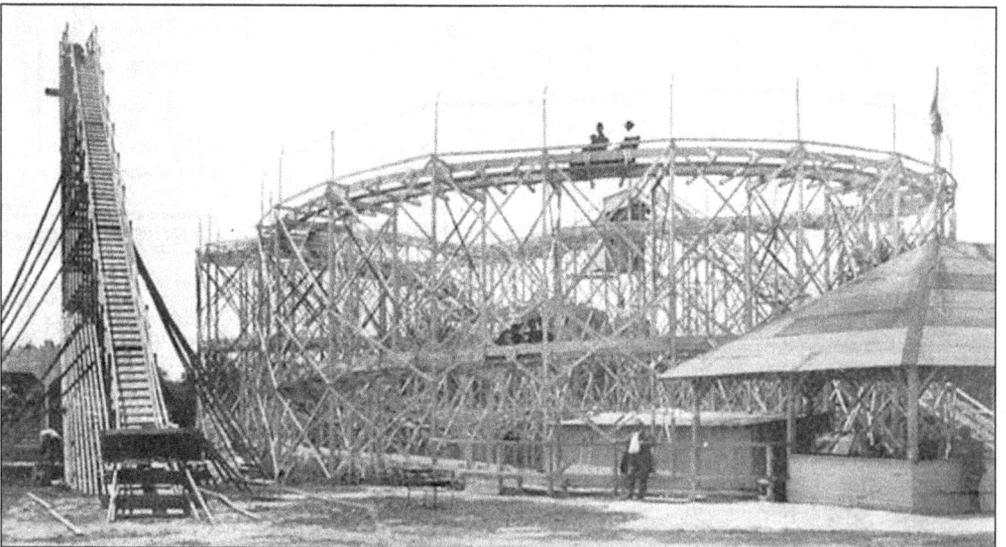

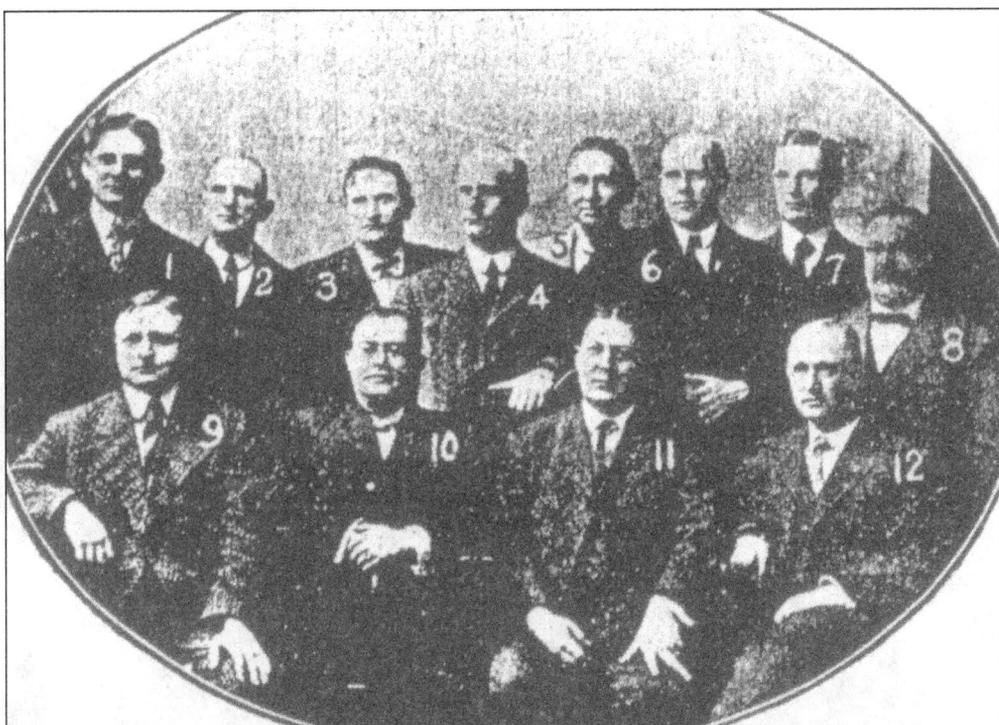

1908 Western Association Officials. Frank Hurlburt returned after his failed attempt in 1906 at managing in St. Joseph, Missouri, and additional an year's absence to again reclaim the title of Springfield president. Hurlburt's last two seasons in Springfield (1908 and 1909) would essentially be the swan song for Springfield's original franchise in the Missouri Valley League and Western Association.

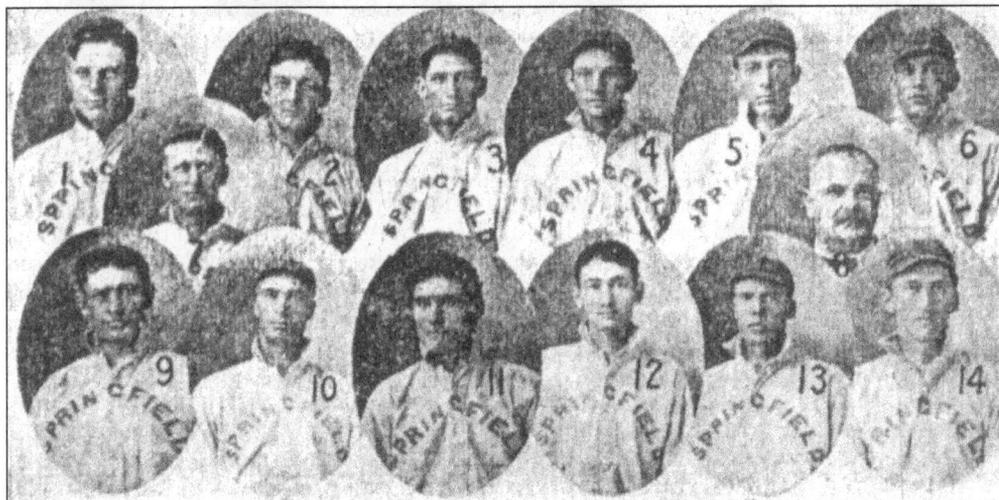

1908 Springfield Midgets. Following up the club's worst season to date in 1907, the 1908 Springfield Midgets played nearly as haplessly, putting together a 50-87 record. The White City Park owners had forced the team to play at the smaller, rougher, and less accommodating Doling Park diamond, which hurt the prospects for a financially strapped team that quickly gained a reputation as perennial losers.

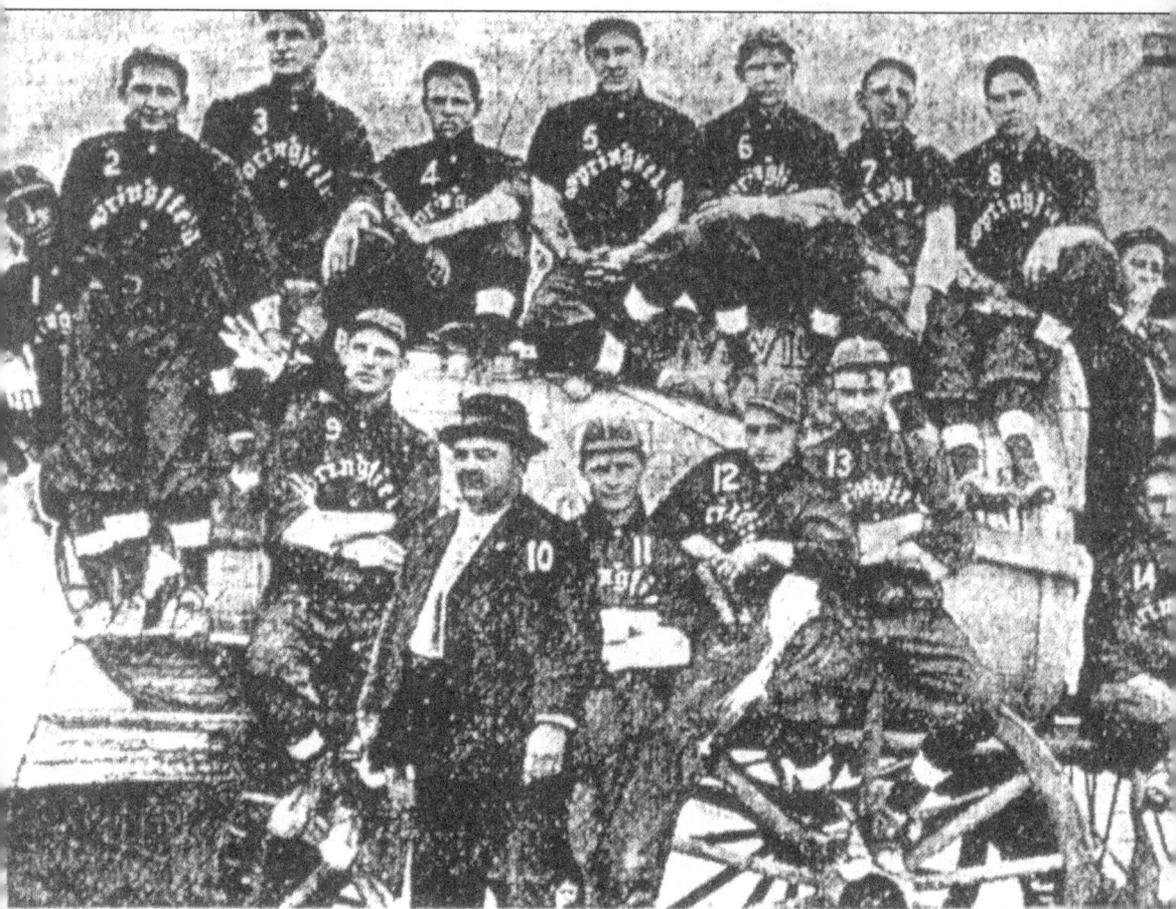

1 Smith; 2, Long; 3, Grady; 4, Burgess; 5, Gregory; 6, Hall; 7, Lamb; 8, Hamilton; 9, Gray; 10, Hurlburt, Mgr.; 11, Brennan; 12, Cole; 13, Ellis; 14, Wood. Murphy, Pho[to]

SPRINGFIELD TEAM—WESTERN ASSOCIATION.

1909 Springfield Midgets. In Frank Hurlburt's final season guiding a Springfield professional team, the Midgets surprised many by leading the Western Association early in the year, before eventual champs, Enid, overtook them in June. From there the team faded into the sunset, finishing a disappointing, but by that point almost expected 56-70. Hurlburt withdrew the Springfield franchise from the league, smart enough to see that the league itself stood on just as shaky of ground as his ball club, heading into 1910. After Springfield sat out a near disastrous 1910 season in the Western Association, longtime league man Larry Milton attempted an ill-fated reprisal in 1911 by entering the Springfield Jobbers in the Western Association. The Jobbers lasted a grand total of one week, or five games, before the league withdrew the franchise, sighting travel issues related to Joplin folding. About a month later the Western Association too folded, leaving the city out of the minor league baseball fold until 1920.

Two

The Not So Roaring 1920s

For many, the 1920s ushered in the greatest period in the history of minor league baseball. The optimism of the post-war period spurred many communities to enter the minor league arena. Springfield jumped on this band wagon in 1920 when the Western Association (W.A.) reorganized as a Class D circuit. Springfieldians Walter Correy, J. Warren "Doc" Seabough, and Willard Hamlin rallied local citizens to buy stock in a new team. One hundred and seventeen residents and businessmen purchased the necessary shares in forming the Springfield Baseball and Athletic Association. The new Springfield Merchants, along with Fort Smith, Arkansas, entered into the W.A. with six teams from Oklahoma: Okmulgee, Enid, Henryetta, Drumright, Chickasha, and Pawhuska. Springfield chose as its manager outfielder Barney St. John, while Harry Cole served as club president and the former Springfield Midgets' player and manager Doc Seabough assumed the primary off-the-field duties as club secretary.

Running a Springfield team proved as challenging for the new club executives as it had been for the previous ones. Economic conditions around the country remained stagnant in the early 1920s, although faith that the continued agricultural basis of the Springfield economy would remove it from the more volatile fluctuations of the manufacturing sector proved well founded. Under the pretense of an improved economic outlook, the hype around the new ball team began during the spring with the erection of a more elaborate grandstand at White City Park. The original small wooden grandstand sat just north of the southwest corner of Campbell and Lynn Streets. The new structure on the southeast corner of the same plot of land (the former right field corner), seated 3,000 spectators and had modern amenities such as separate dressing rooms, showers, and lockers for the home and visiting teams under the stands. The middle section of the grandstand housed club office rooms. Construction of a separate bleacher rounded out the improvements to the park. How the shifting of the grandstand affected the park's dimensions remains a mystery, as descriptions of the field before and after the reconstructions are unavailable. The field's new dimensions definitely created a short left field porch that resulted in homeruns sailing out onto Campbell Street and sometimes, as was the case with an exhibition game homerun reportedly hit by Babe Ruth in 1923, coming dangerously close to the Campbell Street church.

The Merchants opened the season of the eight-team league on April 20 at Drumright and lost their first two games of the season to the Drummers before rain claimed the rest of the series. The Merchants won their only game played at Pawhuska between further rainouts, before the team circled back to Drumright and Pawhuska again in place of opening their home schedule. The new grandstand was not ready for the scheduled April 29 home opener after construction fell behind. With home play pushed back to May 8, the team struggled on its extended road trip and slid to the bottom of the W.A. standings.

Few details are available about the expenses incurred by the Springfield management during their prolonged road trip. Typically, financially strapped clubs such as Springfield suffered in such unforeseen situations. The loss of these revenue-generating home games hurt, but none so much as the current prospect of club management losing all Sunday home games. After pushing the White City Amusement Park out of business for its sanctioning of dancing, a Christian-based group in Springfield impeded the future use of the White City property by inspiring a city ordinance banning baseball within 1,000 feet of a church on Sunday. Club officials lobbied city council during the spring of 1920 to amend the city's Sunday "baseball ordinance," officially known as ordinance 9266. The proposed amendment sought to do away with the total restriction of Sunday games at White City Park and allow games to start at 3:00 p.m. after church services concluded. On June 3, by a vote of three to two, the city council, with Springfield Mayor W.E. Freeman casting the deciding vote, amended the ordinance to allow games on Sunday after 3:00 p.m. The combination of a large new grandstand and Sunday games should have provided an economic boost for the cash-strapped Springfield club. In the end, the ministerial alliance behind a protest of the law's repeal had their way. Led by Pastor W.H. Winton of the Campbell Street Methodist Church, whose building sat within 1,000 feet of the White City Park ball field, they temporarily persuaded club management to begin the season playing Sunday games out at the small and poorly maintained Doling Park.

Springfield finally returned home on May 8, in fifth place at 5-7 on the season. Springfield played its first minor-league home game in nine years against Fort Smith, led by their player manager Charley Schmidt. Eighteen years after he had made his professional debut in Springfield, Schmidt's Twins beat the Merchants, 4-2, following the traditional pre-game parade complete with a marching band and the mayor throwing the first pitch. By late May the Springfield club stood at 9-17, dead last in the W.A. The team never recovered, and within a few months of their grand return, both the Springfield manager and the "Merchants" nickname were history. Doc Seabough briefly took over, and the team changed names to the Orioles, before Steve O'Rourke finished out the season as manager. Springfield finished a combined 54-80 in the league's split season. The second half record provided a slight consolation, as the team improved to 37-34, good for fourth place, following the 17-win, last-place first half.

George LaMonte replaced J.C. Letcher as league president in 1921. Springfield fans expected little out of the club once again known as the Midgets but were pleasantly surprised at the combined managerial efforts of Charley Stis and Wilson White, who directed the Midgets to inspired baseball in the same eight-team Class D Western Association. Behind pitcher Lewis Jones, who led the league with a 22-7 record and .759 winning percentage, the Midgets finished in second place at 39-28, two and a half games behind Chicasha during the first half of the season, and then again in second place behind Fort Smith at 46-32 during the second half. Although Springfield received no post-season honors under the league play-off format, the Midgets combined overall record of 85-60 led the league and qualified the team to play in the five-game 1921 Class D Series against the rival Southwestern League's champion, Independence, Kansas. Springfield's 3-2 Class D Series victory brought considerable hope for a pennant the next year.

The four years following 1921 were some of the hardest times of all for the Midgets, however. With Wilson White returned as Springfield manager the league moved up to Class C standing for 1922. Economically the team made the move to Class C standing more smoothly than in 1905, but the 1922 season still slipped away just as quickly, as the entire league ran up

against arguably the greatest team in the history of the W.A., the 1922 Enid Harvesters. Just like Springfield, Enid had emerged after a decade-long break from professional baseball, but with great results. Springfield completed the first half, a respectable third place (37-31), behind first and second place Joplin and Enid, who dominated the league by winning at least 49 games. Enid picked up the pace even more during the second half, going 56-11 and finishing 104-27 for the season. The Harvesters set two minor league records that season: fewest losses by a 100-win team and highest winning percentage at .794, only to lose to future St. Louis Cardinal manager Gabby Street's Joplin club in the league playoffs. The Midgets slipped to fifth place at 31-38 during the second half (68-69 overall). Springfield first baseman Leo Cotter won the league batting title with an average of .396, barely edging out Enid's home run hitting outfielder Frank Reiger.

For 1923, the Springfield management shook the Midgets up again by hiring Clifton "Runt" Marr as manager. The pint-sized Marr, who contemporaries estimated stood no more than five-foot-five, answered only to "Runt." Marr entered Springfield with one year of managerial experience, after he served the 1922 season as player manager of Norfolk in the Nebraska State League, and won the batting title. Marr played third base, batting third in the Springfield lineup and hit well in the W.A. "Marr's men," however, failed to similarly produce, and the Midgets quickly fell in the standings. By early June Springfield stood in seventh place, while attendance at Midget home games apparently fell quickly, and the team racked up debt. Club management responded by negotiating with the Class AA Kansas City Blues to make the Midgets a farm club of the American Association team. The practice of higher classification clubs owning lower ones became legal in 1921 after amendment of the National Association's agreement, but only a few teams had shown an interest in the practice. Ultimately, the Blues rejected the plan that called for the Springfield club to be sold to Kansas City for one dollar per share of stock. A last-ditch fan drive on June 15 by the local Traveling Men's Booster club, called "root for the home team," produced only single game results, as few fans responded thereafter.

When the sale of the Springfield team appeared unlikely, club president S.E. Wilholt threw in the towel and resigned on June 19. Wilholt, who had been one of the team's biggest financial supporters, cited the need to focus on his other business ventures. He and other backers of the club were clearly tired of the money drain. Into Wilholt's place stepped the most important man in the history of professional baseball in Springfield, Albert G. Eckert.

Al Eckert was born in Pierce City, Missouri, on June 28, 1888, and had lived in Springfield briefly as a teenager, before returning as an adult. Soon after his return Eckert purchased a cigar stand inside the lobby of the Woodruff building on St. Louis Street. Eckert purchased one share of stock in the Springfield team in 1920 and then became club secretary in 1922. The slender, rapidly graying 34-year-old became president of the Springfield club late in June 1923 and remained there for the next 20 years.

Eckert's impact was not immediate, however. A second mid-season effort to offset the growing financial losses by making Springfield a farm club of the Cincinnati Reds also failed. The Midgets finished the first half in seventh place at 29-39. True to form following Springfield's returned to the W.A., the club played better during the second half, going 41-35. Henryetta and McAlester dropped out of the league during the second half, allowing Springfield to finish in fourth place. Just like that of his predecessors, Marr's managerial performance failed to impress the Springfield board of directors, and the often fiery little man migrated south to revive the St. Louis Cardinals' floundering W.A. farm club in Fort Smith, Arkansas.

The face of the Western Association changed drastically in 1924, as did operation of the Springfield club. Central control of the league moved to Springfield when Doc Seabough took over as league president. For the first time since the league's reorganization in 1920, drastic franchise shifts took place before the season. The existence of the Class D Oklahoma State League encouraged some of the W.A.'s weaker teams in Oklahoma to transfer, while four other teams—Bartlesville, Hutchinson, Muskogee, and Topeka—shifted over from the rival, but less stable, Southwestern League. Al Eckert drastically changed the business philosophy of

the Springfield club through creative marketing during his first full season as team president. Seeking to return to the glory years of the Missouri Valley League days, Eckert hired Charley Schmidt as the Springfield player manager. After 22 years in professional baseball and dozens of broken bones, Schmidt attempted resurrection of a Springfield club with few quality players. For his part, Eckert concocted a characteristic whirlwind of promotion and advertisement to draw fans to the ball park. One thing that made Eckert's job easier was the construction of a new field and grandstand at White City Park.

Following the competition of the 1923 season, White City Park's four-year-old grandstand burned to the ground. In its place came an impressive structure that returned the grandstand to the original site but nestled more tightly into the corner of the intersection of Campbell and Lynn Streets. Previous field configurations could not meet club desires due to the ownership of the southern edge of the property by an elderly woman. After the woman's death in the early 1920s, the field's ownership group, the Ozark Stock Show Company, purchased the extra land. The new grandstand occupied three times as much space as the old one, and seated five thousand spectators, including sixty special boxes directly behind the back stop. All seats, shaded from the sun, featured chair backs and 38 inches of leg space between rows. A concrete "promenade" extended up from the new ticket office at the corner of Boonville Avenue and Lynn Street, and around the grandstand frontal wire and netting extended over the length of the structure to protect spectators. The one design hold-over from the previous grandstand was a club house under the stands. With a reconstructed park that the *Springfield Republican* called the "largest and most elaborate in the Western Association" at his disposal, Eckert began promoting heavily

Eckert first sent Schmidt's developing team out to play local semi-pro teams during April. The exhibitions allowed Schmidt to try out new players and mold his ideal team, while Eckert drummed up area support for the Springfield club and demonstrated their superiority over the competitive and well-attended emerging semi-pro competition in Aurora and Branson. Schmidt delegated excess players who did not make his team to well-organized area semi-pro leagues as well as to regional Class D professional leagues such as the new West Arkansas League. Some players saw through Schmidt's move to stockpile local players in area bush leagues and refused to report. Even the *Springfield Republican* clearly recognized the ruse, calling the Paris team of the West Arkansas League a "Midget farm." Schmidt denied all insinuations of impropriety and reaffirmed his earnestness toward the best interest of the players, declaring that "these ball players don't appreciate anything you try to do for them."

Putting together a winning club turned out to be much harder than expected, because the new infield at White City Park was the last thing to be installed. While crews worked to level the dirt infield into playing shape, the Midgets practiced and trained at the Drury College baseball field. The rocky and unrefined field slowed the progress of player evaluations and made exhibitions in Springfield impossible. Predictions for White City Park's preseason availability proved untrue, and the Midgets barely touched their fields before opening at home against Topeka on April 23.

While Schmidt struggled to develop a cohesive team, Eckert's attempts to fill the new stands at White City Park seemed promising. Promotions began from the opening game and continued throughout the season. Opening day against Topeka included free tickets from the Rose Clothing Company, but required a rather costly (for the day) ten dollar minimum purchase. Eckert enticed numerous local companies to close at 3:00 p.m. to allow employees to attend opening day and also organized their combined purchase space of a full page local newspaper ad, encouraging fans to "boost" an anticipated record-breaking opening-day crowd. Additionally, Eckert listed all games in the local papers with ads that were three times larger than before and which, for the first time, included the ticket prices (grandstand–75 cents, bleacher–50 cents, children–25 cents). Box seats, advertised at a pricey $1.25, could be reserved in advance at Eckert's cigar store. League president Seabough developed the idea of an Attendance Cup that offered $100 to the league city with largest opening day attendance. In response, the Traveling

Men's Booster Club's organized a committee that offered $25 to the local town team that brought in the biggest representation at opening day.

Another of Eckert's major departures came in how tickets were sold. Past club executives believed that ballpark only ticket sales reduced confusion over where tickets could be purchased. Eckert challenged this limited-ticket sales concept and spread tickets to civic clubs and businesses all over the city, including his cigar stand in the Woodruff building.

Just under five thousand fans turned out to watch Springfield come from behind in the eighth inning to defeat Topeka, 8-6. Springfield's playoff hopes were quickly rescinded. Two weeks into the season, the hard-hitting Okmulgee Drillers emerged as the dominant club in the league, while the Midgets rested in sixth place at 5-8. Slowly, Springfield sank in the standings, falling to seventh by late-May and to last place by mid-summer, while Okmulgee put on a hitting display never seen before in professional baseball. Drillers' first baseman Wilbur Davis and outfielder Cecil Davis each hit 51 home runs, becoming the first teammates in baseball history to hit 100 homers. Wilbur's overall numbers earned him the yet unrecognized triple crown, also leading the league in RBIs and batting average. Springfield failed to improve late in the season and Schmidt, perhaps feeling a sense of responsibility for the team's plight, petitioned the Cincinnati Reds to purchase three Springfield players. Player sales in the past had produced limited income for the Midgets but hardly offset the team's collective deficits. Before the end of the season, Schmidt resigned in frustration and left the management duties to a combined effort of leading pitcher Alvin Malone (16-18) and first baseman Pete Adams, who completed the worst season in the history of the franchise at 47-112. The Midgets hit poorly, finishing seventh in batting average in the offensive oriented Western Association.

Eckert's attendance boosting strategies of 1924 failed only because of the team's extremely poor play. He realized that without putting a winning product on the field, no club executive could entice fans to the ballpark. For the 1925 season, Eckert hired as manager Marty Purtell, whose long career in the league began the year before when he managed Hutchinson to a fourth-place finish. The addition of Purtell and the reduction of the league to a six-team circuit ultimately did little to aid the Springfield club, as the Midgets demonstrated their usual first-half ineptitude, finishing barely out of last place at 27-47. Okmulgee once again led the league in hitting, but slipped slightly in the standings. The Midgets rebounded during the second half, in usual fashion, going 40-35, good for fourth place. But few loyal Springfield fans held hopes for a Western Association pennant entering the 1926 season.

After a combined 67-82 effort in 1925, Eckert surprisingly decided to retain Purtell as manager. Purtell's management in 1924 and 1925 gave little indication of a mastermind capable of overtaking league behemoths Okmulgee and Ardmore, or the St. Louis Cardinals well-stocked farm club in Fort Smith. Springfield ended the first month of the 1926 season as expected, in fourth place in the six-team W.A.; but for once they finished May at just over .500 and 22-21. Ardmore continued its prior-year domination of the league by playing at a nearly .700 pace, with Fort Smith in second place. In June, the Midgets finally caught fire and made a run to the top. Ardmore refused to release its hold on first place, but the Midgets rewarded their fans, who came pouring into White City Park in increasing numbers, with a second-place finish during the season's first half. The second half turned out to be even more exciting for Springfield fans.

The Midgets jumped to the top of the standings immediately and remained there during a second-half pennant race that was reduced to four teams when Muskogee and McAlester withdrew from the league on July 20. Springfield clung to a one-half game lead on August 8, when the Fort Smith Twins began challenging for first place. By late in the month Springfield fans must have again felt betrayed, after the Midgets were swept by Okmulgee, and Fort Smith appeared to be pulling away. By September 4, the Fort Smith lead grew to eight and a half games, and league president Seabough called a meeting for September 5 to discuss ending the season before the scheduled September 19 date. Both Joplin (who won the first half while playing in Ardmore) and second-half leader Fort Smith favored the

proposal. Springfield and Okmulgee both wanted to continue, giving Seabough the excuse he needed for the season to continue.

Still, Springfield's second half title in 1926 owed itself mostly to St. Louis Cardinals' general manager Branch Rickey. Rickey felt reassured of a second-half championship for his Fort Smith farm club and transferred several of the Twins' best players to the Cardinals Class AA Syracuse, New York, team. Thereafter the Twins completely fell apart, while Springfield went on a tear, led by popular slugging right fielder John Reider. Springfield's home sweep of Okmulgee before packed crowds pulled the team to within four and one-half games of first place on September 8. The next day, behind Reider's league-leading 36th and 37th home runs, Springfield beat Joplin, while Fort Smith won their first game in a week by beating Okmulgee to temporally halt the Midgets' charge. Springfield's sweep of Joplin, combined with Fort Smith's multiple losses at Okmulgee, left Springfield two and a half games out of first. Springfield and Fort Smith flip-flopped positions the few remaining series of the season as each took turns winning and losing games against Okmulgee and Joplin. When the dust settled, the Midgets faced a two and a half game deficit with three deciding games left in the season. Anxious Springfield fans held high hopes of celebrating a long-awaited first pennant for not only their beloved Midgets, but also for the St. Louis Cardinals who were making headlines by challenging for their first National League pennant.

On September 17, the Midgets began a final three-game home series against Fort Smith. In the first contest, 1,500 fans watched Springfield's Norman Sitts win his league-leading 23rd game, and catcher Chuck Funk go three for three at the plate with two doubles, as the Midgets beat the Twins, 13-7, to again pull back to within one and a half games of first. The following day Springfield again won easily, 10-1, behind the combined base stealing of third baseman Carl Shoots and the hitting of Funk. With one game left in the season Springfield stood half a game out of first place. The Midgets completed their remarkable comeback by winning the final game over the demoralized Fort Smith club. Purtell's gamble of starting Sitts on one day's rest paid off as the right hander finished the season with his 24th victory. Jubilant Springfield fans rejoiced a week later when Springfield defeated Joplin, three games to two, to win their first W.A. championship.

After the season things looked very promising for the Springfield club. Responding to the Midgets remarkable comeback, Springfield fans set the league attendance record with 76,000 paid admissions. For the first time since its return to the W.A., the club turned a profit as Eckert's promotional techniques worked with the team winning. The *Spalding Guide* called the 1926 season "the most exciting race in the history of the organization," and expectations were high for a repeat performance by the Midgets in 1927. Few fans realized the hard times that lay ahead.

The W.A. again underwent major change in 1927. Longtime minor league manager and owner Dale Gear became league president and immediately abandoned the split season for a continuous one. The St. Joseph and Topeka clubs each moved over from the Western League and Southwestern League respectively, with the Topeka club serving as the new farm club of the St. Louis Cardinals after the National League club abandoned Fort Smith to Runt Marr's ownership. St. Joseph's addition allowed the increase in the league's population base necessary to move up to Class B standing for the first and only time in its history. Marty Purtell left Springfield to manage the St. Joseph team, and catcher Chuck Funk stepped in as player manger of the Midgets. Financially, Springfield initially did well, as Eckert lured thousands of pennant-hopeful fans with his nightly promotions. Funk continued to hit well in the offensive oriented W.A., but the team around him failed to equal the one of 1926. The Midgets finished 1927 third in the league in hitting at .284, but lacked pitching depth. Despite the league's lofty offensive averages (32 players hit over .300) quality pitching actually decided the pennant. Springfield's mediocre pitching failed to keep up with the strong pitching of eventual champion Fort Smith. A final 63-69 record left Springfield fans wondering what to expect for 1928.

Eckert continued to attract more fans by improving the quality of White City Park. The outfield, considered "the roughest in the league," received attention for the first time in its

history. Removal of uneven spots, rocks, and even concrete left over in right field from the old grandstand improved the field's playability. For the first time management began to consider installing a grass infield, but the cost appeared prohibitive for a club with an uncertain financial outlook for the coming season. Instead, fresh dirt was rolled out onto the infield to smooth out many of the bad hops encountered by Midget infielders. A final improvement to the facility came in the club house, which received heaters at both ends, and had the showers blocked off from the dressing room, a change which new manager Bob Wells believed "will save many a sore arm" because "that steam is bad for players coming off the field in a sweaty condition."

Opening the 1928 season, Springfield faced a new adversary in the Western Association, the Independence Producers. Independence entered the league for the first time, replacing Okmulgee in the six-team circuit. Despite considerable balance within the league, Bob Wells's crew never seriously challenged in either part of the once again split season. Poor first-half play, combined with rainy conditions early in the season, drastically reduced the Springfield crowds. Springfield finished third in the league in hitting and fielding but fourth in the standings each half of the season. By September, Eckert was selling off his best players, trying to make up for the club's $10,000 deficit. All the clubs of the Western Association reportedly had lost money, but the losses hit Springfield especially hard after the expenditures to improve White City Park. Following the 1928 season, all but one of Springfield's ten board of directors, Louis Reps, resigned in disgust over the seemingly continuous cash outlay. Without financial backers for the Midgets, Eckert had to act fast or accept the club's demise.

Eckert and Reps ventured to St. Louis to speak to Carl McAvoy, the general manager of the St. Louis Browns' farm system. For most of the decade, the Browns had been slowly developing their farm system, although far from the scale or quality of their National League co-tenants, the Cardinals. Convinced of the viability of developing players in the W.A., McAvoy agreed to take over ownership and financial responsibility for the Springfield club, with Eckert continuing as president. The Browns signed a three-year lease on White City Park with the Ozark Stock Company and moved in with the intentions of further improving the ball park. Infusing the American League club's talent into Springfield hypothetically should have allowed the club to improve in the standing, thus providing Eckert with a drawing card. Unfortunately, plans under the Browns never seemed to work out.

The Western Association of 1929 offered stiffer competition than ever before, as both the St. Louis Cardinals, who had moved their farm club to Shawnee, Oklahoma, and the Detroit Tigers, who now sponsored Fort Smith, stocked their clubs with top talent. As a result each team captured one half of the season. The Browns' named the much respected Joe Mathus as the Springfield manager and sent players like the other parent clubs, but the team finished a disappointing 29-40 during the first half. A second half improvement to 42-37 raised the team to a respectable third place in the league. Despite Springfield's poor showing on the field, seven players hit over .300, led by Bill Hooten who hit .337 and led the league in home runs with 25. Still, meager attendance figures continued as few Springfieldians were fans of the lowly St. Louis Browns or shared any confidence in the Midgets' ability to win. Had the Browns pulled out their down-to-the-wire 1922 pennant race with the New York Yankees, sentiment might have been different in Springfield. As it was, the Cardinals' National League pennant and World Series victory over the Yankees in 1926 pushed most Springfieldians into the camp of the other St. Louis team.

During the 1929 season all the Western Association teams made money except Fort Smith and Springfield. Springfield lost $12,000, while Fort Smith lost even more. Sale of players to higher classification teams reduced Springfield's annual deficit, but not enough to please the perpetually cash-strapped Browns. The Browns' McAvoy made few off-season moves involving Springfield, indicating the executive's inexperience both in building winning farm teams on limited budgets, and in dealing with the hot and cold attitude of Browns' owner Phil Ball toward farm team sponsorship. This proved especially true when compared to Branch Rickey's cost-saving tryout camp in Shawnee, which amply stocked the Cardinal farm club with low-cost talent.

McAvoy's replacement of Joe Mathus with former major league player and manager Norman "The Tabasco Kid" Elbertfeld turned out to be the only positive move during the off-season. The other baseball note in Springfield making headlines was the sale during the fall of White City Park to the Springfield Board of Education for $60,000. E.M. Wilholt's death in October had caused the transaction and removed one of the Springfield club's biggest allies. Ultimately, the sale presented Springfield management with a new entity to deal with and made future negotiations for use of White City Park less club friendly than before.

McAvoy's lackadaisical approach to farm club ownership seemed inconsequential as the fiery "Kid" Elbertfeld drew out of the Midgets the same intensity that had characterized his play. One month into the season Elbertfeld guided the Midgets into the thick of the 1930 W.A. pennant race. Springfield clung to a one-half game lead over Joplin after the Miners swept the Midgets in three straight games during late May. The story of Springfield's season and the Browns future in Springfield could be summed up during that Joplin series when the Midgets' starting pitcher Dick Grey struck out twelve Joplin batters but still lost the game. The tide of the Midgets' season turned soon after, and by early June, Joplin grabbed hold of first place for good. The Midgets managed to stay close to Joplin throughout the first half but finished four games back and in second place at 35-26. Few fans, however, seemed to notice or even care about the Midgets' improved play and the stands at White City Park remained mostly empty. The second half performance of the team did little to change the trend, as the Midgets slowly sunk to last place and stayed there until the end of the season. A second half record of 29-47 further dulled by the emerging Depression resulted in Springfield's 1930 total attendance reaching only 23,000 paid fans—not even one-third of the 1926 record total.

Speculation began that the Browns might pull out of Springfield despite the year remaining on their lease for White City Park. The Browns denied the rumors, stating emphatically to the Sporting News that they intended to retain the franchise despite absorbing a two-year loss of just over $30,000. The American League club even suggested the installation of lighting at White City Park if the lease on the ball park could be renegotiated. The Browns agreed with league president Dale Gear's recommendation, that all league games needed to played under the lights by the next season. Night baseball, it turned out, had left Springfield behind in the progressive Western Association of 1930.

Even before the 1930 season Gear had been one of minor league baseball's major advocates of night baseball. At the winter meeting for the Western Association and Western League (he was president of both), Gear declared "that night baseball is the exact solution to attendance problems in the minors." Several teams in the W.A. showed interest, but Independence Producers' owner Marvin Truby moved first to bring night baseball to the league. The Producers' spring announcement of their purchase of lighting from the Giant Manufacturing Company convinced Muskogee to add lights. By the end of the 1930 season, all the teams except Springfield had added some form of primitive lighting, and attendance in places like Joplin had soared over the previous year. Springfield saw proof of the effectiveness of lights on the campus of Southwest Missouri State Teachers College, where the addition of a brand new lighted football stadium the previous fall had drawn in people from part of a four-state region. Both Eckert and the Browns realized that without night baseball in Springfield they were losing out on Springfield's numerous blue collar workers, the majority of whom worked ten-hour days and were unable to attend the 3:00 p.m. weekday games.

The laboring masses turned out to be the key to successful operation in Springfield. Springfield's attendance figures of the 1920s had largely gone against the trend in minor league baseball. While many well-established minor league clubs flourished, Springfield usually languished with mediocre crowds. During the 1920s the Springfield area was still agriculturally based but possessed significant railroad jobs and some limited manufacturing inside the city. States in the Plains region (as the federal government defined Missouri) typically suffered economic and population declines during this time. While Springfield's population did increase, the area economy remained stagnate during the 1920s, in line with regional trends. This stagnation,

combined with the limited free time of the local working classes, translated into the small crowds typical at White City Park.

The Browns' negotiations with the Springfield Board of Education over the lease on White City Park fell apart during the winter of 1930–1931. An agreement for constructing lighting and extending the lease to terms that "would prove satisfactory to the Browns" failed to materialize. The Browns pulled out of Springfield in December, leaving the Springfield franchise once more in jeopardy. With only weeks before the league winter meetings, Eckert again franticly scrambled to save professional baseball in Springfield.

As was the case in the W.A. both before and after 1931, several cities sat waiting for one of the league's franchises to become available. Sedalia, Missouri, and Bartlesville, Oklahoma, each awaited word at the league meeting in late January. Eckert's last hope for keeping a franchise in Springfield fell on a trip to St. Louis to visit the Cardinals' Branch Rickey. By the 1930s, Rickey's rapidly expanding farm system included ownership or working agreements with eight minor league teams. Generally, Rickey exercised a policy of retaining only farm clubs that could be self-sufficient and cast off those that lost money. The Cardinals' W.A. farm club in Shawnee had finished only slightly better than Springfield during the second half of 1930, had drawn poorly at the gate, and featured meager faculties. Little is known about what the two men discussed during their January meeting, but Eckert apparently said something right in asking Rickey to take over ownership of the Midgets franchise. The result turned out to be Eckert's greatest move, as well as Springfield's ticket to another long awaited championship.

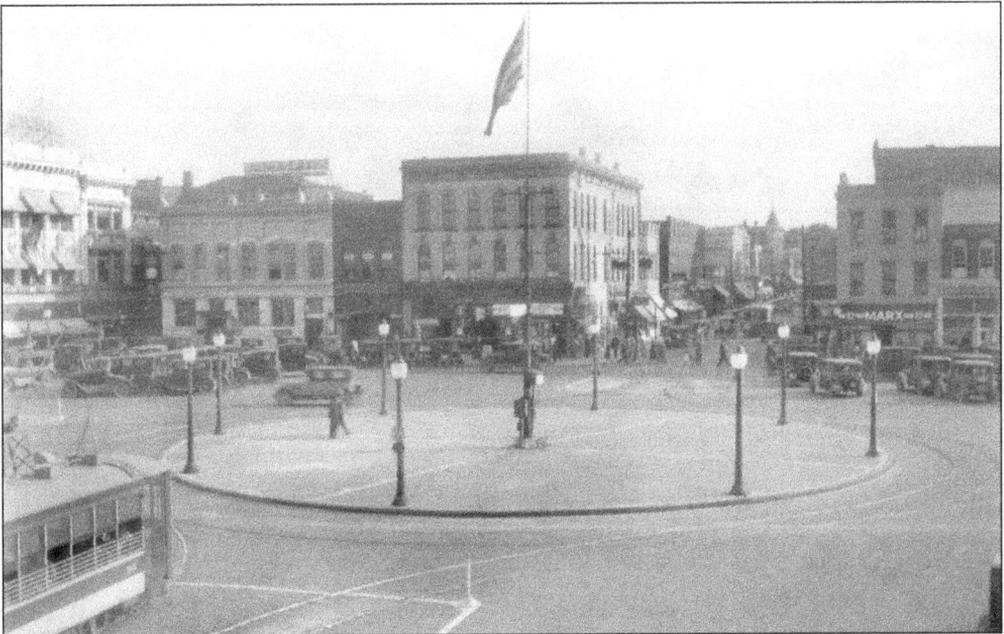

1920s SE Corner of Springfield Square. The Springfield Public Square had changed considerably since the first opening day of professional baseball in 1902. Fires and other new construction totally reshaped the scene people saw when Springfield kicked off their return to professional baseball in 1920. Besides a slightly delayed grand opening day ceremony, wonderful new electric street cars whisked passengers north up Boonville Avenue to league games at White City Park. (Courtesy of Springfield-Greene County Library.)

White City Park, c. early 1920s. Organizers rebuilt the White City Park grandstand in preparation for the 1920 season and touted its improvements over the former multi-use set up. The reconfigured field moved the grandstand to the former right field corner and included separate dressing rooms, showers, and lockers for the home and visiting teams under the stands. While the new grandstand seated 1,000 more spectators than the old and was built specifically for baseball, unlike the original it was entirely exposed to the elements. (Courtesy of History Museum for Springfield-Greene County.)

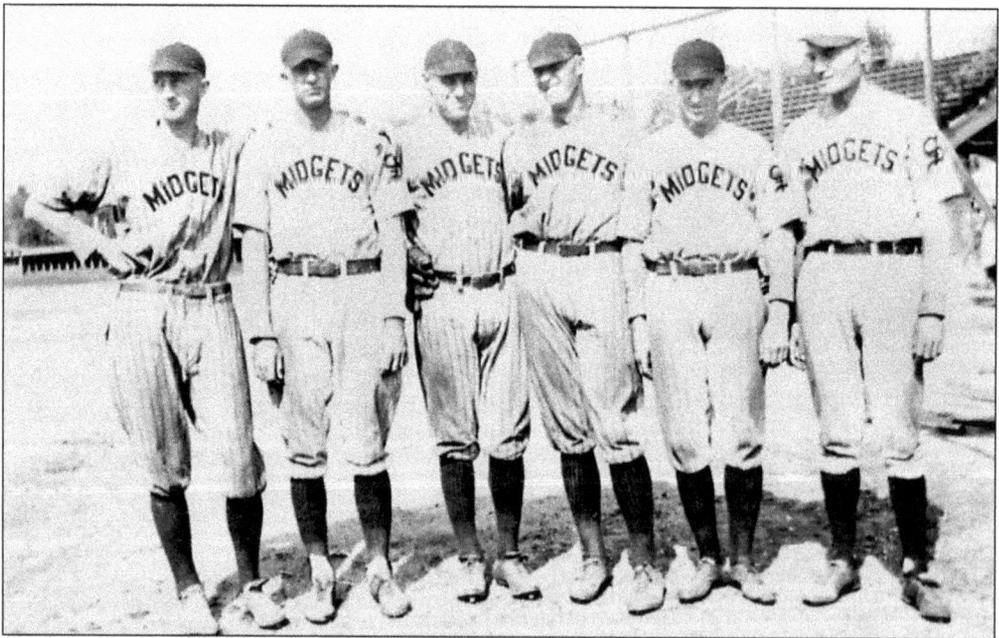

Midgets at White City. Springfield returned to professional baseball in 1920 under the name Springfield Merchants, but that name failed to resonate with fans, so the team instead tried the nickname, "Orioles." As was the case all over the country sports writers and fans often called the team what ever they wanted to, and most people still thought of the team as the "Midgets." The Midgets name crept back into usage during the 1920 season and by the next year it had officially returned, and was placed on the team jerseys. (Courtesy of *Springfield Magazine.*)

40

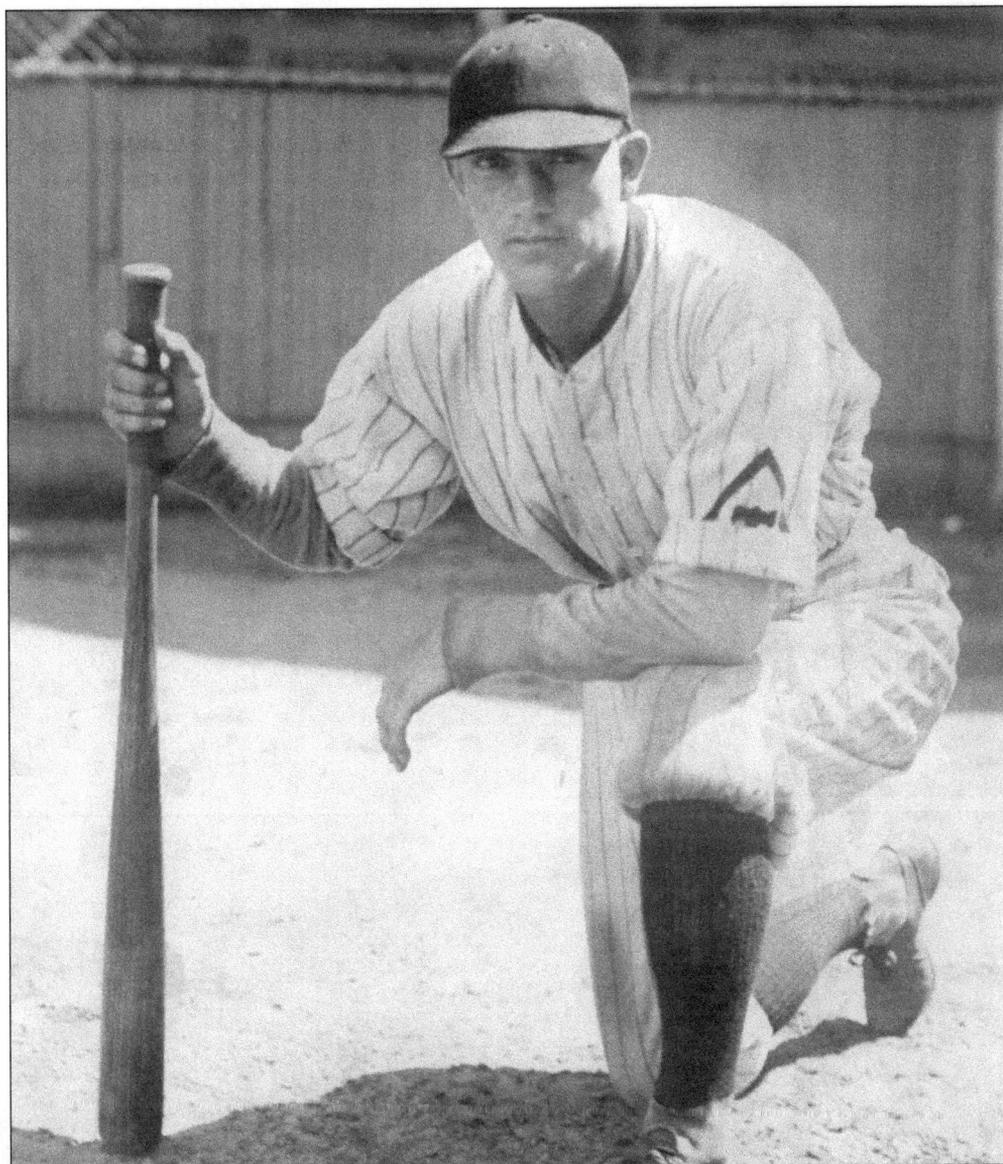

Herschel Bennett. The 1920 Springfield Merchants club featured several players who had polished their skills playing local semi-pro games during the late teens. Included was Herschel Bennett, a speedy left-handed hitting 23-year-old outfielder who hit .285 that season. The following season Bennett moved to Muskogee where he hit .396 in 76 games before being sold to the Tulsa of the Western League. Bennett returned to Tulsa in 1922, where a breakout season (.370 average, 56 doubles, 13 triples, and 24 homeruns) prompted the St. Louis Browns to purchase Bennett's contract for a then record $10,000. Reporting to spring training in 1923 and briefly making the team, Bennett became the first player from Greene County to make the majors. After returning to Tulsa for the remainder of the 1923 season, the Browns called him up for good in 1924. In 1925, Bennett led the American League in pinch-hitting and, despite being 27 years old when he arrived to the major leagues, appeared set for a long career before a collision with the outfield wall at Philadelphia's Shibe Park in 1927 caused a 36-hour comma, essentially ending Bennett's major league career. (Courtesy of Bob Bennett.)

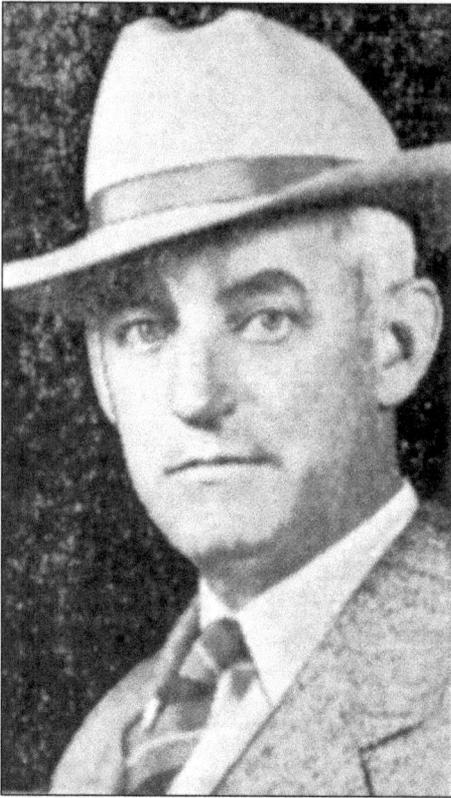

Albert G. Eckert. Al Eckert became president of the Springfield baseball franchise in June 1923, and remained in that position for the next 20 years. Eckert, a former salesman, totally altered the way Springfield teams operated but initially struggled in drawing fans to see losing clubs throughout most of the 1920s.

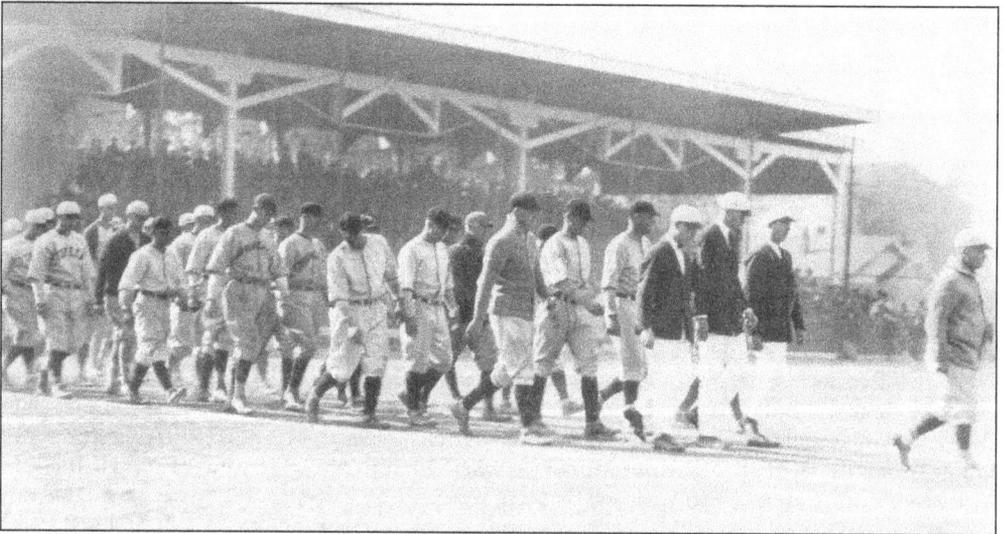

Midgets at White City, c. Mid-1920s. After the previous unimpressive and hastily thrown up wooden grandstand burned following the 1923 season, ballpark owners financed the construction of a larger, all-chair, back-seating, covered wooden grandstand that returned to the southwest section of the property. The new structure covered three times more area, stretched continuously past the dugouts, and seated 5,000 spectators. Rounding out the remodeling of the park, Eckert adorned the top of each end of the grandstand with big letters that read, "Home of the Springfield Midgets." (Courtesy of History Museum for Springfield-Greene County.)

Season Opening Ad. The 1924 season was the Springfield club's first full one under the helm of Albert G. Eckert. Eckert took over as president of the ball club in June 1923, after serving as secretary, and oversaw the slow resurrection of the down trodden franchise. Besides helping supervise the building of the new grandstand, Eckert tried to reinvigorate the team by bringing former Springfield and Detroit Tigers player Charley Schmidt to manage the team. In what became classic Eckert style, a large and flashy merchant-sponsored advertisement touting a long anticipated pennant appeared under his guidance in the *Springfield Republican.*

WELCOME!
CHARLEY SCHMIDT
And Your Midgets

— Use your Dollar WEEKLY PASS to and from the Ball Game —

Springfield Likes Big League Ball

— You Can Give It to Us.

The Fans Are For You

And Will Help Make This a —

"Pennant Year For Springfield"
OPENING GAME 3:30 TODAY

NOTE—Parking space for automobiles will be hard to find. Better leave your car at home and ride the Street Cars and Motor Buses. Use your DOLLAR WEEKLY PASS.

Springfield Traction Company
A. E. REYNOLDS, Vice President and General Manager.

1920s Street Car. With parking around White City Park at a premium, street cars that ran through downtown Springfield became the primary means of reaching the ballpark during the 1920s. On game days, signs appeared posted on the fronts of street cars (all of which had to pass the field running north of the square) encouraging fans to hop on and catch a game. (Courtesy of Springfield-Greene County Library.)

Springfield Baseball and Athletic Association

MEMBER WESTERN ASSOCIATION BASEBALL LEAGUE

(MIDGETS)

-:-

Mr. August, Herman.

Cincinnatti, Ohio

Springfield, Missouri Aug. 20 = 1924

Dear Friend.

I am dropping you a line to see if you are interested in three dandy young Ball Players. one is a big Right handed Pitcher 6 ft 2 in high 19 years old weighes 195 lbs had got every thing will be a real star in a very short time the the other two are in a real outfielder far *[illegible]* an *[illegible]* right hand hiter and thrower a real *[illegible]* *[illegible]* a real Ball hawk he can hit run throw slide bunt and do every thing 6 ft high 180 lbs 20 years old the other is a 3d baseman an infielder right hand hiter and thrower 5 ft 11 in high 20 years old 180 lbs he can hit run throw a wonderful arm and fielder and these men have all the Jeneral make up for a real Ball Player. this League is Playing down *[illegible]* Well and all the money and *[illegible]* to is going *[illegible]* for salarys and these Players can be bought Right and are a Every Buy I know they are as *[illegible]* *[illegible]* *[illegible]* Every let me hery fram you on this

Your Friend

Charley Schmidt.

1924 Schmidt Letter. With Springfield hopelessly floundering since early in the season, the Midgets much hyped manager Charley Schmidt made a late August plea to Cincinnati Reds' president August Herman for the major league club to purchase "three dandy young ball players." Despite the Reds having a loose working agreement with Springfield (they rejected outright sponsorship the year before), the National League club rejected the cash strapped Springfield club's offer. Within a few weeks, Schmidt resigned as manager out of frustration over what seemed an impossible situation. (Courtesy of National Baseball Hall of Fame Museum & Library.)

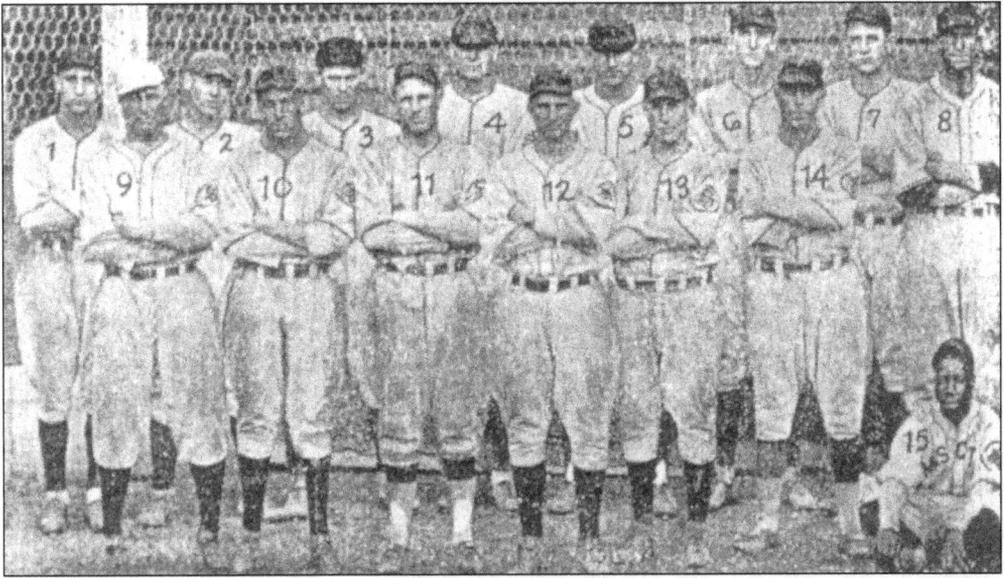

1924 Springfield Midgets. The extreme hype and anticipation over constructing a new facility and the singing of local hero Charley Schmidt ended with the worst season in the history of a city franchise at 47-112. Before the season ended, Schmidt resigned (and thus is not pictured), leaving pitcher Alvin Malone and first baseman Pete Adams to share the managerial responsibilities of the Midgets. The sole real bright spot on the team was the addition of a promising young outfielder, John Reider, whose failed sale to higher classification clubs proved fortunate just two years later.

1926 Springfield Midgets. Reversing the city's fortune as the league's doormat franchise, the 1926 team rose up late in the season to capture the second half title of the Western Association. Led by the league's top pitcher, Norman Sitts (24 victories), and top slugger, John Reider (37 home runs), Springfield edged out the St. Louis Cardinals' Fort Smith, Arkansas, farm team, winning the second half title by half a game on the final day of the season. One week later they defeated Joplin three games to two in the playoffs to claim their first Western Association championship.

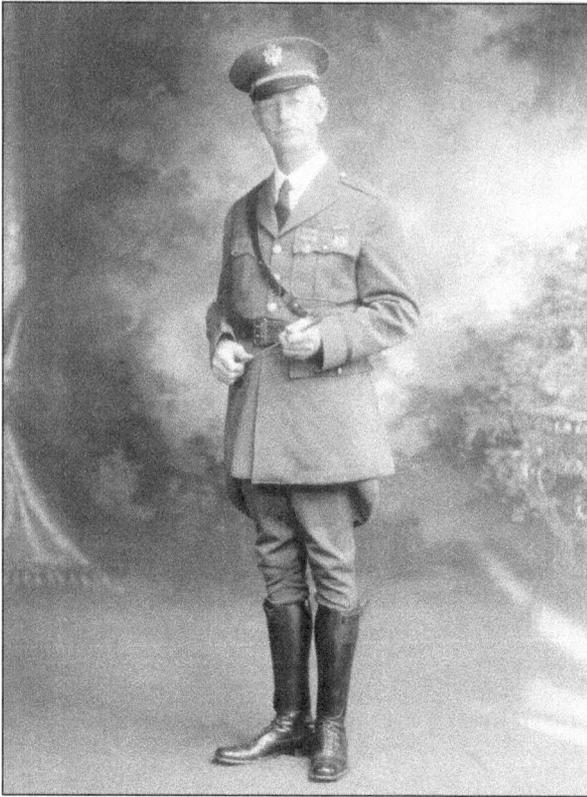

Dr. R. Ritchie Robertson. The Scotsman Dr. R. Ritchie Robertson led the Springfield Boy Scout Band in the group's pre-game concerts around White City Park for just over ten years from the late 1920s until the late 1930s. Robertson also oversaw the creation and maintainance of the Cardinals' Knot Hole Gang in Springfield from its inception in 1931, until his death in 1939. (Courtesy of Springfield-Greene County Library.)

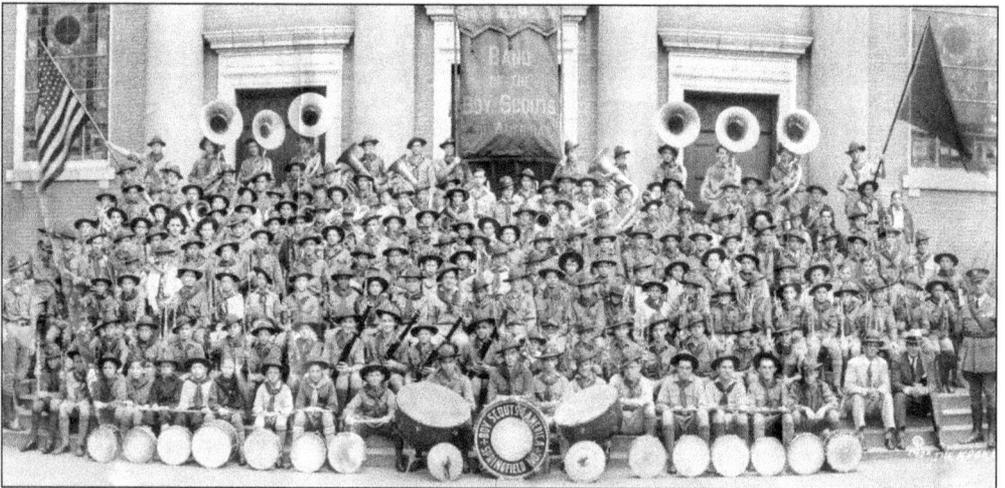

Boy Scout Band. Shortly after it was created in the mid-1920s by Springfield High School band director, Dr. R. Ritchie Robertson, the Springfield Boy Scout Band featured over 400 members. By 1929, the group claimed to be the biggest Boy Scout band in America, the novelty of which helped make their concerts a pre-game drawing card for fans at White City Park. Continued growth and popularity raised membership in the Boy Scout Band to over 500 by 1935, and the group continued even after Robertson's death, lasting until the late 1940s. (Courtesy of Springfield-Greene County Library.)

THREE

The Birds Fly Into Town

Branch Rickey accepted Eckert's proposal for the Cardinals to transfer their Western Association farm club to Springfield. The Cardinals' magnate also scheduled a trip to view Springfield's White City Park. The ball park at Lynn and Boonville undoubtedly was Rickey's greatest consideration in deciding to transfer the franchise, as the ball park in Shawnee paled in comparison to the potential of White City Park. Eckert's negotiations with the Springfield Board of Education regarding greater flexibility for future tenants at White City Park helped seal the deal. When Rickey, chief scout Charlie Barrett, and club secretary P.G. Bartleme visited Springfield in early February to inspect the facilities and sign a five-year lease, the Cardinals minor league boss and the new vice president of the Springfield club noticed the park lacked several keys to success. Installing flood lights, rebuilding the outfield fence, laying a grass infield, and improving the club house became the top priorities of Springfield's new owners. Eckert chose the one team in baseball who could afford these necessary changes. In 1930, St. Louis turned a profit of $230,000, one of the few major league teams to remain in the black. The improvements allowed the Cardinals to make the city the training headquarters for their Midwest farm clubs by 1932 or 1933.

The laying of 900 square feet of sod at White City Park began on March 3, under the supervision of William Stockstick, groundskeeper of St. Louis' Sportsman's Park. After the grading and laying of the infield, the unsightly "cow shed," which had made up most of the left field fence since 1924, was removed. A solid green wood fence replaced it, adding to the visual appeal of the park. Finally, on March 19, the Cardinals signed a contract with the nation's leading installer of field lighting, the Crouse-Hinds Company of Syracuse, New York.

The installation of lighting at White City Park truly turned out to be the best improvement of all. The $9,000-$10,000 cost included eight large metal towers reaching 70 feet in the air, with two smaller wooden poles, holding a total of 124 lights which lit the park well by the standards of the day. The $14,000 total spent on improvements to White City Park during the spring of 1931 created an atmosphere which, when combined with the talent supplied by the Cardinals' network of scouts, allowed Eckert to fill the stands for many years to come.

While the Cardinals improved the field, Eckert prepared for the upcoming season. Two things loomed large for the Springfield president: hiring a manager and assuring the viability of

the Western Association for 1931. Rickey alleviated Springfield's need for a quality manager by sending former Cardinals pitcher Eddie Dyer to manage the Springfield club, which the press was still calling the Midgets. The 30-year-old Dyer had spent the past three seasons somewhat successfully managing two of the Cardinal farm clubs.

Following uncertainty about the future of Fort Smith and the transfer of the former Joplin franchise to Bartlesville, Oklahoma, a solid six-team league had emerged on March 15. With the league again set, Eckert worked hard on overseeing the completion of work on White City Park just as the rookie camp began on March 23. Dyer, along with Cardinal scouts Barrett, Charlie Kelchner, and Joe Sugden tried out over fifty rookies over the final two weeks of March, daily cutting down the numbers until only a handful remained. The few Springfield boys still in camp received what became standard treatment from the Cardinals—all were sent elsewhere to avoid any home crowd nervousness. By the time the few remaining rookies were mixed into the roster with past Cardinal farm hands, the team had a new name.

After much evaluation the Cardinal organization decided that the name "Midgets" lacked credibility with the Springfield fans. In addition, most Cardinal farm teams by 1931 took some form of the parent club's nickname. The Cardinals selected for Springfield the name Red Wings, the same name as their farm club in Rochester, New York. The public, in general, seemed unaffected by the sudden discarding of the traditional Springfield name and most fans identified so strongly with the St. Louis National League team that the name change became a welcome one. Springfieldians expected much of their farm club after Branch Rickey promised that the team would "at least be in the running throughout the season." This prediction, however, meant little in terms of fan attendance in a city just beginning to face the depths of the Great Depression.

Although the effects of the early years of the Depression proved to be more negligible in Springfield than in other parts of the country, residents still monitored their recreational activities closely. Springfield's continuing agricultural economy—which centered on individualized sustenance farming—proved to be less influenced by leading economic indicators, meaning farmers generally fared proportionately better than the manufacturing sector. Limited manufacturing within the city remained diversified enough to employ the population when aided by job-producing government building projects, such as the Federal Medical Center and State Highway Patrol Headquarters; yet guarded and cautious Springfield area residents still looked for a good value from their entertainment. Minor league baseball was easily affordable, especially with the high number of promotions Eckert pushed, but few wanted to watch a loser at any price. For the same ten cent price that people paid for a game during one of Eckert's promotional nights, they could also see a movie at the Gillioz or Electric Theaters. In every year but 1926, Eckert's various specialty nights, which included Associated Grocer nights, merchant loyalty nights, ladies nights, pajama nights, and even time-period dress-up theme nights, lacked one important thing—a pennant-winning team.

The Springfield Red Wings opened the 1931 season on April 30 at Joplin for one of Dale Gear's unusual split-day home openers. The Red Wings played at nearby Joplin during the day, before both teams moved to Springfield for a game that evening. After Springfield lost the opener in Joplin, the Red Wings reeled off four straight games against the Miners at White City Park to jump to the league lead. Then, for the first time since the early days in the Missouri Valley League, the team stayed in first place for most of the first half. Only a slight slump in mid-May caused the team to briefly lose the first half lead to Muskogee before the Red Wings secured first place for good. The Joplin Miners, who had slumped at the beginning of the season and then moved up in the standings quickly, chased Springfield for most of May and June but never came closer than one and a half games.

The Springfield fans' response to the new Cardinal farm club was phenomenal; Rickey made sure of it. Besides making White City Park even more aesthetically pleasing, Rickey scheduled the St. Louis Cardinals and their Class AA Columbus Redbirds for exhibition games in Springfield during early May. Although Springfield lost to both higher classification teams, big crowds turned out to watch the spectacle of their team playing current and future major leaguers. And as predicted, the addition of lighting pointed the Springfield club toward

financial stability. For the first time fans constantly turned out in the thousands for weekday night games. Eckert's heavily advertised promotions such as Merchants' Nights provided discount tickets to people who might normally have been unable to afford a ball game during the Great Depression. The less severe effects of the early years of the depression in Springfield aided those steadily employed residents' decision to go to the ballpark. In order to further fill the stands—with children—St. Louis owner Sam Breadon decided to build a special separate wooden bleacher down the third base line. The subsequent implementation of Rickey's practice of letting children in free, creating space for the Knot Hole Gang, added hundreds of screaming elementary, junior high, and high school aged students.

For some of the oldest of this group, the term was nothing new. During the 1920s, groups of youngsters (and even some adults) had lined the wooden outfield fence along Campbell and Boonville before games, jockeying for choice "knot holes" in the fence. The practice greatly concerned the Springfield management, in small part because of lost gate and disappearing baseballs, but mostly because of the liability issue. So many spectators lined the fence at times that its collapse became an issue.

The official Knot Hole Gang, administered through the Kiwanis, and presided over by Boy Scout Band director, Dr. R. Ritchie Robertson, offered free admission to kids who lacked the money or might otherwise choose to spend a nickel at nearby Grant Beach Park swimming pool before claiming a free place behind the ballpark fence. Over one thousand black and white children, the majority elementary and junior high aged, earned red-colored passes by upholding three principles of good citizenship during the 1931 season. In a city that openly practiced segregation, including in the grandstands at White City Park, the Knot Hole Gang was one of Springfield's few desegregated institutions. After the sixth inning, white Knot Hole Gang members could move anywhere in the grandstand; black children were only allowed to move to the segregated section. On good nights, at least seven hundred children piled onto the "gang's" bleacher section. By late in the decade the "gang" had grown to over twelve hundred members. All of these free and reduced-price admissions increased concessions profits, which Eckert maximized by hiring a group from St. Louis to professionally train the concessions workers he oversaw during games.

Following the 1931 season the media made it seem as if Springfield easily ran away with the Western Association. But only Rickey's move on June 22, to send down Paul Dean from Columbus, brought glory to Springfield fans. Without him the pitching staff would have faltered during the second half. The "gangling youth," as the *Springfield Press* called Dean, sprang onto the scene on June 26, with a 5-4 victory over Bartlesville before five thousand excited fans at White City Park. Once in the W.A., Dean became almost unstoppable. The right hander, just the first of many Springfield players under Cardinal ownership on his way to the majors, dominated during the second half of the season, racking up an 11-3 record. Dean's pitching prevented Springfield from sliding from the quick pace of the early season.

Nevertheless, Springfield slumped at the beginning of the second half of the season. A 1-4 record nearly a week into the second half tied Springfield for last place with Independence, while Runt Marr's Fort Smith club quickly pushed to the league lead. Slowly, both Springfield and Independence improved in the standings. Independence overtook the league lead in late July while Springfield managed to hang on in the pennant race behind the pitching of Dean and Bill Beckman and the hot hitting of Ryba.

Springfield entered the final ten days of the 1931 season in third place and looked as if they were headed for a post-season playoff series with one of the front-runners in Independence and Joplin. In dramatic style, the Red Wings won their final eight games to overtake Independence on the last day of the season by half a game. By virtue of winning both halves of the season, Springfield automatically captured the league title. The Red Wings placed six players on the league's 13-man all-star team, led the league in fielding, and placed second in hitting. Bill Beckman led the league in wins with 24, while Dean led in winning percentages, at .786. Ryba picked up the league's most valuable player honors after he caught, pitched, played the outfield, and hit .336 while leading the league in walks. After the season, prospects for the Red Wings looked very good. Although other

minor league clubs had widespread financial problems during this Depression year, the team easily made money, drawing just over 72,000 paid fans to White City Park.

Unlike under the Browns, under the St. Louis Cardinals, off-season moves for Eckert and the Springfield club became common place. Several quality players returned for the 1932 season, including Eddie Dyer, who Rickey renamed as manager in mid-November. Consequently, Eckert did not face the usual uncertainty of hiring of a team manager each spring. Because of the financial success of the Springfield club, St. Louis extended their plans to make Springfield the major training ground for the Midwest. This included the construction of the larger club house first proposed in 1931, which accommodated up to three hundred players and allowed Danville of the Three-I League, Elmira of the New York-Pennsylvania League, Scottdale of the Mid-Atlantic League, and Keokuk of the Mississippi Valley League to use White City Park as their spring training base. The new larger club house also allowed a larger tryout or "rookie" camp before spring training started, which funneled a wide selection of talent to stock the Springfield club. The final move of the spring came when St. Louis renamed the Springfield team the Cardinals.

Dyer emerged from the 1932 spring training camp with a revamped roster. Only first baseman Larry Barton and shortstop Johnny Keane returned. The Springfield club appeared as strong as ever as the season began, although the same could not be said for the league. The Western Association's annual spring scheduling meeting in March had revealed that only Springfield had major league backing and thus some assurance of stability. The other five clubs in the league— Bartlesville, Joplin, Muskogee, Fort Smith, and Independence—each showed some financial instability. Adding to the money problems was the uncertain standing of league president Dale Gear. Since Gear became the league head in 1927, many longtime members of the league had grown increasingly tired of his style of management and, some thought, his dimwitted ideas. The seriousness of the problems within the league emerged soon after the season started.

The 1932 season began much like that of 1931 for the Springfield Cardinals. The Cardinals jumped out to a quick lead in May while the rest of the league slowly fell apart around them. The season-long merry-go-round began on May 6, when Joplin moved to Topeka. Two weeks later big-spending Independence owner M.L. Truby surrendered his franchise before it moved to Joplin. Then on June 8, Muskogee moved to Hutchinson. Two days after that Joplin moved back to Independence. Just before the end of the first half of the season on July 1, Runt Marr moved his recently reacquired Fort Smith team to Muskogee. Despite Springfield never knowing where they were playing from week to week, the team continued to win, and fans continued to show up at the ball park for home games. The Cardinals, led by Dyer, who topped the balanced Springfield club in hitting with a .320 average, grabbed solid hold of first place by mid-May and held it through the end of the first half.

With the first half title, and extreme league instability through franchise shuffling, Springfield's march toward a second consecutive undisputed league championship seemed assured. The final round of franchise shifts ended on July 17, as Marr's Muskogee team folded. The Independence team then moved again, this time to Muskogee, where Marr took control of the team. The Hutchinson club merged with the first place Bartlesville Broncos. The merger brought little fanfare since Hutchinson possessed one of the weakest teams in the league, but the combined team proved to be formidable. The city of Hutchinson regained a team yet again after Topeka relocated to the central Kansas community. After the 1931 season, however, Dale Gear decided that Springfield's undisputed championship had caused poor second-half attendance around the league. Therefore, a new rule permitted the team with the second best overall record to meet any team that captured both halves of the 1932 season; the eventuality of which appeared probable just two weeks into the second half.

Instability in the rest of the league proved little help to Springfield, however, and the enhanced Bartlesville team held onto first place entering August, two and a half games ahead. No team dominated and the league remained relatively wide open with only four and a half games separating first and last places. Inconsistent pitching plagued Springfield the entire month while Bartlesville pitchers remained successful. Even the performance of Springfield hitters such as Bill Delancey no longer sustained the team, and by mid-August the Hutchinson Wheat Shockers briefly surged into the league lead, knocking the Cardinals into third place. Hutchinson's stay at the top ended

quickly, however, and the team again slipped back to third. The Cardinals' were mathematically eliminated from winning the second half when future National League All-Star Cy Blanton shut them out 13-0 on August 24. Bartlesville's second-half title set up a best of nine-game playoff between the Broncos and Cardinals starting on August 30.

The heat of a drought-filled first full summer of the "Dust Bowl" combined with the general antipathy over the sorry financial condition of the league gradually got to some players and fights among both players and fans began to break out all over. Sometimes fights even broke out between players and overzealous fans. For example, on August 7, a fight between Runt Marr and Bartlesville first baseman Tommy Jordan spilled over into a riot when both benches cleared and fans came onto the field. Marr was short in stature but not in heart, and had scrapped in many a brawl during his time. The underpaid and over-traveled umpires of the W.A. took an apathetic stance on fights, which only facilitated them. During the August 7 brawl, veteran umpire Eddie Goes merely stood back and watched, only responding to fan pleas to intervene by commenting, "Lady . . . I'm not the militia." Springfield fans, mostly lower to middle class and some of spirited Irish descent, especially seemed comfortable in the raucous atmosphere of Western Association games.

Bartlesville took the first game of the 1931 playoff series before Springfield evened the series with a four-run seventh inning to win game two, 4-2. The two teams continued to trade victories until each had four. Playing to another sold out crowd at White City Park, the Cardinals won the final game of the playoff series, 8-5, behind homeruns by Delancey and Barton. Within weeks Delancey was with St. Louis for an end-of-season trail. The left-handed-hitting catcher returned in 1934 as the platoon catcher and hit .316 for St. Louis' World Series championship team of that year. Springfield wrapped up their second straight Western Association championship and became the only team in the history of the league to win back-to-back titles. Springfield fans again turned out to support a winner, as the Cardinals outdrew the next best team by twenty thousand, leading the league in attendance with 60,000 paid admissions. During this rough 1932 season, when nearly every minor league team lost money, Eckert turned a handsome profit. By the end of the 1932 season, the *Sporting News* hailed Eckert as the model for club executives in the lower minor leagues. Prospects for the following year looked better than ever for Springfield, but unfortunately, the Western Association was in trouble.

Frisco Depot. The Frisco Railroad's depot on Main Street was a major carrier of baseball personnel for both the St. Louis Browns and Cardinals during their successive Springfield farm teams (1929–1930, 1931–1942). The Cardinals heavily utilized train service, hauling players to and from spring training in Georgia and Florida. (Courtesy of Springfield-Greene County Library.)

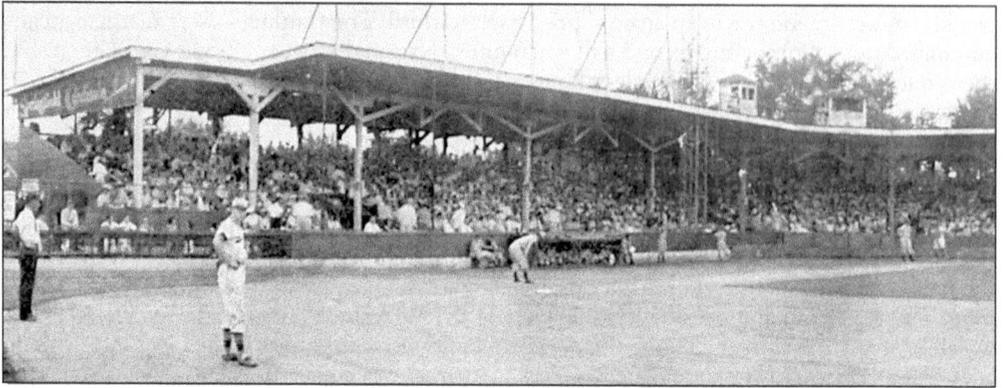

White City Park, c. early 1930s. Immediately after moving their Western Association franchise to Springfield in January 1931, St. Louis Cardinals general manager Branch Rickey financed the refurbishing of the playing surface at White City Park. Undoubtedly the most important improvement came with installation of lighting by the nations leading ball field illuminator, the Crouse-Hind Company. Crouse-Hind's resume already included several of the Cardinals' larger farm teams by the time Springfield's White City Park received flood lights for the 1931 season. (Courtesy of *Springfield Magazine*.)

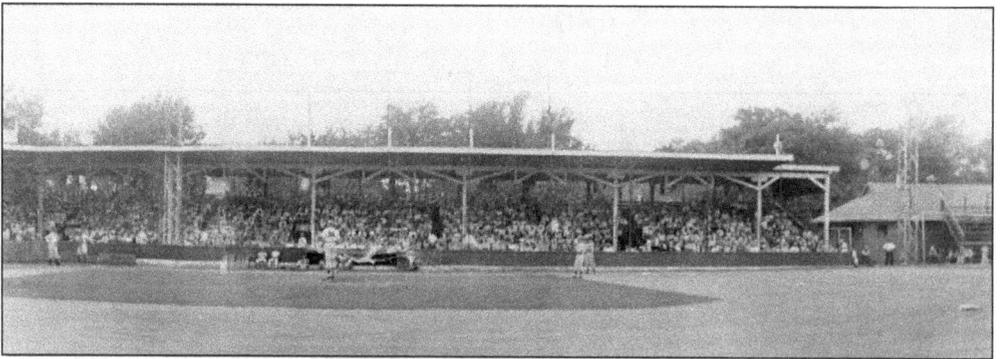

Let there be lights! The improvements to the infield grass and dirt are clearly seen, but the new set of light poles at White City Park made all the difference. The eight large light towers started at the end of the grandstand and lined the field's perimeter. Two smaller towers behind the plate area combined to aid the transformation of the Springfield club from a money drain, to a money maker. The 1931 inaugural season beneath the lights kicked off five straight seasons in which Springfield led their league in attendance. (Courtesy of the History Museum for Springfield-Greene County.)

Charlie Barrett. Years after he had patrolled the outfield of the White City Park grounds while playing for Sedalia in the Missouri Valley League, Charlie Barrett returned to tour a facility that looked remarkably different. In the nearly 30 years that had passed, the ballpark's potential for bigger things were clear as Barrett joined Rickey early in 1931 to make recommendations for the ballpark's overhaul. Until his death in 1939, the famed scout would make many trips to White City Park to help run the annual spring tryout camps and to observe players during the regular season. (Courtesy of Charlie Owen.)

Knot Hole Gang Card. Rickey transferred his idea of the Knot Hole Gang to Springfield in an effort to attract larger numbers of children to games at White City Park. The "Gang" as they were called, required members to uphold three principles of good citizenship: not skipping school; getting parent's permission to attend games; and to practice clean speech, clean 'sports,' clean habits, including refraining from use of cigarettes. Dr. R. Ritchie Robertson oversaw the group, which eclipsed the thousand member mark by the time the Cardinals left Springfield. (Courtesy of History Museum for Springfield-Greene County.)

Eddie Dyer. In following through with his pledge to soon bring Springfield another league championship, Branch Rickey installed longtime Cardinal organization man, Eddie Dyer, as manager. The 30-year-old refined southerner had spent the past three seasons somewhat successfully managing two of the Cardinal farm clubs, after playing parts of six straight seasons (1922–27) as a big league pitcher. Dyer's leadership and ability to recognize and develop talent ignited two consecutive championship seasons for Springfield.

BASEBALL

OPENING DAY—FRIDAY, MAY 1

JOPLIN 'MINERS' vs Springfield 'RED WINGS'

Admission:

Grand Stand 75c, Ladies 25c, Bleachers 50c, Children 10c

Reserved Box Seats $1.00

No Advance In Price for Opening Day

RED WINGS—HOME

May 1, 2, 3, with JOPLIN—Double Header Sunday, 2 P. M.

Buy a coupon book, 20 games $10.00.

Good for any Western Association Game - Only

A New Era. Springfield fans kicked off the city's most successful era in professional baseball on Friday May 1, 1931, when they hosted the Joplin Miners at newly refurbished White City Park. The day before the team had traveled to Joplin and lost as a part of league president Dale Gear's unusual split home openers. Opening day that season was one of the few that Eddie Dyer failed to position the Springfield Red Wings club in the first half lead of the Western Association.

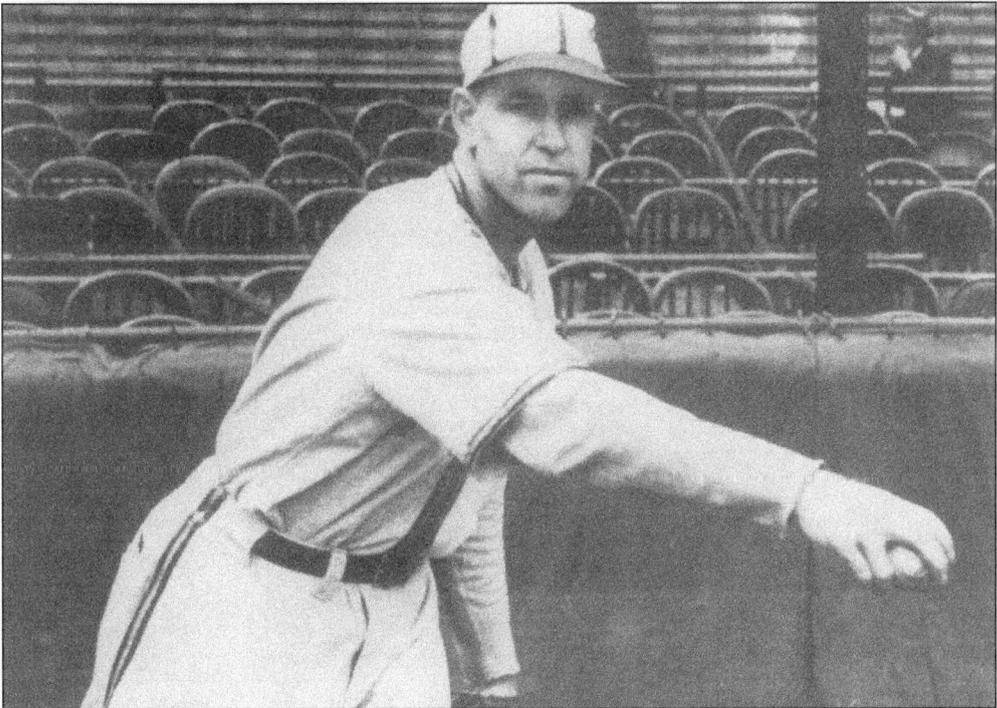

Paul Dean. With some considerable doubt by mid-June about the depth of the Springfield pitching staff, Branch Rickey sent a "gangling" 6-foot, 175-pound 17-year-old pitcher named Paul Dean down from Columbus and the American Association. Dean, whose name was already famous because of his flamboyant older brother, Dizzy Dean, propped up the Springfield pitching staff after he arrived in late June. Dean cruised through his two and a half month stop in Springfield with an 11-3 record, and the top winning percentage in the league at .786, as the Red Wings took both halves of the season to capture the league championship outright.

Pennant Window Display. Excitement over the Springfield Cardinals reached a fevered pitch by mid-way through 1932. After so many seasons of hard luck play, the home town team was finally dominating the Western Association. The pennant for the 1931 league champions, along with the team photos for that year and for the 1932 first half champs, were proudly displayed in the front window of Martin's Sporting Goods at the corner of McDaniel and Campbell.

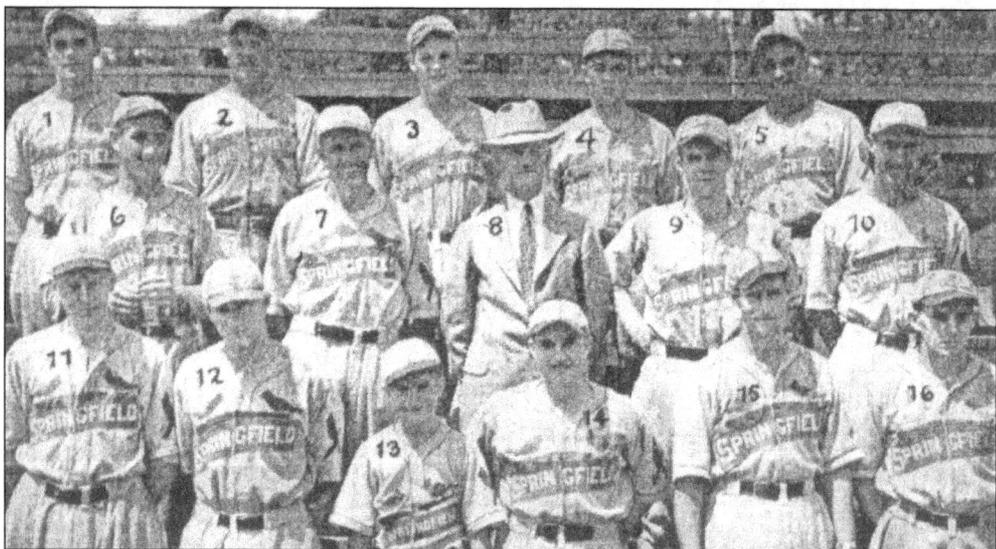

1932 Springfield Cardinals. For the 1932 season, the St. Louis organization sent down used home-and-away sets of the big league clubs' jerseys, each reading "Cardinals," thus prompting the change of their defending Western Association farm team's nickname to the parent club's more recognizable moniker. Springfield returned player manager, Eddie Dyer for his final season, and he revamped the line-up with former American League hitting star Fred Spurgeon, future longtime minor league slugger Larry Barton, eventual St. Louis Cardinals manager Johnny Keane, and a talented left-handed-hitting catcher Bill Delancey, who by the end summer was with the big league club.

56

FOUR

A Faster League

Ever since 1886, the local media had encouraged Springfield to become a part of the Western League, the nation's oldest minor league. This push found some support following the financially successful 1902 season and again during the early 1920s. The sentiment recurred after the 1931 season when the Springfield club finished the season in the best financial shape in its history, while the Class C Western Association struggled to finish the season intact. With the 1932 season just over, talk of Springfield entering the Western League began again as the team's repeated success caused fans to yearn for "a faster league." The Class A Western League had "staggered through and played its schedule to the finish" in 1932 but still remained slightly more stable than the Western Association. The continued animosity between Gear and most of the owners in these two leagues, however, set up a situation where reduction to one league could leave some teams out. Al Eckert's extraordinarily good relationship with Gear assured Springfield's inclusion in one league or the other.

During the fall of 1932 Eckert remained noncommittal about Springfield entering the Western League. Rickey offered no support for Springfield switching leagues but the St. Louis general manager faced a dilemma. The Western League had abruptly discarded the two Colorado teams—Denver and Pueblo—during fall meetings, citing the extreme cost of travel. Denver had been a Cardinal farm, and Rickey faced the possibility of losing both its successful Class A and C farm clubs, leaving a deep gap in their farm system. Most Western League owners favored adding Springfield and possibly several other former Western Association teams should two separate leagues become unviable. Eckert, for his part, held out hope for the reemergence of the Western Association for 1933, with it a possibility as late as December of 1932.

By January 1933 all hope of the Western Association's reorganization evaporated, and the few secure teams from the Class C circuit began scrambling for Western League admission. Funding Springfield in the more travel-intensive Western League was a risk that Rickey accepted in order to retain a Class A team for St. Louis in the Midwest. Hutchinson and Joplin joined Springfield to round out the eight-team league that included teams from as far north as Des Moines, Iowa, and Omaha, Nebraska. The fears regarding placement of Springfield in the

Western League proved unfounded, as the team played well, and big crowds continued to turn out at White City Park.

Springfield's experience in the Western League began on a positive note when Rickey installed Joe Schultz as manager. Schultz previously demonstrated good knowledge of the game as a manager in the St. Louis chain, and Rickey believed that the 39-year-old former Cardinal outfielder would guide Springfield competently in the new higher classification league. The spring rookie camp immediately netted Springfield several talented players, especially Frank "Goldie" Howard, an outfielder from Dustin, Oklahoma. Howard, who earned his nickname after running into an outfield fence, knocking out a tooth, and having it replaced with a gold crown, rounded out perhaps the most talented lineup in Springfield history. Six players from the 1933 Springfield Cardinals went on to play in the major leagues. The leader of the group that year became Mike Ryba, who returned to Springfield and led the league in hitting with a .380 average. Joining Ryba on the league's top hitting team were outfielders Dallas Patton (.345), and the rookie Howard (.340), along with returning shortstop Johnny Keane (.324), and second baseman Emmett Mueller (.280).

Despite strong hitting and the great pitching of Mays Copeland, Springfield struggled to stay above the .500 mark through the first half of the season. St. Joseph and Des Moines battled to the wire for the first half title, and the shift of franchises also plagued the Western League, when Wichita moved to Muskogee and early season leader Hutchinson moved to Bartlesville. The Cardinals finished in fourth place with a somewhat disappointing 30-28 record. Overall, pitching was the noticeably weak point in the Springfield club, and Eckert once again appealed to the St. Louis front office for help. This time, however, it was Eckert's own keen eye for talent that resurrected Springfield, lifting them from the middle of the Western League pack. Around mid-season, Eckert noticed that a talented right handed pitcher named Mort Cooper had become available. Cooper's season began with Des Moines, before he was released and signed by Muskogee, and then released again. Eckert saw potential in Cooper and reasoned that injuries had prevented the 20 year old from reaching his peak. Many years later the Springfield president called the discovery of Mort Cooper, who became one of St. Louis' most reliable pitchers in the early 1940s, his greatest achievement in baseball.

Springfield fans were able to return for strong team play in the second half, and a title race with Topeka. The two teams went back and forth, with Springfield appearing ready to take the lead for good after winning 27 out of 31 games during August. The Cardinals slipped a bit during the last week of the season, and the pennant race developed into a dead heat between Des Moines, Topeka, and Springfield. Topeka and Springfield entered the last day of the season nearly deadlocked, with Springfield holding an .005 advantage in winning percentage. Topeka defeated Joplin, leaving Springfield's fate precarious. A win against St. Joseph and their ace Cy Blanton would enable the Cardinals to win the second half. The Cardinals' hopes held to the end of the last game, when a dramatic home run by St. Joseph's Wally "Kit" Carson, off Springfield reliever Ward Cross, deprived the Cardinals of the second half title and a shot at the league playoffs.

The second half success of the Springfield club during the 1933 season caused the team to lead the Western League in attendance. Despite the team's accomplishments both on the field and at the gate, Eckert faced a dilemma again during the off-season over which league to join. The Western Association could be reformed, but the prestige of playing in a higher classification seemed to appeal to the fans. The question was solved when, to reduce travel, the Western League removed Springfield during the National Association's annual winter meetings in Galveston, Texas. As he had done before, Eckert scrambled to reorganize the Western Association. He began in November 1933 by recruiting baseball promotions manager for the A.G. Spalding Company, Tom Fairweather, to become league president. Although the 300-pound sales rep. from Des Moines lacked experience as a league head, Eckert still appreciated Fairweather's potential as an administrator. Fairweather reluctantly took on the role, nevertheless giving the Western Association new life. Eckert and Fairweather then contacted the former cities of

the league to gauge interest in reentry. Longtime teams like Joplin, Bartlesville, and Muskogee jumped at the chance to return to Class C baseball, while a new entry formed in Ponca City, Oklahoma. Hutchinson wanted to return to the league, and was the only real option for a badly needed sixth team, but lacked funding. With Hutchinson still a long shot entering the spring of 1934, Branch Rickey intervened, thinking he would help out his Springfield club as well as expand his minor league system.

With the rebirth of the W.A. still in doubt during the spring of 1934, Rickey arranged for his Houston club in the Texas League to use Hutchinson as their farm team. The idea seemed harmless enough, and as a relatively weak team, Hutchinson posed no threat to Springfield's dominance in the league. St. Louis still made sure that Springfield received an ample supply of new talent to allow the club to carry on successfully. With league stability assured, Eckert and Rickey agreed to replace the departed manager Joe Schultz with the club's best all-around player from 1933, Mike Ryba. Ryba, whose versatility, playing every position, had earned him the nickname, "the one man gang," took over a team with five returning starters. Normally, a team in the lower minor leagues might lose more key players, but a glut of players throughout the still small St. Louis farm system allowed Springfield to return to the Western Association with their 1933 team nearly intact. Newcomers to the team included pitchers Luke Bucklin, Dick Elston, and Bill McGee. McGee, who earned the nickname "Fiddler Bill" the year after joining St. Louis for performing famously in their Gas House Band, eventually became a top starter behind Ryba.

The 1934 season started badly for Springfield, however. Higher classification backing for all of the league's teams clearly evened out the competition. Ryba's coaching inexperience resonated too, as the Cardinals lost close games early because of managerial mistakes. The team struggled through early May, as questionable pitching changes late in various games accompanied shaky Cardinal hitting. Ryba finally turned the team around when he cut back on use of Everton, Missouri rookie right-hander, Wendell "Bill" Davis, and began pitching more himself. When Davis finally began to perform, the Cardinals inched closer to the league-leading Ponca City Angels.

Despite the renewed strength of the Springfield ball club, Ponca City held firm. Filled with players from the West Coast, the Angels led the league from day one. Springfield's charge to overtake Ponca City started with a seven game winning streak in late May. By mid-June, Springfield's early season hitting slump had disappeared, and the Cardinals led the league in hitting and fielding, but still remained behind Ponca City. Eckert's confidence in the Cardinals chance at winning induced him to diminish team batting depth by releasing outfielder Dave Cheeves to Hutchinson. Later, after he fell to 3-9 on the season, Davis too was released. Springfield's dominant hitting and fielding continued throughout the first half, with the rookie backup catcher and shortstop Lyle Judy leading the team in hitting at .331. In the final days of the first half, the Cardinals finally caught up to the young Ponca City team, and the two finished the first half tied at 37-30.

Tom Fairweather had planned for the W.A. to have its first ever All-Star game in 1934 as part of his revamping of the league. Fairweather called off the two-day break between halves of the season and dictated that Springfield and Ponca City play a best-of-three series that Ponca City ultimately won in two games. Springfield picked up right where they left off during the first half, and both the Cardinals and Angels won consistently. Fans packed the Springfield ballpark, as they had all season, but became increasingly tense during the tight pennant race. During an August game at White City Park, umpire Claude Tobin ejected Ryba after the Cardinal Manager argued that Bartlesville pitchers who were warming up on the field were obstructing the fans' views. Returning players like Ryba often were fiercely loyal to fans and developed very strong relationships with their hometown rooters. Tobin, in his first year of umpiring baseball at any level, refused to grant Ryba's request in front of 3,000 fans, and ejected the Cardinal manager when he continued to argue. Tobin's reportedly strained relationships with several Springfield players probably led him to eject Ryba, and when he refused to leave

"within three minutes," the field umpire declared a forfeit, and then dashed for the dressing room. A large, angry crowd followed Tobin to the dressing room, with two fans nearly jumping him just as the police shoved him inside. The crowd remained agitated for 15 minutes, throwing rocks at the dressing room door, while inside, Eckert and club secretary Roy Watts argued with Tobin over his hasty move in declaring a forfeit. Afterward, Eckert wired Fairweather to demand that the game be replayed and to ask that Tobin be sent somewhere else for his safety. Fairweather refused, and the game stood. Springfield police chief Paul Frey had to station a huge contingent of his men at the ballpark the next night to protect Tobin. In the end, the *Springfield Daily News* called the fracas the "wildest baseball scene in Springfield since 1927, when the late E.M. Wilholt led a crowd of fans onto the field against another umpire."

Behind the 12-3 record of Ryba and the 23 victories of McGee, Springfield separated from Ponca City in late August and won the second half by three games. To the public, things looked very positive heading into Springfield's playoff series with Ponca City. The Springfield players saw things in a different light. After several years of wages reductions and long travel, many minor leaguers had become disgruntled. Before the playoffs started in September, a large group of Springfield players, tired of Eckert's notoriously cheap ways, demanded bonuses for winning another championship. Eckert's thriftiness and lowballing of players became well known around Springfield, and likely helped endear him to his equally tightfisted boss, Rickey. Years later, the Springfield president called this his most trying time as a minor league executive. After coaxing and even threatening suspension under National Association rules, Eckert finally convinced the team to play without the promise of bonuses. Springfield then beat Ponca City in a best-of-seven series that went down to the wire, with the Cardinals winning four games to three.

Ryba won two more games during the playoffs, increasing his season record to 14-3 and drawing serious interest from the St. Louis organization as a pitcher. Springfield gained the distinction of being the first team in league history, and one of the few Class C teams since the founding of the National Association, to win three straight championships. Eckert looked like even more of a baseball genius when the Cardinals led their league in attendance for the fourth straight year, with 58,000 paid admissions, and once again turned a profit. Branch Rickey began to treat the Springfield president as the expert wheeler and dealer Eckert perceived himself to be.

Dallas Patton Swinging at White City. In his lone season in Springfield, outfielder Dallas Patton helped the team come close to winning the Western League's second half title, finishing first in hits on the team with 175, and second in batting with a .345 average.

Mays and Hays Copeland. Twin brothers Mays and Hays Copeland arrived at the 1933 Springfield training camp looking to earn spots in professional baseball. Hays, a catcher, failed; but Mays, a right handed pitcher, not only made the Springfield squad, but dominated the Class A Western League, winning 17 games. By 1935, he'd gone to spring training with St. Louis and pitched in one early season game before experiencing arm troubles. Ultimately, Mays made two more stops in Springfield (mid-1935 and 1936), but never made it back to the majors.

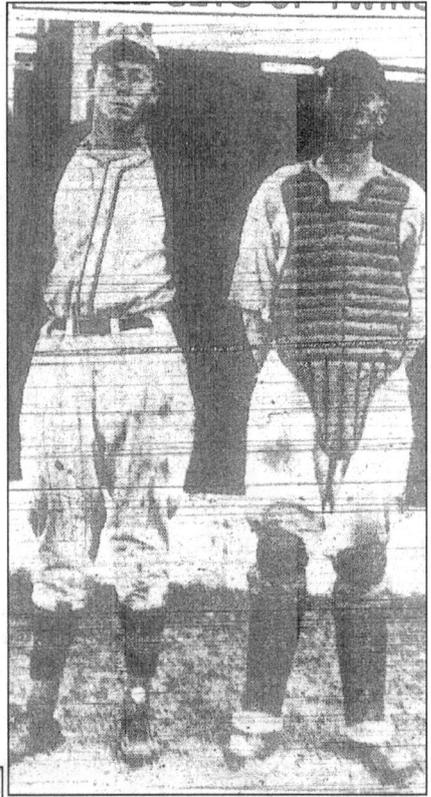

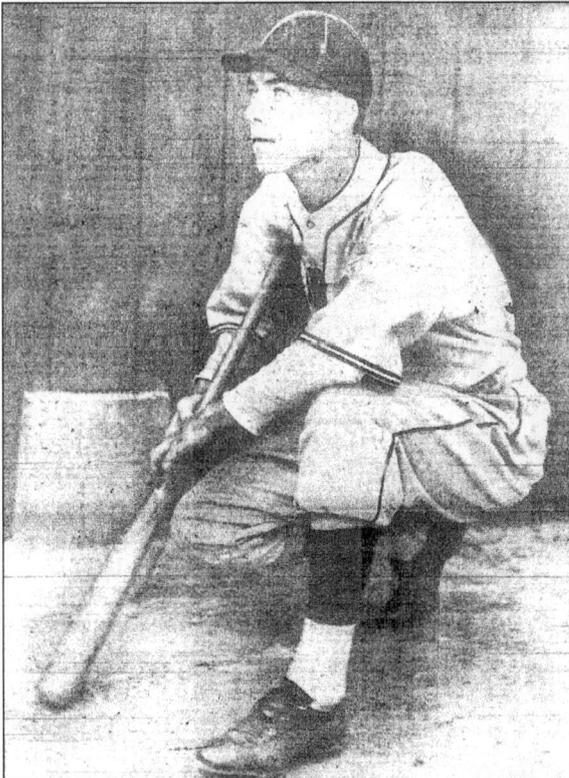

Johnny Keane. Johnny Keane starred for Springfield as shortstop over a period of three seasons (1931–33) and played nearly all levels of professional ball, but never made it to the majors as a player. Keane finally arrived at Sportsman's Park in St. Louis in 1961 when he began four very successful seasons as Cardinal manager, culminating in a 1964 World Series title.

Joe Lyon's Tap Room. Down the right field line, situated in small parcel of land close to the White City Park ticket office and main entrance on Boonville, sat Joe Lyon's Tap Room. Joe Lyon, a former minor league catcher, opened the establishment as an eatery in 1929. After the repeal of prohibition, the Tap Room became a popular watering hole for fans both before and after games. Bored players' wives were known to wander in during games, and even players called on Lyon's after games to suck down some of his signature Wagner beer. (Courtesy of Springfield-Greene County Library.)

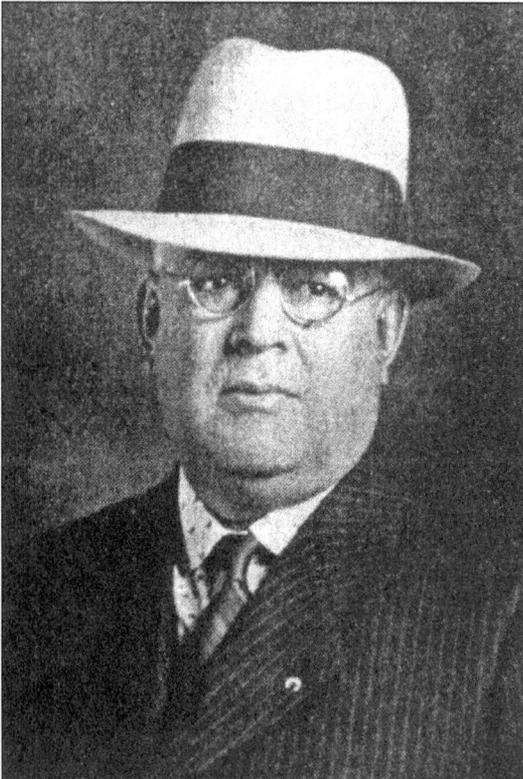

Tom Fairweather. In the fall of 1933, once his clubs removal from the Western League became apparent, Al Eckert initiated a reorganization of the Western Association. While at the National Association fall meeting Eckert sought out and recruited an old acquaintance, Spalding sporting goods rep. Tom Fairweather, to serve as league president. At nearly three hundred pounds, the portly Fairweather had a small background in minor league baseball but more importantly brought a solid reputation and imposing presence to the office of president of the Western Association.

AL. G. ECKERT
PRESIDENT

BRANCH RICKEY
VICE-PRESIDENT

ROY WATT
SECRETARY

SPRINGFIELD BASEBALL CLUB, Inc.

Springfield Cardinals

SPRINGFIELD, MISSOURI

January 25, 1934

Mr. James Franklin Howard,
Dustin, Okla.

Dear Goldie:

 Am enclosing contract for the 1934 season. This is the first contract I have send out. The reason for sending it at this early date is that you have a chance to train with the Rochester Club at Bartow, Florida.

 No player will be allowed to report until he has signed his contract. I would like for you to make this trip south. First place, you will have a fine trip and not many boys are fortunate enough to get such a trip with all expenses paid. Second, you have the chance to make a better then ours which means more money. I hope you can make a better club, not that I would not like to have you back but I would like to see you advance.

 As soon as I receive your signed contract I will notify Mr. Giles and he will notify you when to report. Send you transportation and all needed instructions.

 Trusting this finds you in the best of health and wishing you a good 1934 season. I remain

Very truly yours,

President, Springfield Baseball Club

E/W

Goldie Howard Letter. One of the many duties of longtime Springfield president, Al Eckert, was to send out contracts and correspondence to players during the off-season. Letters like this one, sent to standout outfielder Goldie Howard, informing him of his tentative assignment to train with Class AA Rochester, represent the types of things that kept Eckert busy with baseball ten months out of the year. (Courtesy of Mike Vincent.)

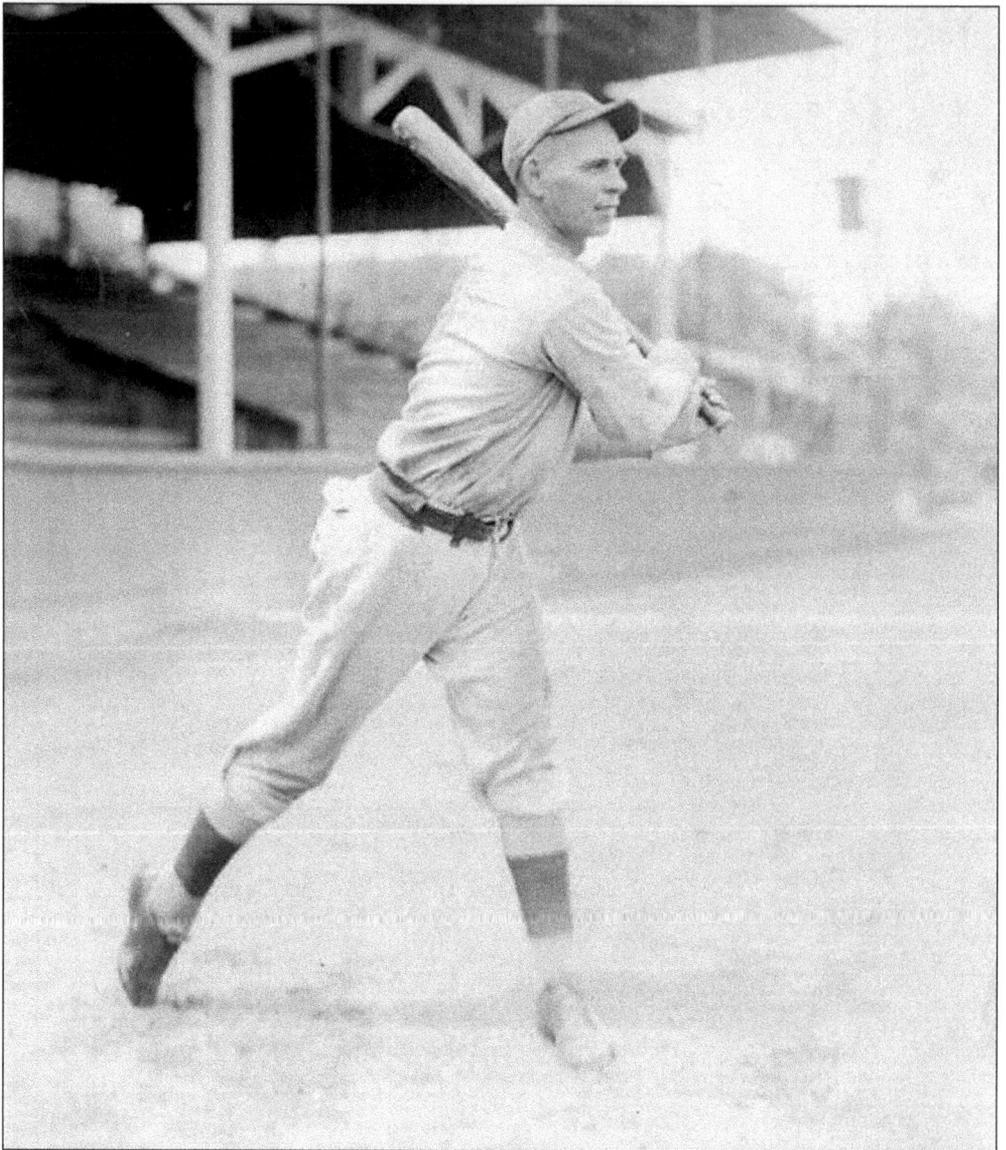

Dominic "Mike" Ryba. Ryba arrived in Springfield after three seasons in the minor leagues. After playing for Eddie Dyer at Scottsdale in 1930, where he won the league MVP crown, the versatile Ryba again captured the honor in 1931 after hitting .342, with 12 homeruns and 117 RBIs for Dyer in the Western Association. Following a season with Houston in the Texas League, Ryba returned to play for Springfield in the Class A Western League, and added a third league MVP trophy in 1933 after he hit .380 to lead that league. However, it was as player manager during his final season in Springfield, in the Western Association of 1934, which catapulted the then 31-year-old's career. Despite being known primarily for his catching and hitting, Ryba increased his mound time and garnered league top pitching honors after going 14-3 including the playoffs. In 1935, while playing at Class AA Columbus, Ryba received an incredible fourth different league MVP honor, before finally earning a late season call-up to St. Louis. That fall, he married Southwest Missouri State College instructor Thelma Howell and settled in Brookline Station, Missouri, where he lived until his death in 1971. (Courtesy of Patricia Ryba Hoover.)

64

Emmett "Heinie" Mueller. The scrappy, five-foot-six, switch-hitting infielder began playing professionally at the age of sixteen and played two seasons in Springfield (1933-1934), hitting .292 with 10 homeruns his final season. Mueller was one of many talented Cardinal farm hands during the 1930s and 1940s to reach the majors with another team. In 1938, he became the only player in major league history until 2004 to lead off a season by homering on the first pitch he saw in the big leagues.

Oscar Judd. Oscar Judd came to Springfield as a rookie in 1934 after being signed out of a Canadian semi-pro league. Rather old for the time (25) to begin a professional career, the left handed pitcher was just as well known for his hitting. During the 1934 season he went 10-6 and hit .351 in 74 at bats. Eventually, Judd advanced to the Pacific Coast League and earned a promotion to the Boston Red Sox as a 33-year-old in 1941. In 1943, Judd became the first Canadian born player to make the American League All-Star team.

65

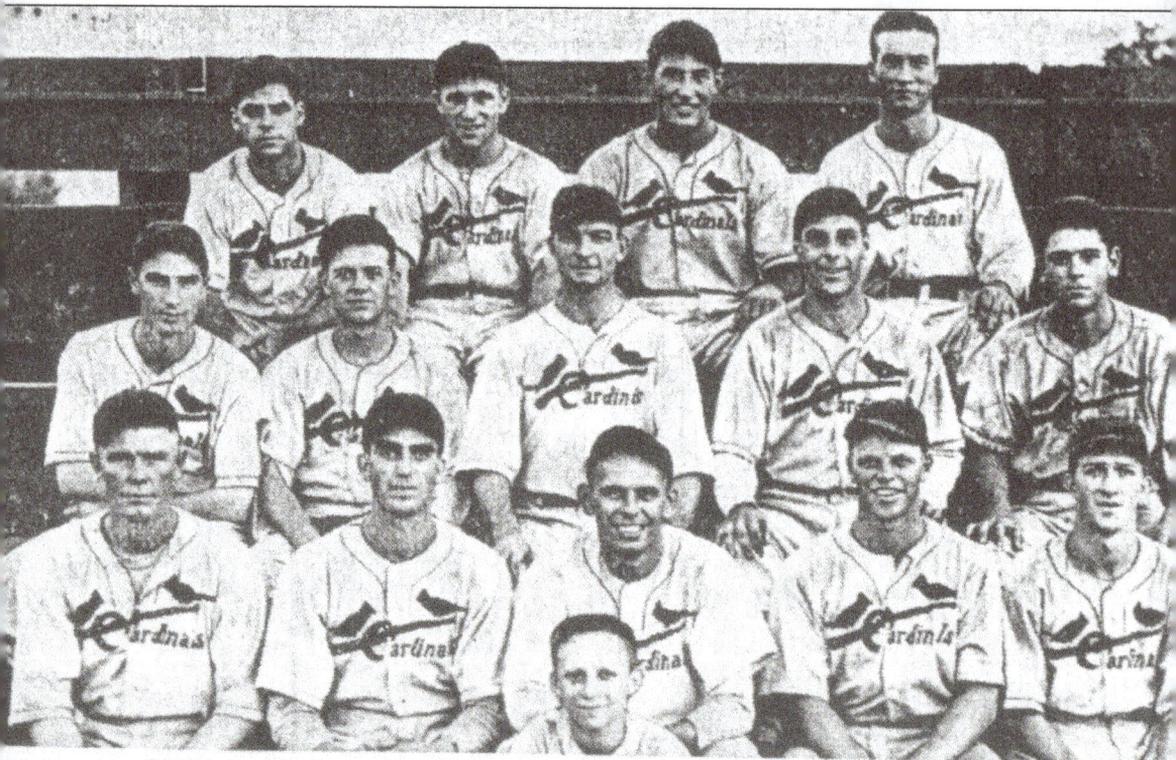

ont row—William McGee, Wilbur C. Dumford, Dominic (Mike) Ryba (Mgr.), J. Fra
Howard and Lyle Leroy Judy. Row 2—Oscar Judd, Richard A. Elston, Harold
hl, Melvin J. Kestner, Joseph C. Orengo. Back row—John Kyler, Emmett J. Muel
olph Arlitt, William M. Jones, Junior Simon (Mascot). Photo Mart. Ph

1934 Springfield Cardinals. The Springfield Cardinals captured an unprecedented third successive Western Association championship in 1934 by defeating the upstart Ponca City Angels in the playoffs. Featuring a roster of five future major leaguers, including "Fiddler" Bill McGee, Lyle Judy, Oscar Judd, Emmett Mueller, and player manager Mike "the one man gang" Ryba, the Cardinals tied for the first half lead (losing a best two-out-of-three game playoff) and won the second half outright, finishing with a combined 76-54.

FIVE

A Near Class C
Minor League Dynasty

In September 1934, Charles H. Morgan, the president of the Arkansas State League, a Class D circuit in nearby northwest Arkansas, worked feverishly for his league's survival. Fully aware of St. Louis' expansion of its farm system, Morgan sent out a plea during the fall, asking St. Louis to commit to the league. After consideration Rickey decided to make all the Arkansas State League clubs essentially farm teams of Springfield, with Eckert a quasi-overseer of the league. The Cardinal organization provided and monitored the players, and whenever needed, Springfield could access the Arkansas State League's players instead of always depleting the rosters of the Cardinals higher classification clubs. The finalized plan of January 1935 called for St. Louis to provide financial assistance in exchange for Cardinal control of all the league players. The Arkansas State League agreement intended to bolster St. Louis' player pool in the lower minor leagues, while providing stability for the Springfield club through a steady supply of quality talent.

Following the Arkansas State League matter, Eckert pressed Rickey in early February for Ryba's replacement. By mid-February "Mr. Rickey," as Eckert and nearly everyone called him, offered a ten-man list of candidates. Eckert chose 41-year-old Burleigh Grimes, the fiery spitball pitcher whose Hall of Fame career spanned 19 years and 270 wins. Grimes, however, had no free pass into the minors for his famous pitch, meaning any team wanting him needed their league's approval for use of his "wet-one" in games. On February 18, Eckert initiated a vote of W.A. club officials by telephone and telegraph. Rickey indicated that Grimes would only go where he could use his spitball, meaning one nay vote would kill Eckert's plan. The next day, that single dissenting vote came from Hutchinson president G. Carl Hipple.

Despite the Grimes setback, Eckert focused on signing his 14 "contract men," who were generally returning players, or those assigned to Springfield from lower classifications, mostly the St. Louis controlled Class D Nebraska State League. Eckert's duties in dealing with returnees and incoming tryout rookies had changed since Springfield's first year in the Cardinal chain. Instead of players corresponding with Charlie Barrett in St. Louis, Eckert received all letters himself and responded accordingly. The growing size of the St. Louis farm system made Eckert's added involvement and periodic additional tryout camps logical, because Rickey deemed the

pool of good available rookies to be shrinking. Ultimately, the move did little more than to reduce the number of quality players arriving at the Springfield spring camp.

With all players signed by the first week of March, the controversy over Grimes escalated. Rickey called the Hutchinson president and appealed for him to reconsider. When Hipple defiantly refused, Rickey totally removed him from consideration for managing in the W.A., despite Grimes' preference to go to Springfield, which was closer to his New Haven, Missouri farm. Grimes even offered to quit playing while in Springfield, but Rickey held the line.

The dejected but focused Eckert continued his typical mid-March preparations for the season, traveling to Kansas City for the annual league scheduling meeting. There, the same six clubs agreed to compete in the W.A., as in 1934. The league announced there that, unlike 1934, it would play mostly night games. Ponca City, the lone team without lights the year before, had added floodlights to its tiny field. With sustained major league backing for the six clubs, and with minor league baseball continuing to rebound, the W.A. in 1935 appeared stronger and more balanced than ever before.

The day after Eckert returned from Kansas City, Burleigh Grimes officially signed as manager of the Cardinals' Bloomington club in the Three-I League (a club that would train in Springfield). Eckert was vocally upset. The *Springfield Daily News* reported that he "worked himself up into a fine lather" when Phil Bartelme of the St. Louis front office notified him of the decision. "It just means this," Eckert shrieked to the press, that "the Western Association has lost one of the most colorful attractions in the game because of its refusal to vote yes." The usually subdued Eckert went on to say that he would "cry" his "head off for the strongest ball club I can possibly get in Springfield and show some of those guys who voted against Grimes how we feel about their action. . . . Those fellows will regret their vote before we're through."

Eckert's anguish over Grimes diminished somewhat on April 3, when Rickey named George Washington Payne, a near-career minor leaguer, as the new manager of the team. The 44-year-old Payne, who advertised his age as 37, had been with the Cardinals' Houston club in the Texas League since 1931. Although he'd garnered excellent statistics as a pitcher, Payne, like his predecessor, lacked managerial experience. Only days before the opening of the training camp, Payne arrived as the fourth manager in the Cardinals five years in Springfield.

As Monday morning, April 6, dawned, 223 young men hopeful for a chance in professional baseball converged at White City Park. Looking on were legendary veteran Cardinals scouts Charley "Pop" Kelchner and Charlie Barrett. The managers of the Cardinals' Springfield, Bloomington, and Omaha clubs, Payne, Grimes, and Joe McDermott monitored and assisted with daily drills run in rain and cold weather, which reduced the numbers of players in camp by nearly half by Wednesday. As became the case every year, nightly throughout the week, the veteran baseball men met in the Colonial Hotel to coordinate evaluations and make regular cuts.

On Friday, Rickey arrived in town to make final cuts. After observing afternoon workouts, the St. Louis entourage retired to their meeting room in the Colonial hotel, and conducted an all-night, closed-door session that determined the fate of most players. When the tired group emerged from an evening of Rickey's sifting through player evaluations, the Springfield and Burlington rosters had neared completion, along with those of the Arkansas and Nebraska State League teams.

Only a few player slots remained for Springfield. With Judy returning to play second base and Gerald Sanders the only acceptable rookie catcher, a solid everyday backstop eluded Springfield. A new catcher came by chance. Between stops in and out of the Springfield camp, Barrett arrived on the tail end of the Houston, Texas club's spring camp. There he found one of his California recruits, Arnold Owen, teamless after the Houston manager cut the 19-year-old. Partly because Owen was already under contract, Barrett drove him back to Springfield where a catcher was needed.

Two days after the hotel room meeting the Springfield and Bloomington clubs staged a first exhibition game. Five hundred people watched for free as Grimes and Payne squared off against each other in effortless first innings, with Bloomington winning 5-3. By April 25, Eckert

received his first of a season-long series of player setbacks when minor league player transfer rules sent top pitcher, Luke Bucklin, back to Class A Omaha. Still, the pitching staff remained strong as Springfield won a second and final exhibition game against Bloomington, 6-2. The Springfield four-man pitching rotation included lefties Tom Seats and Mike Pociask, along with righties Payne and Gottlieb "Doc" Liepelt. The final of two exhibition games started well on May 3 in Arkansas, when Seats struck out 12 in a complete game, 13-2 Springfield victory over Bentonville. The final game against the Kansas City Monarchs was rained out.

Eckert's confidence in his club remained high as they opened at White City Park on May 7, against Runt Marr's Joplin Miners team. Two thousand fans watched Payne win his 14th straight opening day game. Leading 4-3 in the sixth inning, Joplin surrendered seven straight runs to lose 10-4. The Cardinals stole three bases, including one by Judy. Eckert kicked off the night with a grand pre-game ceremony. Following a performance by the Boy Scout Band, a parade including the band and two teams marched around the field and down the third base line to a giant redbird suspended above the centerfield fence. Springfield won the final two games of the brief home stand to start 3-0.

Following a road trip through the leagues' three weakest teams—Joplin, Muskogee, and Bartlesville—the Cardinals returned home in first place at 7-3 overall. Despite the team winning consistently, only John Kyler hit well, with a batting average of .390. Regulars such as Judy, Owen, and third baseman Buster Adams all languished with averages at or below .200 as the Cardinals opened a long home stand with the Ponca City Angels. After dropping two of three games to the Angels, Springfield rebounded to take the opener of a Bartlesville series, 4-2, on May 22, and Pociask improved to 3-0 on the season, while contributing two homeruns—the last a two-run shot in the bottom of the ninth inning to win the game. The next night Eckert attracted over four thousand fans in the first of his many United Grocery Stores games that season, and the Cardinals won 6-1 before rain wiped out the series finale.

Normal rainy late spring conditions persisted across much of the league's territory, and between rainouts only great pitching kept the Cardinals in first place. A double-header win in Ponca City preceded the loss of two of the three games to Hutchison, even without the Larks stopping Redbird base stealers—both Judy and Ewing stole almost at will. Stolen bases were one of the few bright spots in a team playing more poorly than their 13-7 record indicated. The final phase of the road trip ended with a doubleheader split against third-place Joplin, which, combined with nine straight Bartlesville wins, dropped Springfield into second place for the first time on June 1.

The Cardinals returned home on June 3 and caught fire, immediately sweeping a doubleheader from Muskogee, while Bartlesville lost to a sleeping giant, Ponca City. The Cardinal bats finally awakened, and Springfield swept the three game series. With Bartlesville losing two of three to the Angels, Springfield regained first place for good. This offensive explosion was not enough to raise anemic Cardinal batting averages across the board. Joe Orengo now topped the team at .326, with Kyler the only other player above .300. While Judy's average rose slowly, other starters, including Buck Ewing, Red Schuerbaum, and Owen, continued to hit below .250. The backup catcher, Sanders, hit just .118 in limited play time. Eckert left little to chance with the pitching staff, just as in years past, and on June 7, he further strengthened the rotation when he added an extra pitcher. Eckert re-obtained right hander Mays Copeland from Columbus on 24-hour recall, which the *Springfield Leader and Press* declared made the Cardinals new rotation "one of the greatest in class C baseball." The Cardinals five current pitchers had each won at least four games, while only one had lost as many as three.

The home stand continued, with Springfield taking two of three games from Hutchinson, before another swing into northern Oklahoma practically clinched the first half title in mid-June. Arnold Owen collected four hits in the double-header victory header in Bartlesville, helping to raise his average over 30 points in one week. Lyle Judy also received mention in the nationally syndicated *Sporting News* that same week, for his base stealing success. Judy's four stolen bases in that week's game against Bartlesville gave him 35 with two-thirds of the season

remaining. Springfield's 16 victories in 19 games left them 32-12 on June 18 and thrust them to a nine and a half game lead over Bartlesville, the only other team in the league over .500 at 23-22. The winning streak finally ended when Ponca City won two out of three games at White City Park. Ponca City used the triumph to advertise current moves to strengthen their fourth place club, which manager Mike Gazella confidently predicted would result in a second half championship.

With the first half title wrapped up, the Cardinals cruised through the end of June playing .500 baseball. Judy continued to amaze, receiving widespread national coverage for his 37 stolen bases in 50 games, and the Cardinals officially clinched the first half of the season with more than a week remaining. Things appeared secure for the Cardinals, so Eckert bowed to rising league pressure against another runaway championship victory for the team, and shipped the promising and speedy Buck Ewing to Greenwood, Mississippi. Eckert also sent the floundering Sanders to Greensburg of the Class D Pennsylvania State Association. On the last day of the first half, Payne rested his already tired and overworked pitchers, especially Liepelt, whose sore arm had limited his innings pitched but not his effectiveness, by pitching a wild Arlitt in a final-game loss that completed a 42-21 record.

As champions of the first half, Springfield hosted the first All-Star game in league history. The July 3 All-Star game pitted Springfield against a team of the league's best as voted in by the fans. Eckert's extensive advertising netted a crowd of 3,000, each of whom cheerfully paid full price to see Springfield lose 5-2. The next day Eckert sold Mike Pociask, the team's leading pitcher, with ten victories, to Rochester of the International League. Eckert expressed his rationalization for the move as an effort to "bring the Cardinals down" to the rest of the league's level. Ross, Seats, Payne, and even the ailing Liepelt, would to carry the team to the pennant. With a record of 3-2 in his limited time with the team, Copeland's sporadic success, combined with the threat of recall, left room for concern about an uncertain pitching staff.

The second half of the season started with Springfield renewing their dominance of Joplin by sweeping the four-game series. Judy added to his stolen base total, reaching 50 in that first game. Only 17 shy of Guy Sturdy's league record of 67, set with Joplin in 1922, Judy seemed assured of the record. Judy's batting average also continued to inch upward throughout the Joplin series, as did those averages of Adams and Owen. With Adams and Judy batting one and two in the order, and Owen in the catcher's traditional eighth spot, the trio headlined the Cardinals initial second half success. Elsewhere in the league, Hutchinson began with four wins of its own to tie with Springfield for first.

The Cardinals then began a four-game road trip to Bartlesville, splitting the two games of a rain-shortened series; meanwhile Hutchinson lost two games to Muskogee. Springfield returned home to play Hutchinson, with whom they were again tied for first place at 6-2. Behind Seats' 12th victory in the opener, the Cardinals briefly gained sole possession of first place, before losing the final two games to fall behind the Larks. Two weeks into the second half, Springfield remained tied with Ponca City for second place.

Springfield returned home on July 22, 14-8 on the season and two games behind the Larks. The highlight of the home stand came in the final game of the Bartlesville series, when Seats achieved his sixth straight shutout and Judy stole his 66th base in the first inning, putting him one shy of the league record. Still, Springfield pulled no closer to red hot Hutchinson, remaining two games back.

Unfortunately, the Ponca City series that followed was representative of things to come. Springfield played without the services of Arlitt, who had contracted blood poisoning after being spiked during play against Bartlesville. The loss of Arlitt forced Harrison Wickel, a newly added rookie outfielder from Ohio State University, to play first base. With only 13 healthy players, a pitcher filled in at Wickel's position in the Cardinal outfield. Springfield limped out of northern Oklahoma and stopped in Joplin for a series where, on Sunday July 28, Judy broke Study's record, with three stolen bases. As the stolen base leader in all of professional baseball, Judy then set his sights on the magical 100 mark. Judy added three more bases in Joplin, which

earned him an article in the August 1 edition of the *Sporting News*. In addition, Judy's sub .250 mark of earlier in the season had been replaced with a .310 average by late July. Things looked bright for the Springfield club heading into August, and little about the club appeared to require Eckert's attention.

On July 30, Springfield hosted Ponca City and celebrated the raising of the 1934 W.A. pennant. Five thousand fans along with Charlie Barrett, St. Louis treasurer Bill DeWitt, and Springfield Chief of Police Paul Frey, watched a game that came down to critical errors by Adams and Orengo in the sixth inning. Two unearned runs deprived Seats of another shutout victory, while Judy contributed to the miscues by getting caught trying to steal home in the first inning. Springfield reeled from the loss, Ponca City swept the series, and the Cardinals fell into third place.

Following the pennant-night game, the Eckerts had about 30 guests over to their house at 824 S. Weller for a backyard barbeque. Sitting around in a big circle eating and talking were many Springfield and St. Louis Cardinal dignitaries. Barrett brought up the subject of Mays Copeland, who he had heard could not "get anybody out in this league." Payne assured him that Copeland's fast ball had only recently returned, and that the big red-headed pitcher's career would continue. Barrett's concern over Copeland's downswing, with a record of five wins and six losses, bespoke his more general concern for Springfield's eroded pitching staff. Springfield's winning record through late July hid the seriousness of the pitching staff's rapidly tiring arms. With the team still winning, Eckert remained little troubled, and Payne's personal durability, combined with his lack of understanding of young arms, clouded his awareness of the situation.

The August 3 series opener against Joplin at least temporarily eased existing apprehension over Copeland when he struck out ten Joplin batters to claim victory. Then, for the first time in six weeks, Seats faltered, surrendering 16 hits. Luckily, the team benefited from an offensive explosion to win 19-9. Owen, whose batting average had risen to .281, was the star of the August 4 double header, collecting five hits with seven runs batted in. Springfield pulled back into second place and won two more games before the season began its final descent with baseball Commissioner Kensaw Mountain Landis's order to return Copeland to Columbus. Baseball law prevented major league clubs from optioning their players to Class C clubs, and Landis reasoned that Copeland technically belonged to St. Louis. With Copeland gone, and Leipelt's arm still sore, Eckert immediately sought Copeland's replacement as the team left on a nine-day road trip.

In Muskogee, Leipelt gave up three homeruns to Tigers' third baseman Tony Masucci, in a loss that pushed Springfield into a second place tie with Hutchinson. The next night, Springfield ran wild, winning 17-2, with Judy pilfering four bases to raise his total to 81. Eckert had barely begun his retooling of the Cardinals pitching staff in acquiring the Arkansas State League's top pitcher, Arlie Gayer, before Ross went down with appendicitis. After Gayer signed his Springfield contract, Eckert sent him to Bartlesville—on the same day that the lone Springfield boy who had signed out of the 1935 tryout camp, John "Hooky" Evans, hit a big homerun to win in Bartlesville.

The Cardinals then moved on to Hutchinson for a key series where Seats again lost to the Larks in the opener as a sporadic Cardinal offense scored only twice. When the Springfield offense scored six runs the next night, Gayer, making his pitching debut, surrendered eight runs and the team fell further back, into third place. With little over two weeks left, Springfield returned home for three critical series against Muskogee, Hutchinson, and Ponca City. A losing record over the nine days could end all second half pennant hopes. After dropping a close first game to Muskogee on August 14, the triumphant return of Ross the next night started the Cardinals toward victory in the final two games of the series. Judy's climb toward 100 stolen bases continued to overshadow the Cardinals inconsistent play. With 85 stolen bases in mid-August, he remained on pace to reach not only his personal goal but the major league record of 96 achieved by Ty Cobb in 1915.

Three and a half games out of first place, the Larks returned to Springfield for a four-game series. In the first game, John Kyler hit a ninth inning walk-off home run to win. On the afternoon of August 19, Eckert, creating another of his crowd pleasing promotions, fashioned an "Everton Day" pitching dual between the Cardinals' Gayer and Hutchinson's Wendell Davis. Five hundred Everton fans rolled into Springfield by train to watch their hometown boys square off. Once again Davis got the better of the Cardinals, 5-4, despite a solid performance by Gayer. During the nightcap of the double header, Judy added two stolen bases to raise his total to 89, but Payne lost a heart-breaking ten inning battle, 5-3, with Hutchinson's ace Morris "Cy" Young. Ross then allowed the Cardinals to split the series and actually to pick up ground on Ponca City, closing to two and a half games out.

Springfield geared up on August 20, as a sweep of league-leading Ponca City would put the Cardinals into first place. With only 17 games left, the obstacles to victory loomed larger as Houston, in need of a veteran shortstop, summoned Joe Oregno. The Cardinals stole five bases in the first game, three by Judy (92 total) to win 8-3. The next night, Seats won 7-3, striking out ten batters and raising his season total to 241, only 41 short of Flint Rhem's 1922 league record. The win put the Cardinals one game out, in third place behind Hutchinson, who had moved a half a game past Ponca City by winning over Bartlesville. In a Merchants Loyalty Night of 7,500 "widely excited spectators," Gayer blew a two run lead in the ninth to lose again. Springfield's chance at first place slipped away, ruining what should have been a celebration of Judy's contract sale to St. Louis.

Beginning the last road trip of the season, the Cardinals swept Joplin again, for their 17th win in 19 games, and Judy stole his 96th base, equaling Ty Cobb's 20-year-old mark. The Cardinals regained first place for the first time since July 13 after taking two of three games from Ponca City. Judy reached his goal of one hundred stolen bases the next night, leading the team with a batting average of .323, and second in hits behind Kyler. Second place in batting averages belonged to the once light-hitting Owen who came in at .296. Springfield won two of the three games in Bartlesville, but Gayer's fourth straight loss dropped Springfield to third in the tightly clustered W.A. pack.

With four games left, Springfield needed to win, and hoped for Ponca City and Hutchinson losses. Springfield's season came down to consecutive day-night double headers against Joplin. On Sunday, September 1, the Miners succumbed to Seats and Payne again, and the Cardinals climbed into first place by half a game. A double header win on Memorial Day would earn Springfield the second half crown and outright title in the league, regardless of the other two clubs' performances. Unfortunately, the Cardinals lost the first game 5-4 on Monday afternoon, and the team's fate lay in the hands of the Angels. Springfield's second game victory was not enough, as Ponca City beat Hutchinson twice—Hutchinson had also had a mathematical chance that day—and took the title by half a game. Judy's three stolen bases of the final day raised his season total to 107.

Springfield opened the 1935 play-offs on September 4 against Ponca City in a rematch of the 1934 post-season. The previous year, Springfield had won the best of seven series by taking all four games played at White City Park. In 1935, the Cardinals opened at Ponca City in a best of nine series. Payne took the mound for the first game and showed the grit of a veteran in winning 7-0. All Cardinal players, except Kyler, collected at least one hit, with Liepelt, banging out four. Adams, who had led the league in home runs with 19, added another in the fifth inning.

A small but rowdy crowd of 1,200 watched their Angels beat Seats, 2-1, in 13 innings the next day. In game three, Ross's worst pitching performance of the season ended in defeat, after Gayer's and Eckert's second Arkansas State League pitching addition, Moose Fralick, failed in relief. Owen led the Cardinals with two doubles, an RBI, and one run scored in game three, but appeared lost for the remainder of the series after a diagnosis of tonsillitis on the team's day off. Despite the inherent discomfort, Payne managed to insert Owen's steady bat into the lineup by playing him in right field, a position he had never played competitively. Judy then took over the catching duties for the first time since the 1934 playoffs.

The series moved to Springfield and 5,000 tense fans watched as, with the score tied at six all in the first game, Schuerbaum hit a fly ball to the deepest part of White City Park, a triangular corner

in left center field some 470 feet away. The ball lodged in the wire enclosure hanging off a light poll tower just inside the field of play. As the Ponca City outfielders wrestled with extraction of the ball, the 17-year-old sprinted around the bases for an inside-the-park homerun to win the game. In the second game, Arlitt hit a Joe Berry pitch onto Boonville Avenue with one man aboard for a 3-1 win. The Cardinals took a three games to two lead.

The next night the Angels beat Ross in the tenth inning. Tied at three games apiece, Payne pitched the Cardinals final home game on September 10 and surrendered six unearned runs in the fourth inning. The Cardinals used four pitchers, including Seats, who pitched the next night, to "limit" the score to 10-0. A Springfield rally in the eighth inning began with walks to Judy and Owen and ended nine runs later. The 10-9 loss put Ponca City ahead four games to three with the final two games in Oklahoma.

Just as in 1934, Ponca City needed just one win to capture the club's first ever championship. Only Tom Seats stood in their way on September 12. A crowd of 1,700, small by Springfield standards but a record to date for a game in Ponca City, again watched their home town team lose to Seats, with Owen back behind the plate.

The final night Payne, in an intriguing move, started the promising Arkansas State League rookie reliever, Moose Fralick. Payne's gamble back-fired and the Angels scored six runs before Seats entered the game in the first inning. Ponca City won 8-1 behind Springfield native Eddie Carnett's third victory of the series, wrapping up their first Western Association title and ending Springfield's run of the league.

Springfield enjoyed the distinction of leading the league in attendance for the fifth straight year in 1935 with 52,497 paid admissions. However, while still strong compared to the rest of the league, these numbers represented a slow decline since 1931. Fans expected a fourth straight Western Association championship, but the failure of the 1935 Springfield pitching staff ultimately prevented this. No organization ever achieved four consecutive titles in the highly volatile lower minors, a feat which perhaps would qualify a team to be considered a minor league dynasty. Had the Western Association operated in 1933, period observers agreed that Springfield would have risen to the occasion. The 1935 playoff loss turned out to be the beginning of the end for the St. Louis Cardinals' farm club in Springfield.

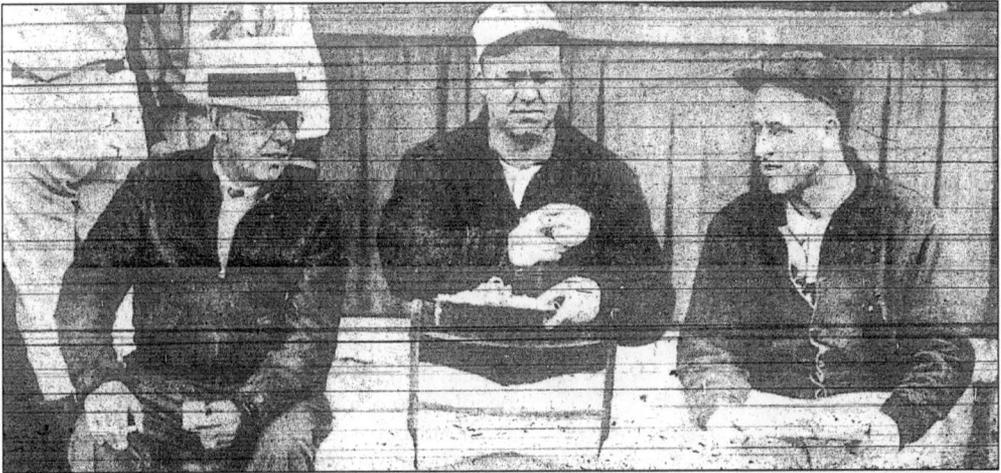

Barrett, Grimes, Payne. While conducting spring training at White City Park in 1935, three old baseball men—Charlie Barrett (left), Burleigh Grimes (center), and George Payne (right)—sat and talked about the national pastime. Grimes demonstrated for all those in attendance the famous spit-ball pitch which made him a five time 20-game winner in the National League and eventually would land him in the Hall of Fame.

Colonial Hotel. Springfield's fanciest hotel, the Colonial, located at the corner of St. Louis Street and Jefferson Avenue, became the temporary residence of St. Louis Cardinal officials during the team's tenure there. Branch Rickey routinely stayed in a suite, and during the spring held late night meetings that decided many a young man's fate in professional baseball. In spring 1931, the St. Louis Cardinals, featuring the ostentatious Dizzy Dean, stayed at the Colonial while playing an exhibition in Springfield against their farm club. Dean entertained fans and journalists in the lobby with his drawl-filled provocations. (Courtesy of Springfield-Greene County Library.)

Sterling Hotel. While major league executives and scouts slept in the more lavish Colonial Hotel, visiting teams during the 1920s and 1930s usually put their players up in the more run-of-the-mill Sterling Hotel. The Sterling, which, by the 1930s, was owned by the same people who owned the Colonial, stood just yards off the city square, and just across the street from the Walgreen's drug store and soda fountain, where players often killed time. Some of the home club's players even roomed at the Sterling, which took several names in the 1920s, most notably the Sansone. (Courtesy of Allen Casey.)

George Payne. Forty-four-year-old George Washington Payne entered his 22nd year in professional baseball in 1935 when Branch Rickey named him Springfield's player manager. Following a cup of coffee with the Chicago White Sox in 1920, Payne had starred in the Texas League for Ft. Worth and Houston from the mid-1920s until 1934. Although Payne pitched well, adding to the eventual third best all-time minor league total for wins (348), games pitched (900), and total innings (5,324), his lack of managerial experience partially explains why Springfield fell just short of reaching the never achieved distinction of four successive Class C championships.

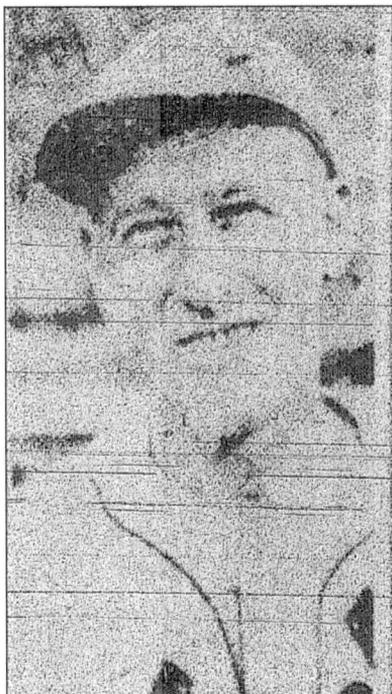

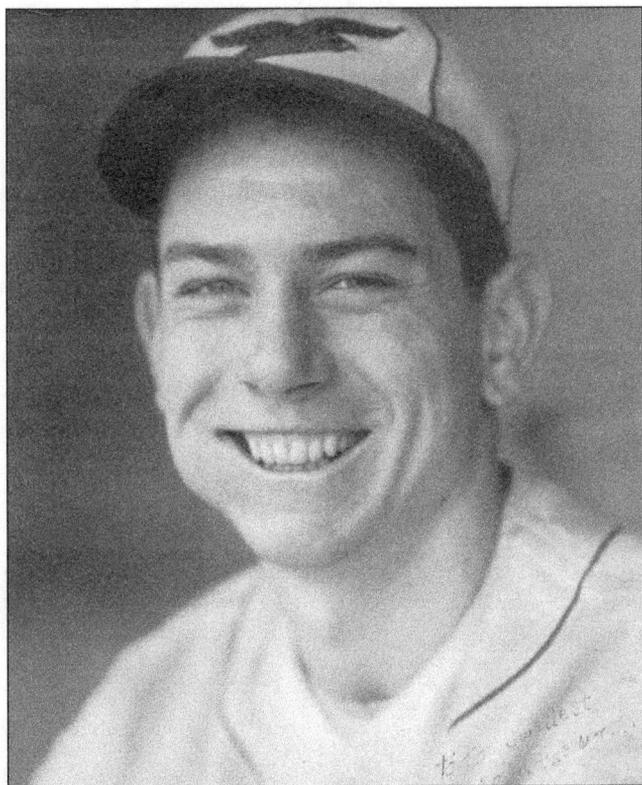

Mickey Owen. Easily the most famous Springfield area native to reach the majors, Arnold Owen was born in Nixa, Missouri, and had moved to California as a child. The Cardinals' Charlie Barrett signed Owen, who was spotted playing semi-pro ball in southern California, to a Class A contract. Owen reported to the Houston, Texas spring camp in 1935 but was released, prompting Barrett to bring the nineteen-year-old back to Springfield, where a catcher was needed. Owen hit .310 against Western Association pitching and earned a 1936 promotion to Class AA Columbus, where he gained the well-known nickname, "Mickey."

Lyle Judy. Lyle "Punch" Judy began his professional career in Springfield in 1934 as a shortstop and catcher. Despite serving as a back-up, Judy regularly found his way into the line-up and hit .315. Based mostly on his hitting and less on his Olympics-like 10.2 second speed in the 100-yard dash, the Cardinals designated Judy for assignment to Columbus of the American Association. Repositioning to second base during spring training in Florida revealed Judy's rawness at the new position, thus prompting his return to Springfield for a spectacular 1935 season.

Bob Ross. Long before an artist by the same name painted "happy little trees" on PBS, the Springfield Cardinals acquired a promising 19-year-old rookie pitcher named Bob Ross. Ross, an engineering student from Tennessee, fought through a mid-season attack of appendicitis to go 18-4 in 1935, with the league's best winning percentage at .818.

Tom Seats. Left handed pitcher, Tom Seats, followed up a solid rookie year in the Class D Nebraska State League by moving up to Springfield in 1935. The fireballer went 25-9 in his lone season in Springfield, at one point hurling an unbelievable six straight complete game shutouts, and nearly broke Flint Rhem's Western Association strikeout record with his league leading total of 279. Seats reached the majors first with Detroit in 1940, and then reappeared with Brooklyn as a wartime reliever and spot starter in 1945.

1935 Flag Raising Ceremony. Springfield fans celebrated the raising of their 1934 Western Association pennant before their game against Ponca City on July 30, 1935. Five thousand fans watched Ryba, Branch Rickey, and Springfield Mayor Harry Durst, raise the 1934 pennant up the flag pole in right-centerfield. Ponca City president Earl Hamilton gave his permission for Mike Ryba to skip the American Association All-Star game and take part as a coach.

SCHEDULE AND PRICES
Little World Series of Western Association
Games to be played in Springfield
SUNDAY, SEPTEMBER 8TH—DOUBLE HEADER
MONDAY NIGHT, SEPTEMBER 9TH
TUESDAY NIGHT, SEPTEMBER 10TH

These will be the only games played in Springfield.

ALL ADULTS .40c
CHILDREN, UNDER 12 YEARS26c
BOX SEATS, EXTRA20c

Coupon tickets and passes are not good.
Tickets now on sale at Al G. Eckert Cigar Store.

1935 Play-off Ad. Al Eckert extensively advertised Springfield's participation in what he labeled the "Little World Series of Western Association," little realizing—along with most Springfield fans—that the half-season first place finish, which again landed his ball club in the playoffs, would be the franchise's last.

Boy Scout Band at Sportsman Park. By 1935, R. Ritchie Roberson's Boy Scout band had grown greatly in size and recognition. Numbering over five hundred members, the group's reputation earned them the opportunity to do their familiar pre-game march around Sportsman's Park before a September 15 Cardinals-Giants National League game in St. Louis.

78

Six

The End of the Line

While the years following 1935 led to the slow demise of the Cardinal farm team in Springfield, Rickey and Eckert each carried on with business as usual by stocking the Springfield roster with talent. Rickey designated Payne to replace Burleigh Grimes as manager of the Cardinals' farm club in the Three-I League, and in turn Joe Brown became the Springfield manager. However, Brown inherited a team which, unlike those of previous years since 1931, returned no starters, except for outfielder Red Schuerbaum. Complicating matters early in the season were a string of injuries to the infielders and terrible hitting from two of the three outfielders. The sole bright spot in the outfield turned out to be Lynn South, an underperforming outfielder for the great 1934 and 1935 Ponca City clubs. Two consecutive sub-.300 batting averages had earned South his release, which came at a time when Springfield needed an outfielder. One month into the season, South led the league in hitting with a .500 batting average, a mark the team's win-loss record could not match.

Springfield's sub-.500 record early in the season cast the team into the unfamiliar territory of holding a low position in the standings. Fans initially seemed to discount the poor play—huge early season crowds continued to fill White City Park. The climax of Springfield's era as a Cardinal farm club came on May 25, when a league record of 10,000 Merchants' Loyalty Night fans packed the stands, and lined the park's roped off outfield fence, standing four rows deep. From then on, attendance began to decline, as Springfield's many fair-weather fans slowly returned to their pre-Cardinal tendencies.

Young players such as future major league all-star catcher Walker Cooper (the younger brother of former Springfield player Mort Cooper) spent most of the season failing to live up to the promise he'd shown the year before in the Arkansas State League. Overdependence on the Arkansas State League as a supplier of fresh Springfield players translated into the same meager results in 1936. Without St. Louis sending proven players from the upper minor leagues, Springfield lacked the talent to compete with other Western Association teams whose parent clubs began to copy St. Louis' old formula for success. Springfield's record briefly breached the .500 mark before mid-season, but only because of an improved pitching staff and the sustained

near .400 batting average of South, who closed the first half as the league leader. Although Springfield finished fourth in the league at 32-36, the Cardinals sent four players (with South the only unanimous selection) to the league all-star game against first half winner, Joplin. First half attendance totals told a tale of things to come, however. Springfield led the league in first half paid attendance again (22,848), but by a smaller margin, as the team was never in serious contention. Team attendance projections for the first month of the season had Springfield ahead of its 1935 pace, but by mid-season, totals indicated a sharp drop-off that would continue.

Early in the second half, things looked even bleaker for Springfield, as the team sunk into fifth place. Even the effective addition of starting pitcher Bill Winford failed to rally the team. Eckert, for his part, continued working to improve the team, and acquired several marginal players from Columbus in addition to re-signing the hard-throwing but oftentimes wild, Wendell Davis. Both Columbus players contributed nothing to Springfield's attempt to rebound, however, and Davis repeated the inconsistency he had exhibited of 1934. Even the return of Mays Copeland only complicated matters and made Joe Brown's attempts to establish a consistent rotation out of the jumbled-up pitching situation difficult. By mid-August, Eckert seemed to have given up on the 1936 season—he began to plan for 1937, drumming up new talent through a Springfield sponsored 'no letter required' tryout camp in Bloomington, Illinois, starting on August 31.

Springfield finished fourth again in the second half, and fans responded accordingly. For the first time since 1930, Springfield failed to win at least one half of the Western Association season or to lead the league in paid attendance. The off-season brought a flurry of change for most teams in the Western Association, as repeat champion Ponca City scoured the West Coast for top talent. Joplin, entering their third year as a Yankee farm club, had strengthened their club considerably over the year previous, making Springfield's climb back to the top that much harder.

Eckert mended the roster mistakes of 1936 by installing a more competitive nucleus. He re-obtained first baseman Adolph Arlitt, who served as player manager of the St. Louis-owned Monett club of the Arkansas-Missouri League in 1936. Rickey then replaced Brown with a more experienced manager, Clay Hopper. Hopper, nine years before he was to face the managerial pressure of Jackie Robinson's lone season in the minor leagues, again added a good-hitting outfield-playing manager to the Springfield club. Behind Hopper's leadership and the Judy-like base stealing of shortstop Frank Mabry and centerfielder Ken Miller, the Cardinals jumped into an early lead in the W.A. race. Although the pitching remained weak at times, Springfield stayed in first place through early July, until a balanced Muskogee team with good higher-classification backing overtook the Cardinals on July 8. Just two days before, Springfield had become the first home team in the history of the league to win the all-star game.

League President Tom Fairweather's off-season decision to institute the new Shaughnessy playoff format allowed the league's first place team on July 1 to host the game. Following Springfield's dramatic ninth inning victory in the all-star game, the team slipped back just enough to allow Muskogee and Hutchinson to overtake the Cardinals in the standings. Springfield remained in third place, around three games out, until the last few days of the season, when Joplin too passed the Cardinals in the standings. As opposed to the old split-season, which allowed only two teams to participate, the Shaughnessy playoff system allowed the top four teams in the league to qualify for the post season. Once in the playoffs, the Cardinal pitching staff, none of whom had won over 16 games, stepped up and pitched the team to series victories over Hutchinson and Joplin to take a somewhat diluted fourth W.A. championship for the decade.

Clay Hopper's ability to get the most out of his players had kept Springfield competitive in 1937 despite the absence of any future major leaguers on the roster. In 1938, the Springfield management was again forced to gut their roster to provide talent for the upper ranks of the ever-expanding St. Louis farm system. By this point, St. Louis owned or had working agreements with 31 teams throughout the country. Rickey himself admitted to a thinning player pool, which for Springfield meant that more talent was leaving annually than arriving. Hopper returned

80

for a second year with a team that carried no legitimate starters. As a result, the Cardinals immediately sank to the bottom of the standings. Despite the poor opening performance of the team, several off-season improvements to White City Park actually increased attendance, which rose above the 54,992 who had paid entrance in 1937. The addition of a fourth bleacher along the third-base side of the park increased capacity to a reported 6,000, while the installation of new lights, which Rickey proclaimed as "the finest we have in any of our minor league cities," improved night-play conditions.

Although the Cardinals played uninspired ball most of the season, the real blow to Springfield's hope of regaining sustained competitiveness in the W.A. had came during the previous fall, when Commissioner Kennesaw Landis decreed that St. Louis and several of their farm clubs were in violation of controlling more than one team in a league. In the ruling known as the Cedar Rapids case, Landis turned loose 90 players in the St. Louis minor league system. Perhaps no team felt the effects of the decision more than Springfield. Landis released all of the players of St. Louis' Monett team of the Arkansas-Missouri League. Rickey no longer controlled the entire Arkansas-Missouri League, but had a working agreement through Cedar Rapids with Fayetteville in the same league. Even though Rickey quickly restocked Monett with players, Springfield lost access to higher potential players. In addition, Landis singled out Springfield as one of three Cardinal farm clubs fined a total of $2,176. Eckert paid a $1,000 fine to the Commissioner's office on June 9 for his participation in the Arkansas-Missouri League caper. The Cedar Rapids case had early season repercussions for Springfield. By June, not even the return of Lynn South as the league's leading hitter, and the outstanding shortstop play of Frank "Creepy" Crespi, who became an emerging National League star by 1941 before military duty ended his career, raised the Cardinals above sixth place in the larger eight-team Western Association.

In mid-June things finally turned around as Hopper found the right mix of players. Springfield pulled into third place and cracked the .500 mark. A month and a half later the Cardinals pulled past the Fort Smith Giants into second place, where they remained until the end of the season. The playoff season proved less friendly in 1938—the Cardinals were eliminated in the first round by Hutchinson. Springfield's climb to second place netted an increased gate of 62, 647. The numbers seemed good when compared to past years, but not compared to attendance in the league, which had skyrocketed, increasing every year since 1934.

The 1939 season proved to be the last satisfactory season for the Springfield club. War concerns were not yet a reality in the United States, and Eckert still had no problem drawing people to the ballpark. Over 64,000 people turned out to see a repeat of 1937, as player manager George Silvey, whom Rickey advanced from St. Louis' Class D club in the Ohio State League, led Springfield to a third-place finish during what the *Spalding Guide* called "a torrid three-way race" in the regular season. The Cardinals then added what proved to be Springfield's sixth and final league championship after they defeated regular season champions Fort Smith in the first round of the playoffs and then beat Topeka three games to two.

Silvey's return in 1940 proved to be less inspiring, as the club utterly fell apart at just the wrong time. With thoughts of World War II now more firmly on the minds of Americans, and the economic tide in Springfield changing in the shift toward war production, a losing ball club failed to attract much attention. The Cardinals slipped back in the W.A. pack early and remained there, finishing 56-76 on the season. Twenty-seven-year-old outfielder Ollie Vanek replaced Silvey late in the season and for the first time since the introduction of the Shaughnessy system, the Cardinals failed to qualify for the playoffs, after finishing in seventh place. This marked the team's worst finish since the Midgets of 1930, and final attendance numbers for 1940 also mirrored 1930 in producing a large deficit. Springfield drew only 35,800 paying fans—a drop-off of nearly fifty percent—and as a result the club lost an estimated $10,000. St. Louis owner Sam Breadon was unhappy, and Eckert did not know what to do. Eckert pleaded with Rickey to retain the Springfield franchise, and despite Rickey's usual policy of discarding unprofitable farm teams, he obliged his devoted minor league president for at least one more season. Springfield, however, sat on very thin ice heading into the 1941 season, especially since

Breadon's financial situation had weakened because of the six-year long pennant drought of his National League club.

By 1941, Rickey had decided to consolidate the spring training of St. Louis' Class B and lower farm teams at their facility in Columbus, Georgia. As a result, Vanek had to travel to Columbus rather than holding the usual spring training in Springfield. Vanek selected available players from the Cardinals' vast player pool and, aided by Rickey and the numerous St. Louis scouts, almost completely retooled the roster from the team of the year before. Only promising left-handed pitcher Lloyd "Lefty" Hopkins and underachieving right-hander Sylvester "Blix" Donnelly were retained from the previous team. Donnelly, with an unimpressive 7-13 record in 1940, quickly emerged as the ace of the pitching staff in 1941. The Cardinals featured several future major leaguers, but none equaled the greatness of the new right fielder, Stan Musial.

Musial, a left-handed pitcher, had spent two seasons toiling in Class D ball before an injury rendered his pitching arm essentially useless. Accounts differ, but Springfield needed an outfielder, so Rickey and Vanek (who had scouted and signed him in the first place) took a chance on the promise Musial had shown as a hitter. Vanek taught Musial to play right field where the short (310 feet) right field fence at White City Park minimized pressure on his weak arm. The move ultimately proved successful.

Behind the early season .400-plus batting average of Musial and the six straight victories of Donnelly and Hopkins, the Cardinals jumped to a big lead in the Western Association standings. Little, if anything was expected from Springfield, compared to the New York Yankee's farm team in Joplin, which remained a distant second. Musial picked up the pace in late June, as his batting average reached .427, while his teammates were hitting and pitching well. On June 24, Springfield held a ten and a half game lead and appeared to be coasting to the regular season pennant. Despite a slight hitting slump in early July, the biggest problem turned out to be the pitching staff. Overuse of the staff's three best pitchers, Donnelly, Hopkins, and knuckleballer Al Papai, partly explained their ineffectiveness later in the season. But when both Hopkins and Papai were called to military duty, the team faced real trouble. Eckert attempted to solidify the Springfield staff with three new pitchers, one each from Class B and C clubs, and a third untested rookie. The disbanding of the Arkansas-Missouri League the year before removed the Springfield president's former source for acquiring new talent and made it difficult for Eckert to gauge the effectiveness of the three new pitchers. Quality pitching simply was not available within an overextended St. Louis farm system of some forty teams. Within days, the team lost Musial, too, as Rickey abandoned his promise of 1926 to leave his Western Association farm club's players intact through the end of a pennant race.

Following Musial's departure to Rochester, the Cardinals lead of seven and a half games began to disappear, despite the capable play of Musial's replacement, Henry Redmond. Joplin caught fire in August and won 30 of 41 games, while the Cardinals played barely above .500 baseball the last month of the season. Vanek pitched Donnelly nearly every second or third day down the stretch in an attempt to halt the slide, making the Cardinal ace less effective, although he was the only pitcher in the league to eclipse the 20-win mark. Springfield entered the last two days of the season with a two and a half game lead over Joplin for back-to-back double headers against the Miners. Joplin swept all four games and won the regular season title by one and a half games. Fort Smith then crushed the downtrodden Cardinals in the first round of the playoffs.

The successes of three 1941 Springfield players exceeded their team's accomplishments. Catcher John Dantonio, Donnelly, and Musial all reached the majors. Dantonio played two seasons as a war-time ball player for the Brooklyn Dodgers and Donnelly played in the majors with the St. Louis Cardinals and Philadelphia Phillies from 1944 to 1950. Donnelly's most memorable performance came in the 1944 World Series in relief for the Cardinals against the St. Louis Browns, ultimately preventing the Brownies from taking a two game series lead. And then there was Musial, who arrived in St. Louis at the end of that 1941 season, beginning a Hall of Fame career which lasted 23 years and during which he set many National League records. Musial easily was the greatest player to ever wear a Springfield uniform.

Remarkably, Springfield's 92 wins in 1941 tied the record in the city's history and set a record for winning percentage, at .681, as well. Still, attendance for the 1941 season barely exceeded that of 1940, and the Cardinals again suffered financially, despite the increased competitiveness of the club. Fans had, perhaps, expected a poor team, and simply tuned the Cardinals out. The effect of an escalating war took its toll as well, as blue-collar workers, who usually attended games, steadily poured out of Springfield in search of war production jobs in the West. Speculation surrounding the team after the season included talk of the team relocating. For whatever reason, Eckert's desperate plea somehow persuaded the Cardinals boss to allow a 1942 return to Springfield. Runt Marr, who spent the past few years as a St. Louis scout, managed the team. Things went no better for Marr in 1942 than they had 20 years earlier.

Eckert's celebrated his 20th and last season as the Springfield president in 1942. To most, the 54-year-old still seemed whole-heartedly committed to baseball; but after years of running a ball team and a cigar stand concurrently, the long days and meager break period in November and December began to wear on the still slender, but aging man. And people in Springfield seemed less interested in what Eckert had to offer. Only his rock-bottom priced promotional days attracted interest in the team. Baseball became secondary in the hearts and minds of many Springfieldians after the United States entered World War II. By the summer of 1942, headlines in the local press hughlighted the British chase of the Nazi tank commander Rommel across Africa, and American war casualties began to arrive at Springfield's newly constructed O'Reilly Hospital on Glenstone Street after the U.S. entered the campaign during the fall. On the Pacific front, American naval power battled Japanese fighters back and forth with little initial progress. At the same time, fast pitch softball gained popularity in Springfield during the early 1940s—threatening the national past time. Springfieldians' fascination with baseball's sister sport began in the mid-1930s under the leadership of former major leaguer Hershel Bennett. Bennett's introduction of the organized sport into the Queen City resulted in rapid gains in not only player participation but, more importantly, fan attendance. According to longtime local baseball player and fan William Moore, the phenomenon of allegiances shifting, to softball especially, caused attendance at White City Park to fall off. Others opinions leaned toward the idea that a stagnant Springfield economy led to the sudden and dramatic decline in attendance after the 1939 season.

When the W.A. returned to a split-season format for 1942, Springfield lost the structure that made possible its fourth and fifth league championships, in 1937 and 1939. The team, which once again lacked significant talent and lost players to the draft, finished third during the first half of the season. It sank to last place in the second half after Muskogee swept the Cardinals at White City Park in early August. Springfield fans, who lacked enthusiasm for baseball before the season, lost all hope. A late-season winning spurt propelled the team to fourth place, but no superstar players emerged. Still, 16-year-old back-up catcher, Joe Garagiola, whom Rickey hid from competing teams as the equipment boy on the 1941 Springfield Cardinals team, reached the majors after the war ended. Probably few Springfield fans were impressed, however, by his .254 batting average in 1942.

Player shortages during the war caused most minor leagues to shut down after the 1942 season. Eckert returned from the National Association meetings in Chicago on December 7, all but sure that the W.A. would not operate in 1943. A survey by the Springfield president of players from the 1942 roster revealed that all players expected to be drafted before the start of the season. Cardinals' owner Sam Breadon, perhaps realizing the great unlikelihood of the Western Association operating, promised to return the team to Springfield in the improbable event that the league continued. The official league meeting in February proved anti-climatic, as the Western Association shut down for the duration of the war.

Al Eckert and Joe Brown. For the 1936 season, Eckert (center) chose Joe Brown (right) as manager of the Springfield club. Brown's resume included a single game with the White Sox in 1927, when the right handed pitcher failed to record an out in his only big league start. By the time he arrived in Springfield, the Little Rock, Arkansas native played the outfield. He led the Cardinals to fourth place finishes in both halves of the season, down from what fans had come to expect, with an enormously disappointing 64-78 overall record. (Courtesy of History Museum for Springfield-Greene County.)

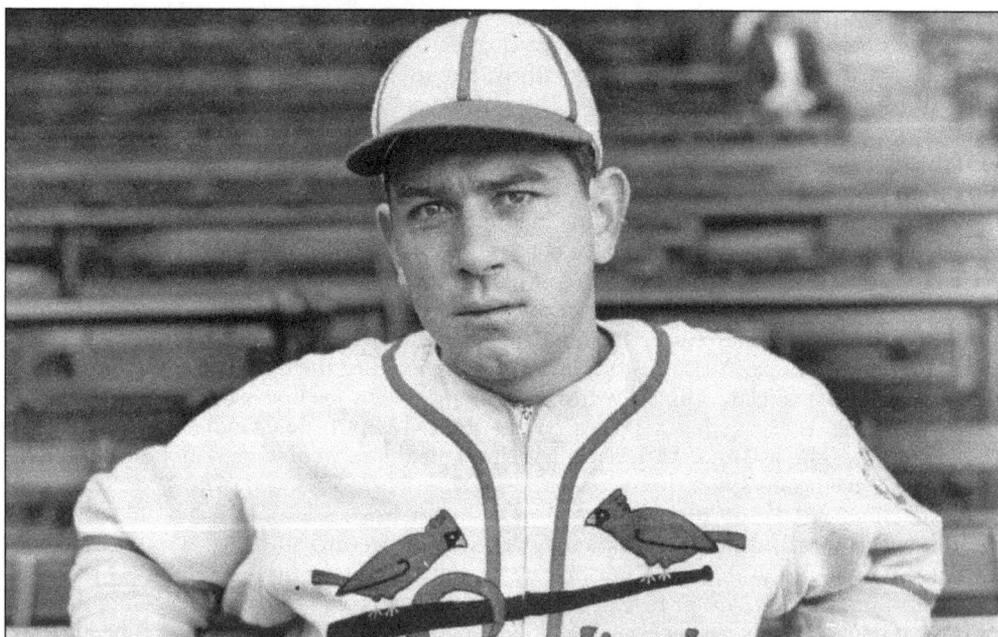

Mickey Owen. Two years after returning to Springfield as a rookie catcher, Mickey Owen entered spring training with the St. Louis Cardinals and made the team. Much press hype surrounded Owen after he led the American Association in hitting for part of the 1936 season. Still, Branch Rickey coveted the little scrapper primarily for his defense, which was fortunate when Owen hit poorly his rookie season. By 1938, Owen had emerged as the primary catcher, and retained the position until the Cardinals sold him to Brooklyn for $85,000 before the 1941 season. (Courtesy of Charlie Owen.)

Joe Kosel. One of the few players to return from a mediocre 1936 Springfield Cardinals team was Joe Kosel. Kosel hit and fielded well during his first season at short stop, but slumped badly at the plate (.242 BA) in 1937 when Clay Hopper moved him to third base.

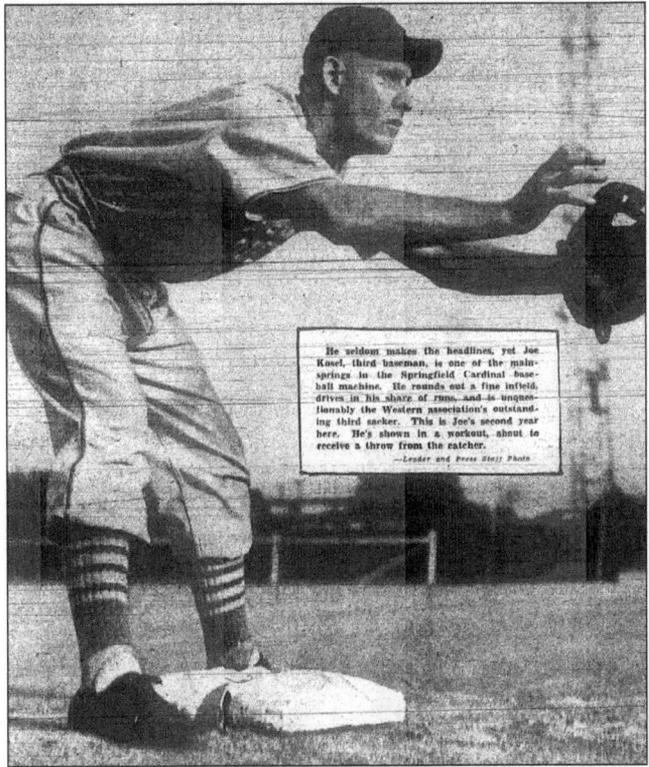

He seldom makes the headlines, yet Joe Kosel, third baseman, is one of the mainsprings in the Springfield Cardinal baseball machine. He rounds out a fine infield, drives in his share of runs, and is unquestionably the Western association's outstanding third sacker. This is Joe's second year here. He's shown in a workout, about to receive a throw from the catcher.
—*Leader and Press Staff Photo*

Ken Miller. The leader of Clay Hopper's playoff-winning Springfield Cardinals team of 1937 was Kenneth Miller, the speedy center fielder who gained league MVP honors that season after he led the league in stolen bases with 87—the second most in league history, behind Lyle Judy's 107 in 1935.

Joe Cusick. Joe Cusick came to Springfield to continue what turned out to be a fairly unremarkable minor league catching career. It was as a scout in the 1960s and '70s, that Cusick distinguished himself in professional baseball: first, with the Baltimore Orioles in the 1960s, when he signed eight-time Gold Glove winning short stop Mark Belanger; and then again in the mid-1970s, with the Detroit Tigers, for whom he signed that decade's biggest rookie pitching phenom, Mark "The Bird" Fidrych.

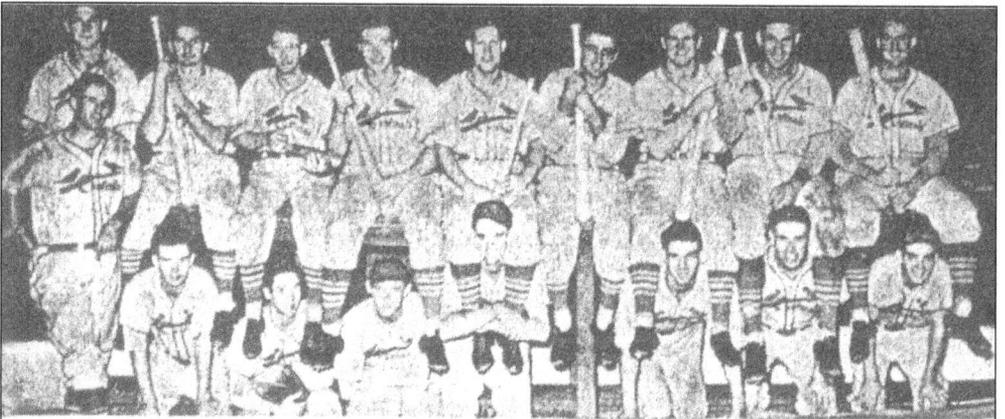

Front row—Ray Browne, Tom Perry, Alois Kamp, Lloyd Wallace, Max Marshall, Joe Cusick, Dick James(Mascot). Back row—Robert Hopper(Mgr.), Kenneth Miller, Frank Mabrey, Rolland VanSlate, Jerry Burmeister, Joe Kosel, Ado Severi, Alex Weldon, Adolph Arlitt, James Johnson.

SPRINGFIELD (MO.) CLUB—PLAY-OFF WINNERS.

1937 Springfield Cardinals. Taking advantage of the new four-team Shaughnessy playoff system, the 1937 Springfield Cardinals turned a fourth place finish in the league (76-67) into their fourth Western Association championship of the decade. Springfield defeated Hutchinson in the first round, and then beat Joplin for the title.

86

George Silvey. Branch Rickey considered Silvey one of the most intelligent men in the St. Louis organization when he appointed him the Springfield manager in 1939. Silvey led the Springfield Cardinals to their fifth and last Western Association championship when his third place team (78-60) cruised through the Shaughnessy play-off system, beating regular season champs, Fort Smith, in the first round, and Topeka in the finals. Though replaced midway through Springfield's miserable 1940 season, Silvey remained with the Cards for over 50 years as a field manager, assistant and head farm director, scout, and director of scouts.

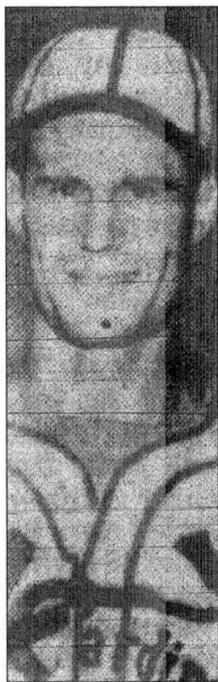

Archie Templeton, Joe Garagiola, and Bill Yarewick. Although the Springfield Cardinals' marquee figures in 1941 were three players soon headed for the major leagues, Branch Rickey secretly stashed away a 15-year-old catcher in Springfield that summer named Joe Garagiola. Rickey recognized Garagiola (center) as a top youth prospect and hid him as a club house attendant and bullpen catcher during the summer of '41. The next year the then-16-year-old returned to become Springfield's back-up catcher. In 1946, he began a nine-year major league career. (Courtesy of Springfield-Greene County History Museum.)

Al Eckert. Springfield president Al Eckert celebrated his 20th season as head of the club in 1942. Eckert's enthusiasm for the game had yet to fully wane, although the 51-year-old grew tired of the tough times that had again befallen his ball club. With the heartbreak of the 1941 season's finish still fresh, and World War II soon to shut down the Western Association, Eckert slowly became ambivalent about professional baseball; even to the point of total disinterest when the league reemerged after the war.

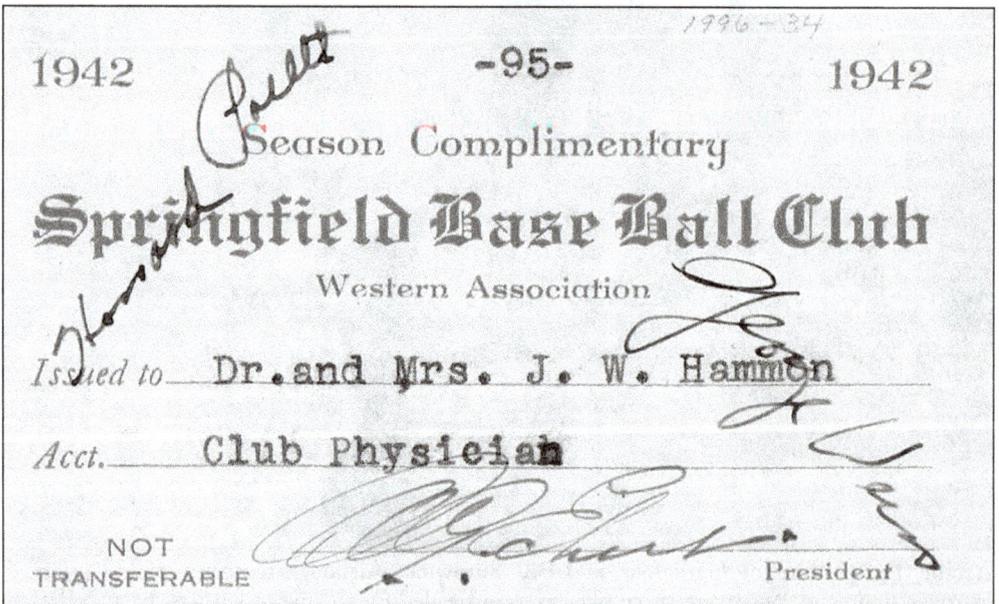

Season Pass. Complimentary season passes, like this one for club physician Dr. J.W. Hammon and his wife, were issued over the years to local sponsors and dignitaries for home games at White City Park. Noteworthy of this certificate from the franchise's last season was the use of old English lettering, a look that Springfield teams had featured on their uniforms and letterhead since just after the turn of the twentieth century.

Runt Marr. Clifton "Runt" Marr entered his second tour of duty in 1942 as a Springfield manager when he took over for the departed Ollie Vanek. Since being forced out as owner-manager at Joplin during the 1935 season, Marr had primarily scouted for the St. Louis Cardinals. Marr returned to a Springfield team without a hint of the talent the team had enjoyed the year before. The 1942 ball club combined for a 62-69 record, which ultimately was nearly identical to that of twenty years before.

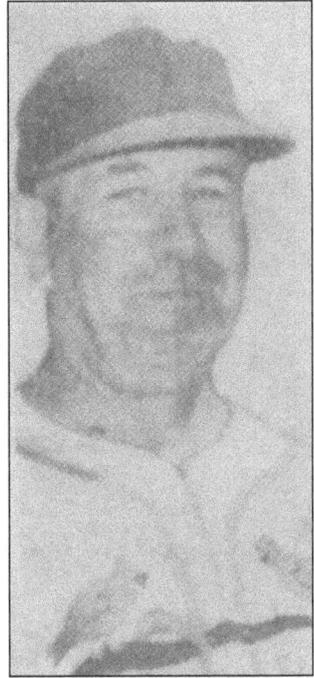

Duglas Duffy. Springfield Cardinals manager Runt Marr, a former Springfield Midgets third baseman, instructs Independence, Kansas native, Duglas Duffy, who converted to the position before the season. With World War II siphoning players away from the game, the 21-year-old rookie Duffy was one of the oldest players on a very young ball club.

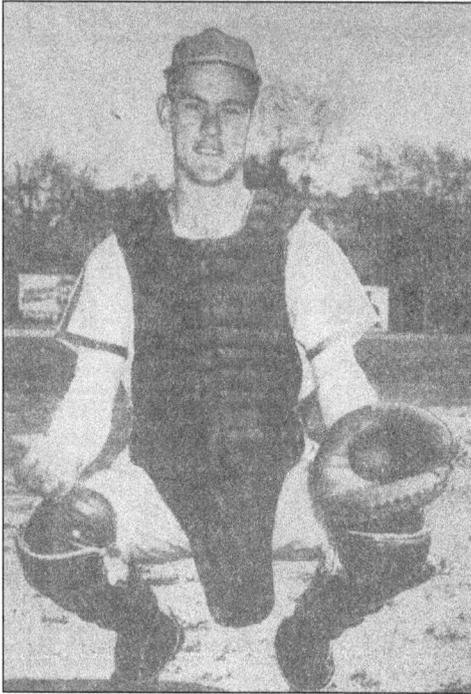

Frank Cunningham. As an 18-year-old rookie catcher—soon converted to pitcher—on the last Springfield Cardinals team of the twentieth century, Frank Cunningham, went 11-9 in 28 games during the 1942 season. The Providence, Rhode Island native's near .500 pitching record that season mirrored his ball club's performance.

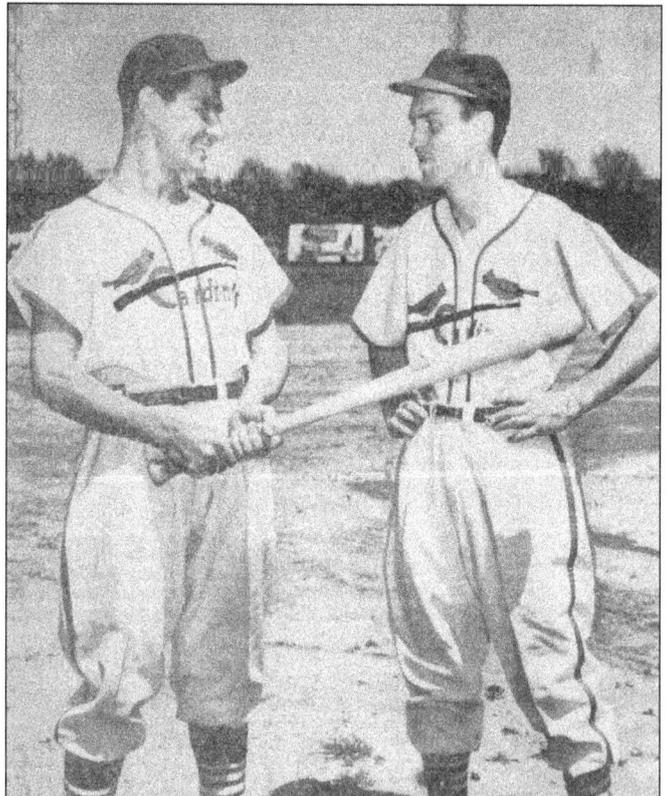

Unidentified Cardinal Players. This unknown pair of 1942 Springfield Cardinals helped make up a largely no-name group of young talent. With World War II already siphoning off the player pool, only the upper minor leagues received the remaining older, more experienced players. Springfield was relegated to a roster of mostly unproven 18-year-olds who produced ordinary results.

SEVEN

The Post-War Swoon

The war years brought a lull in baseball in Springfield. Adult baseball stopped on an organized level, and only Kiwanis little league and American Legion high school ball persisted. White City Park sat largely dormant, except for its occasional use by the Springfield High School baseball team during the spring, and by barnstorming teams such as the Kansas City Monarchs, who would play against a hastily thrown-together local team of former semi-pro and minor league players. As the war neared an end, it became obvious that Eckert had become ambivalent about the Springfield Cardinals' prospects. Still president of the franchise, Eckert recognized the unlikelihood of professional baseball's immediate return to Springfield. Eckert had lost his greatest ally when Rickey departed St. Louis for the Brooklyn Dodgers following the 1942 season. Breadon, who assumed primary operational control of all of his teams, was undoubtedly disillusioned by his last three money-losing years in Springfield. White City Park's suspicious and opportunely timed sale (for $25,000 less than the city's purchase price 16 years earlier) to the National Assemblies of God in December 1945 conveniently left Breadon with no suitable place to play when the Western Association reorganized for the 1946 season. Despite Eckert's lack of attendance at the league meeting, and subsequent comment to the press that, "it looks like we'll have to lay out of baseball next season," Springfield remained listed as a league member, raising the false hope that something would transpire. Joe Mathus, a former Springfield manager and current manager of operations for the St. Louis farm system, furthered the optimism by stating that the lack of a quality replacement for White City Park was all that was missing. In response, Louis Reps and the Chamber of Commerce offered to initiate a $150,000 bond issue to build a new park. In the meantime, the team could play at the Springfield High School Stadium, which, within a few years, would have White City's lights. Breadon rejected the offer, citing, in mid-December, insufficient time for construction. Breadon's intention to move his farm club regardless of field availability was futile. The White City property lay untouched for three years before the Assemblies of God constructed a publishing facility. Use of the field for one more season would have allowed the time necessary to build a new park, which might have kept the Cardinals in Springfield. In the end, Breadon bypassed Springfield and moved his franchise to the newer stadium in St. Joseph.

Following the war, minor league baseball experienced a boom greater than ever seen before. The minor leagues expanded throughout the country, rising from 31 leagues, when the Western Association folded in 1942, to 41, when it reemerged in 1946, and peaking at 59 leagues in 1949. Even towns such as Carthage, Missouri, returned to the minor league fold after the war. In 1947, the Springfield Memorial Baseball Association initiated construction of a ball field west of the city limits. The new field, to be called Memorial Stadium, required the sale of $100,000 in stock before ground-breaking could occur at the corner of West Street and Madison Avenue. By the summer, sales had reached only $7,000, a sum too far below the goal to allow completion of the stadium by the 1948 season. Several reasons, primarily the remote location of the field, caused the poor public response. Original plans had called for construction at the corner of Division Street and Glenstone Avenue, a more highly trafficked, and more accessible area, but neighbors rejected the prospect of having a ballpark near their homes. Few people became excited, however, over the prospect of driving out to the open field areas west of the city. Even the proclamation campaign by Springfield mayor Harry Carr declaring June 22–29 to be "Baseball Week" ultimately netted only around $20,000. The Memorial Baseball Association's board of directors cut back on the initial scope of the park and explored gaining major league backing for a prospective team. The most curious aspect of the campaign was the aloofness of Al Eckert, who seemed content with running his cigar stand and overseeing concession stands at indoor wrestling matches.

Something finally went right for the Memorial Baseball Association when the group convinced the Chicago Cubs of Springfield's potentional as a farm club. The Cubs had been slow to jump into the minor league fold before the war, and were desperately trying to catch up in the post-war years. Chicago had created its first directly-sponsored Western Association farm team in 1946 at Hutchinson, and the team had gone on to capture the championship that year. The team slipped badly the next year and drew the second worse gate in the league, causing the Cubs to consider transferring to another city. During the spring of 1948, Chicago loaned Springfield the $25,000 needed to finish construction of Memorial Stadium, hoping to cash in on the Cardinals former success in the city. With lease agreements pending, Chicago maintained their Western Association franchise in Hutchinson for the 1948 season, while construction on the Springfield park began. In mid-July, with the Hutchinson team again playing poorly and drawing even worse at the gate, a wind storm blew down the grandstands, forcing the Cubs to move their team to the uncompleted field in Springfield for the remainder of the season. Results in Springfield proved little better than in Hutchinson, and the team, under manager Frank Piet, finished in last place. Fan response to a team with an overall 43-87 record was thin during the remaining month and a half of the 1948 season. Still, the Cubs remained optimistic about the prospect of an established farm team in Springfield.

The Cubs fought hard with two other league members to keep their franchise in Springfield, and even appealed to National Association president George Trautman, but Hutchinson retained rights to a spot in the league in 1949. After sitting out a year, the Cubs won the right to place a franchise wherever they wanted. The 1950 Springfield Cubs became the first professional team to begin a season in the city in eight years. The Springfield Cubs played remarkably well under manager Bob Peterson, although few in Springfield seemed to notice. Because of the overpowering smell of the city sewage treatment plant on Bennett Street, a few blocks south of the new stadium, many fans who attended a game once never went back. First baseman and Springfield native Bob Speake also remembers general apathy amongst both club officials and the press. The local press failed to take the team as seriously as it had the Midgets and the Cardinals, and officials of the Memorial Baseball Association still had not raised the funds necessary to finish the park. The Cubs demonstrated the same tight-spending approach that had characterized the Browns before them, and wavered on completing the ball park that Speake called "the worst in the league." Memorial Stadium, with mostly open-air bleachers, poor lighting, and unpaved parking lot and walkways, reminded no one of grand old White City Park's vast covered chair-back seating.

92

The league played using the Shaughnessy system in 1950 under new president Howard Goetz, with Springfield finishing a strong third in a Western Association dominated by Joplin and their hard-hitting shortstop Mickey Mantle. Mantle led the league in nearly every offensive category, and the Miners coasted to the regular season championship. Behind two future major leaguers—Speake and pitcher Don Elston (a third player, 17-year-old catcher Harry Chiti, left Springfield by mid-season and finished the season in Chicago)—Springfield shocked the Miners in the opening round of the playoffs, three games to one, but lost the championship series to Hutchinson's "well-oiled machine" of veteran players, four games to none.

However, not even the on-the-field success of the team got the cost-conscious Cubbies to overlook the fact that Springfield drew a measly 34, 860 regular season fans. The last-place total accounted for less than one third of the fan total of league-leader Topeka, who finished 33 and a half games out of first place but drew 106,250 people. The Cubs pondered the future of their farm club in Springfield during the fall, taking into account the generally rainy weather throughout most of the summer, which contributed to the horrible attendance. While falling attendance would become widespread for most of the minor leagues within just two years, the Cubs saw a special problem in Springfield. In October, John Sheehan, the Cubs director of farm operations and the Springfield president, officially pulled the franchise out of Springfield, citing, among other things, the amazing statistic that fast pitch softball outdrew baseball nearly two to one. Nearly 70,000 people paid to watch softball in the city, compared to the 38,399 amassed for baseball's regular season and playoffs. The smell from the neighboring treatment plant, which remained until the 1960s, undeniably hurt attendance. Even three teams in the neighboring Class D Kansas-Oklahoma-Missouri (K-O-M) League managed to outdraw Springfield. Springfield business manager Ed Boyle had budgeted for the season based on 60,000 fans, but the team never had much hope of reaching that level.

Supporters of professional baseball in Springfield continued to wrangle furiously to keep the city a part of the minor leagues. The 1950 attendance, while very poor for Class C ball, was adequate for the less expensive Class D circuits. The Memorial Baseball Association began negotiations with the K-O-M League to enter in 1951, while they continued to discuss repayment of the Chicago Cubs' loan for the ball park. Under the terms of the original agreement, repayment was set at $500 per year, which proved to be too slow for the Cubs. Consequently, the National League club tried to acquire repayment more quickly by persuading another major league club to move into Springfield and to assume the remaining $21,500 debt. In the end, the Cubs absorbed the debt when they sold their share of the property to Springfield grocer L.D. Heinlein at a fraction of the money owed them. The plans to enter the K-O-M League crashed when the league announced that it would operate as either a six or eight team circuit—Springfield remained the seventh team. Neither Chanute nor Independence pulled together teams as they had the year before, and after a last-ditch attempt by Coffeyville failed, Springfield lost its final chance to field a team.

After 1951 the Memorial Baseball Association disbanded. The Memorial Baseball Stadium remained standing (used occasionally for semi-pro games) until the late 1950s when it was razed for future development of a subdivision. After 35 up-and-down seasons of professional baseball brought great future major league players and mangers to Springfield, the 1950 season was the last of the twentieth century. Few Springfield fans connected with the game as they had during the early 1930s, and, when not distracted by an emerging entertainment medium—television— they continued to focus their attention on softball and the budding basketball program at Southwest Missouri State College.

1945 White City Park. Reinforced by a long-standing story, retold in 1995 by Ralph Harris, about five teenage boys who had claimed the property for God in 1915, the Assemblies of God selected the vacant White City Park property as the future location for their publishing plant. Springfield Public Schools discarded the White City Park land in 1945, for $25,000 less than its $60,000 purchase price. Former players, such as Herschel Bennett, publicly objected, but to no avail. Months before the finalized land purchase, the Assemblies of God solicited this architectural survey of the land, showing the ballpark largely as it had stood since 1924. (Courtesy of Springfield-Greene County Library.)

1948 Memorial Stadium. Early in 1948, the Chicago Cubs loaned the Springfield Memorial Baseball Association $25,000 to help finance a new ballpark project that the group had begun in 1947. After a wind storm badly destroyed the grandstand of the Cubs' Western Association farm team in Hutchinson, Kansas, the organization transferred to Springfield in mid-July. The yet-incomplete stadium was barely playable and had only small steel bleachers on each side of the foul line, seating only about 1,300 people, which, when combined with the team's season-long last place standing, produced poor crowds.

Springfield City Map. This 1951 city map of Springfield shows the location of Memorial Stadium (*aka* Park), which sat on the far west side of town, at the corner of Madison Avenue and West Street. To the south, on Bennett Street, is the infamous water treatment plant. Because of booming property values, residential development, and lack of a professional ball team, the field lasted less than a decade. (Courtesy of Springfield-Greene County Library.)

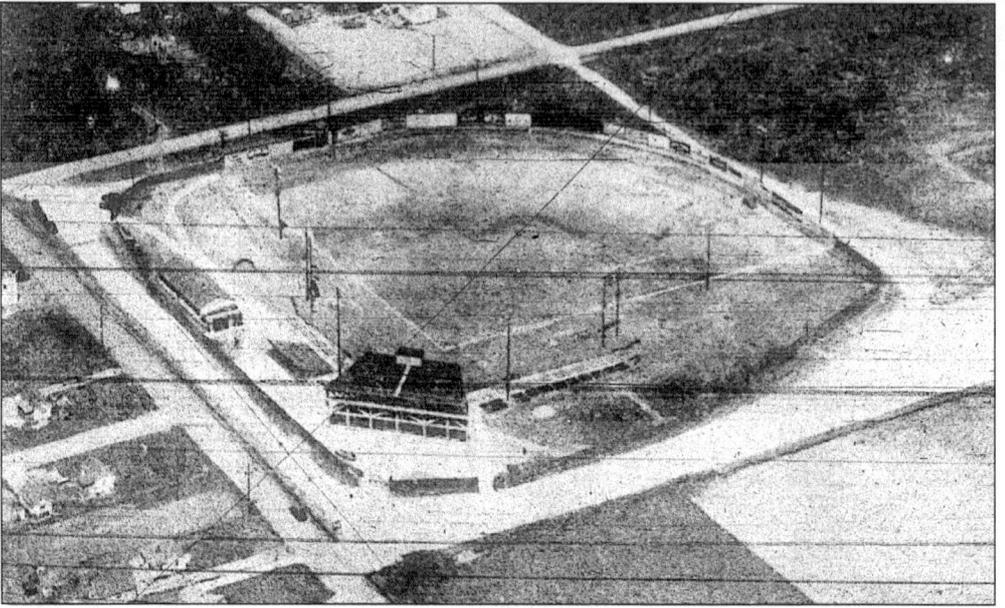

1950 Memorial Stadium. Springfield Memorial Baseball Association directors used the teamless 1949 season to round out improvements to Memorial Stadium. In addition to building a club house down the left field line, a small wooden grand stand was constructed behind the home plate area, better lighting was installed, and walkways, drives, and the parking area received fresh white gravel.

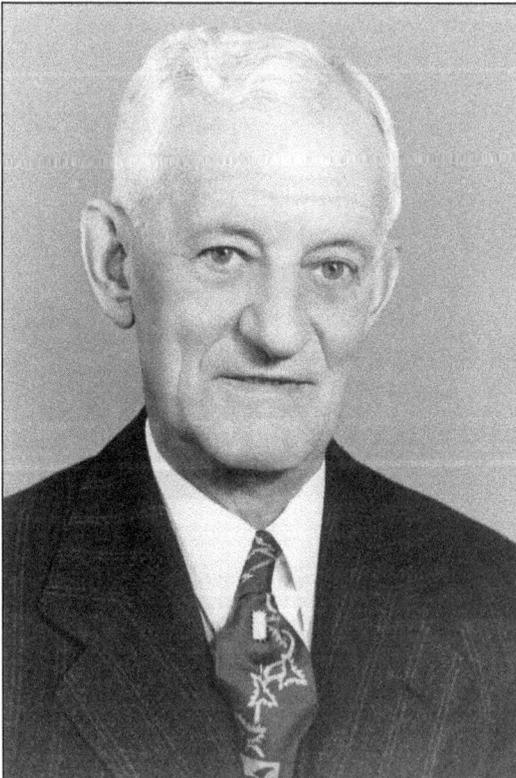

Al Eckert. Even though he no longer held a serious interest in professional baseball in Springfield, Al Eckert lent his help one last time to the 1950 effort. During the 1950 season of the Springfield Cubs, Eckert once again made games tickets available at his cigar stand in the Woodruff building. After 1950, Eckert lived out the rest of his life Springfield, continuing to run concession stands at sporting events; he died at the age of 90 in 1978.

Bob Peterson. Peterson became manager of the Chicago Cubs permanent Springfield farm club in the Western Association. Peterson, a right handed pitcher, appeared in 14 games on the mound—mostly in relief—during the 1950 season and posted a 4-3 record, primarily working to improve the pitching staff.

Glenn Barclay. Springfield native Glenn Barclay never pitched in a game for his home town team before the club optioned him to Chicago's Janesville club in the Class D Wisconsin State League. Barclay's professional career lasted the same length as the Cubs farm team in Springfield, only one year.

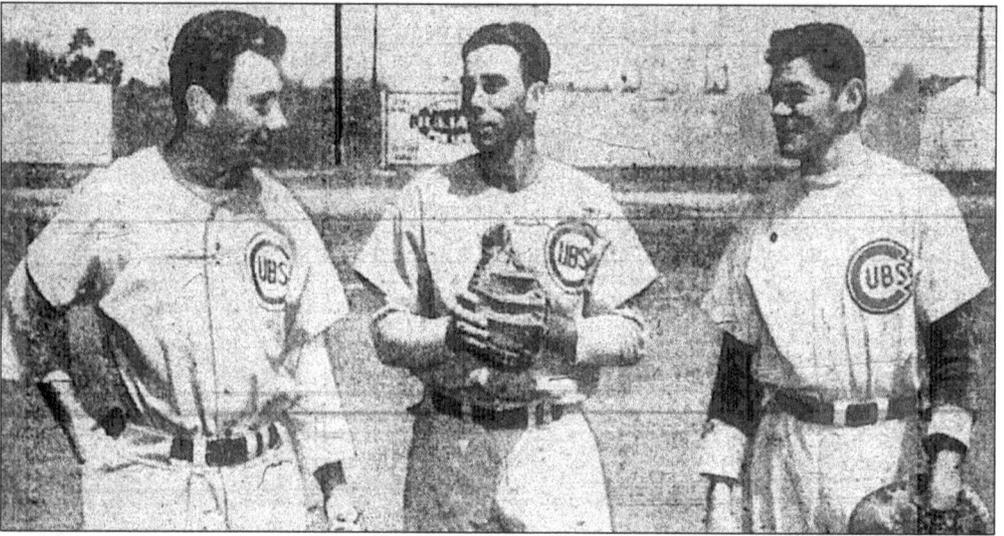

Fanning, Dant, Batchelor. Three men began 1950 vying as catchers for the Springfield Cubs. Fanning (left) quickly disappeared, but the plot thickened later, when outstanding 17-year-old Harry Chiti appeared. Bob Dant (center), a Jansville call up, and Russ Batchelor (right), on option from Class A Des Moines, began the season sharing duties, before Chiti stole the show with his .317 batting average, with four home runs and 37 RBIs in 50 games by mid-season. Things leveled out when the teenager earned a minor league promotion, and, finally, a brief September call-up to the parent club.

Cubs Pitchers. Pictured left to right, Jim Benes, Don Vike, Leonard McClure, Don Tepe, and Woody Wuethrich, were all projected as starting pitchers on the 1950 staff. Only Benes and Vike made it, each appearing in over 30 games. Another pitcher in camp, Don Elston, earned a spot in the rotation, appearing in a team high of 34 games, with a 14-12 record, and 166 strike-outs, while hitting a respectable-for-a-pitcher .288 in 80 at-bats. Three years later Elston made it to the big leagues, and by the late 1950s emerged as one of the National Leagues best relievers.

Jack Rutledge. The starting second baseman for the 1950 Springfield Cubs, Jack Rutledge, led the league in turning double plays but also committed the second most errors. The 22-year-old Alabaman's batting remained in line with the overall poor numbers of his Springfield team, languishing at .233, while racking up 114 strikeouts, second most in the league.

Johnny Freund. Johnny Freund played every infield position but first base during the 1950 season but spent the majority of his time at shortstop. Overall, he hit .253 in 110 games.

Pete Koblosh. Pete Koblosh, a Notre Dame graduate from Yonkers, New York, played 91 of his 101 games at third base and filled a problem position for manager Bob Peterson with his solid defense. Koblosh also started off the season hot at the plate, hitting over .300 before his batting average cooled off. He finished the season at .251.

Fast Pitch Fever. Perhaps the ultimate downfall of professional baseball in Springfield (at least in the post-WW II period) was fast pitch softball. The Chicago Cubs couldn't ignore an obvious attendance disparity, noting that in a rain-saturated summer, the new craze of fast pitch softball still outdrew the 1950 Springfield Cubs two to one. Nightly, fans packed into Fassnight Park to watch softball, while baseball suffered in a literal haze, brought on by the nearby water treatment plant. (Courtesy of Bus Harless.)

EIGHT

The Semi-Pro Boom

When professional baseball failed to reemerge in Springfield following the war, semi-pro baseball benefited greatly. This semi-pro expansion, while tied to the aforementioned circumstances impeding professional baseball's return to Springfield, more acutely traced its progress back to events of the nineteenth century. Semi-pro baseball's cycles of viability in Springfield began with the Reds of the mid-1880s, and returned when that same team successfully reemerged as a city favorite at the turn of the twentieth century. The overall success of the 1901 Springfield Reds contributed directly to Springfield rejoining a professional league in 1902. That transition apparently impeded further semi-pro growth, until professional baseball's temporary disappearance in the early 1910s.

During the mid to late-1910s, semi-pro baseball's popularity returned once more and drew good-sized crowds for Sunday games at Doling Park. Talented local semi-pro players from this period emerged, just as they had in 1902, to help fill the roster of Springfield's Western Association entry in 1920. The promise of moving up from the semi-pro level to the Springfield pro team, or any other regional minor league club, fueled increased semi-pro participation into the 1920s. By the mid-1920s, the dual availability of the Doling and White City Park diamonds, combined with the enhanced travel options provided by larger, more dependable automobiles, precipitated the birth of the semi-pro Springfield Merchants. The Merchants, taking the same name as the 1920 Springfield professional team (and perhaps using their old uniforms), pulled together, for the first time in decades, a well funded and competitive traveling team, which played all over the Midwest, and even down into Texas and northern Mexico.

By the early 1930s, the tightening financial situation failed to completely stem the tide of area semi-pro teams; although decreased financial support restricted their scope and range to a more limited locale. Once economic conditions stabilized late in the decade, sponsorship money began to flow again. The improved financial situation, combined with the initiation by Branch Rickey during the mid-1930s of a Kiwanis Club-sponsored little league program (the first such organized little league program in the city's history), furthered local connections to the game. The combination of all these factors produced a larger crop of fundamentally sound

ball players, which resulted in a nearly two decade-long era of remarkably competitive and well-organized semi-pro play.

The Springfield Semi-Pro Baseball League (SSBL) organized in 1938 and crowned yearly champions until WW II caused a smothering player shortage. During its approximately five year run, the SSBL produced many talented players from all over southwest Missouri. Some, like pitcher Ken Gables of the 1941 league champion Springfield Peppers, emerged as wartime players in the major leagues. Others either returned to join the rapidly expanding minor leagues or rejoined the semi-pro ranks. Those who returned to play semi-pro ball in 1946 found a flurry of activity. No less than five teams in Springfield, and nearly every small town around southwest Missouri, fielded a team. A Springfield-based semi-pro league returned under the control of park board director, Jim Ewing, and initially included two of the Springfield teams plus three town teams around the city.

The Patton Creamery-sponsored team, owned by John Thompson, emerged as the dominant team as baseball returned in 1946. With no professional game in Springfield to lure away fans, numerous local residents made the semi-pro games their main Sunday afternoon recreation. As many as 500 to 1,200 fans sometimes attended games, with typically the top figures coming when the better known Springfield teams ventured to towns in southwest Missouri and northern Arkansas. In addition, during that "pivotal" summer of 1946, an American Legion team called the Springfield Generals, sponsored by tire distributorship owner, C.E. Russell, entered the semi-pro league in mid-season. The Generals, in spite of featuring teenagers, challenged for the league's second half title, losing out only to the eventual league champion Creamers, who finished fifth at the state tournament and amassed a 22-14 record. The following year, the Generals dominated league and area play most of the season after naming catcher Mickey Owen as player-manager. Owen, whose short lived jump to the "outlaw" Mexican League the previous summer had earned a five year suspension from organized baseball, instantly elevated the Generals to the top team in the Springfield area. However, the team experienced problems entering various semi-pro tournaments as a result of the backing organizations honoring Owen's suspension. After Owen moved on following the 1947 season, the Creamers again dominated the Generals until 1951.

A third quality Springfield semi-pro team simultaneously emerged to challenge for city bragging rights. The Springfield Stars, an all-black team led by Carl Thompson, began play in 1946, and played surprisingly well in spite of dealing with Springfield segregation as well as an initial lack of funding. The Stars racked up a 21-7 record that first season (tying the Creamers for most area wins on the season), and then gained a quality sponsor the next year in Carl Harlow and his "Hyde Park" beer distributorship. Overall, the Hyde Park Stars, as they were sometimes called, won an estimated 85 percent of their nearly 200 games from 1946 to 1951.

The enthusiasm over semi-pro baseball in Springfield continued growing throughout the remainder of the 1940s. In 1948, sponsors John Thompson and Ray Mang constructed a lighted, dirt infield ballpark, with 800 covered seats, just southeast of the corner of Glenstone Avenue (Hwy. 65) and Sunshine Street. The new field, designated for semi-pro play, but used occasionally by others, took the name Thompson-Mang Park. However, because of its location, people knew it better as Sunshine Park. Thus, when a new semi-pro league began play at the new park that summer, it became known as the Sunshine League. Thompson's Creamers again dominated local play and captured the league title after coming from behind to beat the Springfield Stars in a 1948 championship game played at Memorial Stadium. It was the Stars first season playing in a city league, and their only trip to the league championship game— primarily because segregation prevented them from entering earlier.

Thompson's Creamers continued to dominate the Sunshine League throughout the 1950 season, only missing out on five straight league crowns when they lost to former minor leaguer Joe Sumner's Red Birds team in the 1949 title game. While John Thompson outspent all other sponsors during this time (an average of $2,500 per season, with a $3,000 limit—not including upkeep on the ballpark), Generals sponsor, C.E Russell, never fell very far behind when he

fielded a team. By 1951, Thompson's eleven years sponsoring the ball club had netted four trips to the state tournament but no National Baseball Congress Semi-pro National Championship bids, the reward for winning state. Russell, diverging from Thompson, entered the 1950s with no pre-set spending limit in his quest for a national tournament bid. With Thompson gone, Russell formed a team that completely dominated the Springfield baseball scene for the next three years.

The Springfield Generals of 1951–54 dominated local semi-pro ball like no other team before. With a loaded-up lineup of almost entirely former minor leaguers, the Generals consistently defeated their only real competitor, Webster's Oil, who had replaced the Hyde Park Stars as Springfield's only all-black team following the departure of Carl Thompson. In 1953, the Generals finally broke through, winning the Missouri State Tournament, and thus became the first team from Springfield to accomplish the feat in the 18 years of the tournament. The Generals then won three games at the 1953 NBC Semi-Pro National Championship Tournament and finished in seventh place. The 1953 outcome furthered Russell's thirst for the national championship he felt was achievable with better pitching. The perceived problem of 1953 was corrected in 1954, via Russell's deep pockets, and the team made a run at greatness.

The Generals won the Springfield League and Missouri State Tournament again in 1954, cruising through with similar pitching as the year before. However, when the August national tournament approached, Russell began to maneuver. Adding five players from the 1953 national champion Fort Leonard Wood Hilltoppers (outfielder/ first baseman Whitey Herzog, shortstop Jerry Lumpe, outfielder Vince Magi, and pitchers Ed Stabb and Bill Black) to the 1954 line up, the team became almost unstoppable. Three of the five men who joined the Generals were destined to play in the major leagues. Herzog ultimately made the biggest name for himself, as manager of the Kansas City Royals and St. Louis Cardinals, but it was Black's contribution that made the biggest difference in the Generals improvement over 1953.

Bill "Bud" Black pitched every other game of the tournament, rotating with Ed Stabb and Phil Kemp, to total six straight wins. Black pitched win number six, as they beat the perennial powerhouse Wichita Boeing Bombers to reach the championship game. Then, the wheels fell off. Russell had been paying to fly three of the enlisted players back and forth from the all-army baseball tournament in Colorado Springs, Colorado. The trio even changed uniforms in the plane and played two games in one day at least once. Unfortunately, an army officer read about their exploits in the newspaper, and ordered them to stop. Missing half of the team's offense and the best pitcher, the Generals played the Boeing Bombers again and just barely lost with Stabb on the mound. The final game of the double elimination tournament became a rout; Wichita blew out the demoralized Generals. Russell's expenditures for 1954 far exceeded previous totals, and as a result both his wife and his business partner insisted that the 1954 season be the last.

For the remainder of the 1950s, semi-pro baseball remained a lightly organized and dying activity in Springfield. Just as with minor league baseball, the advent of television took away the spectators that made semi-pro ball work. The further diversification of sports in America, with softball, football, and soccer, in particular, gaining popularity, made baseball less and less America's game. By the 1960s, semi-pro baseball as it once was known all but disappeared from Springfield, destined to follow a nation wide trend, with most original traces vanished by the 1970s.

1915 General Electric Team. In the years during which professional baseball departed from the Springfield scene, semi-pro ball made a comeback, starting in the mid-1910s. General Electric

1925 Springfield Merchants. Perhaps the first serious traveling semi-pro team since the 1880s Springfield Reds, the Springfield Merchants featured a group of local ball players who trekked all over the Midwest playing competitively. The group, featuring Springfield-area residents Bill Moore, Diz Kirkpatrick, and Spike Littleton even made one trip to Texas and northern Mexico, riding in two seven-passenger Studebaker touring cars. (Courtesy of *Springfield Magazine*.)

104

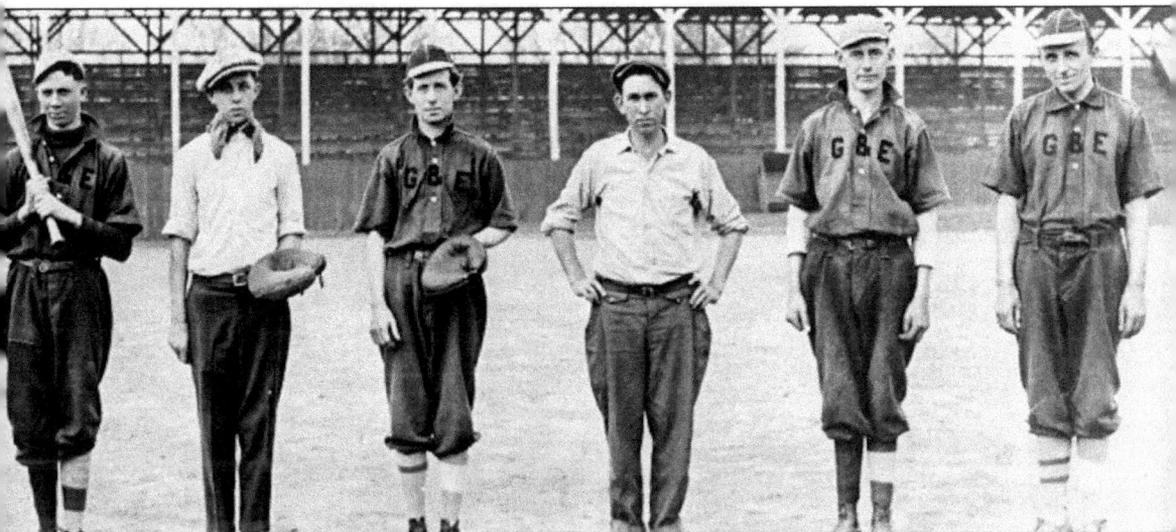

fielded one such team, which played alongside numerous teams from the Frisco railyards to Sunday afternoon crowds at Doling Park. (Courtesy of History Museum for Springfield-Greene County.

1927 Kiwanis Adult Team. Before the Kiwanis organization ran little league in the city, the group fielded a men's baseball team. Although their play was far less reaching than some other clubs, the Kiwanis epitomized the handful of fine local semi-pro teams that sprang up during the 1920s. (Courtesy of History Museum for Springfield-Greene County.)

Early 1930s Springfield Semi-Pro Team. A great example of a rag-tag group of all-ages guys playing semi-pro baseball during the early 1930s, this group, featuring veteran local semi-pro second baseman, Edgar Tuckley, demonstrates why the game appealed so widely to males during the cash-strapped 1930s. Semi-pro ball allowed many working class men to continue their childhood love on their Sunday off.

1936 Bridges Grocery Team. Led by 17-year-old, future St. Louis Browns' left hander, Clarence "Hooks" Iott (top row, third from left), this poorly clad group of teenagers won the city's first teen Kiwanis championship in 1936. Iott's pitching and switch hitting, combined with Charley Talley's (bottom row, third from right), and Harold Barclay's (top row, third from right) play carried the team in its weekly games. In 1939, Iott entered the minor leagues, briefly appeared in the majors in 1941 and 1947, and over 20 professional seasons compiled 2,561 strikeouts in 2,875 innings. (Courtesy of Harold Barclay.)

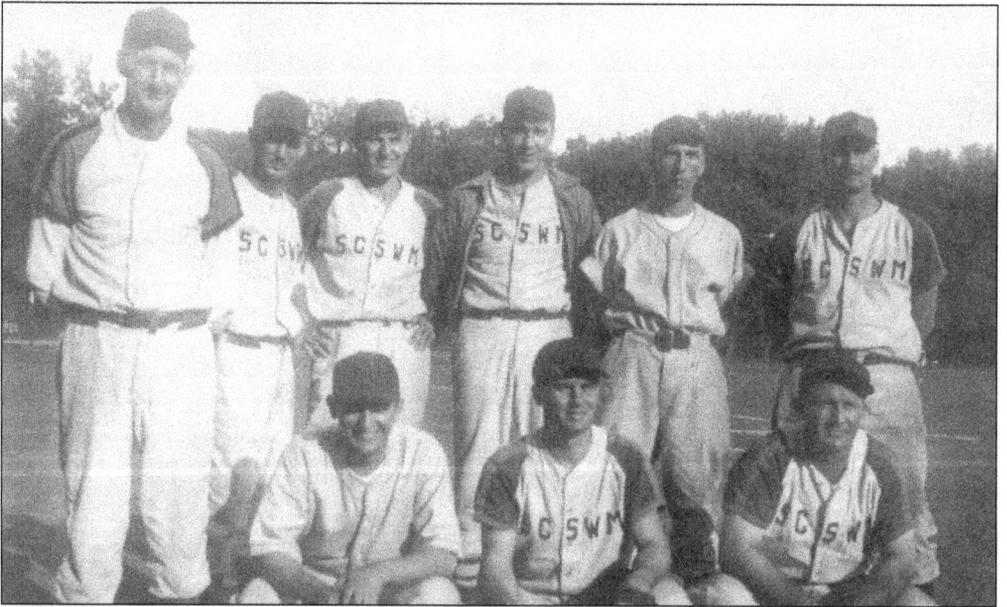

1939 SCSWM Team. Even though measurable growth of semi-pro ball came after the war, the SCSWM (abbreviation unknown) team of 1939 became, perhaps, the first of the many Springfield teams during the semi-pro game's 15-year heyday. Several of the team's players, including tall lanky right handed pitcher, Duff McCoy (top row, third from left), played in an exhibition game that summer at White City Park against Satchel Paige and the Kansas City Monarchs. Predictably the local nine were no match for Paige, and fell easily to defeat. (Courtesy of Duff McCoy.)

1941 Springfield Peppers. The 1941 Springfield Peppers emerged as the dominant semi-pro team of the pre-war era. Featuring a formidable line-up that included future Pittsburg Pirates pitcher Ken Gables (top row, third from left), player-manager Duff McCoy (top row, second from right), former minor league third baseman Denny Melton (bottom row, second from left), and 16-year-old future professional shortstop Bus Harless (bottom row, third from left), the Peppers won the city championship. (Courtesy of Duff McCoy.)

1945 Springfield Generals. Springfield tire distributorship owner, C.E. Russell, began sponsorship of the Springfield Generals American Legion team in 1945, in large part because of the lack of organized baseball in the area during World War II. Russell, always known for eccentricity, and addicted to various sports (most notably boxing), paid for the team to travel all over the Ozarks to play ball, but also always expected a winner. (Courtesy of Al Billingsley.)

1946 Springfield Stars. The Springfield Stars began play in 1946 and became Springfield's most successful all-black semi-pro team ever. After being released from O'Rielly Hospital in 1945, Carl Thompson started the team by organizing a rag-tag group of talented players he observed playing down the street from his work place. The team, pictured from left to right, included as follows: (bottom row) Edwin Looney, Paul Warren, Herman "Doc" Horn Jr., Pete Patterson, Clarence "Sunny" Reed, Howard Duncan Jr., and Louis "Shag" Looney; (top row) Carl Thompson, Robert Spencer, Milt Skillins, Clarence Looney, Wentworth "Bud" Starks, Walt "Junior" Thompson, Johnny Starks, Carlston Looney, Udell "Mickey" Looney, and Benton Abbott (umpire). The group, many of whom were experienced semi-pro players from the late 1930s, practiced at Springfield's only black city park, Silver Springs, and produced a formidable line-up. Without the luxury of a sponsor, like those supporting some of the better white teams in Springfield, Thompson made do that first season with a scantly uniformed team that impressively won most of their games. (Courtesy of History Museum for Springfield-Greene County.)

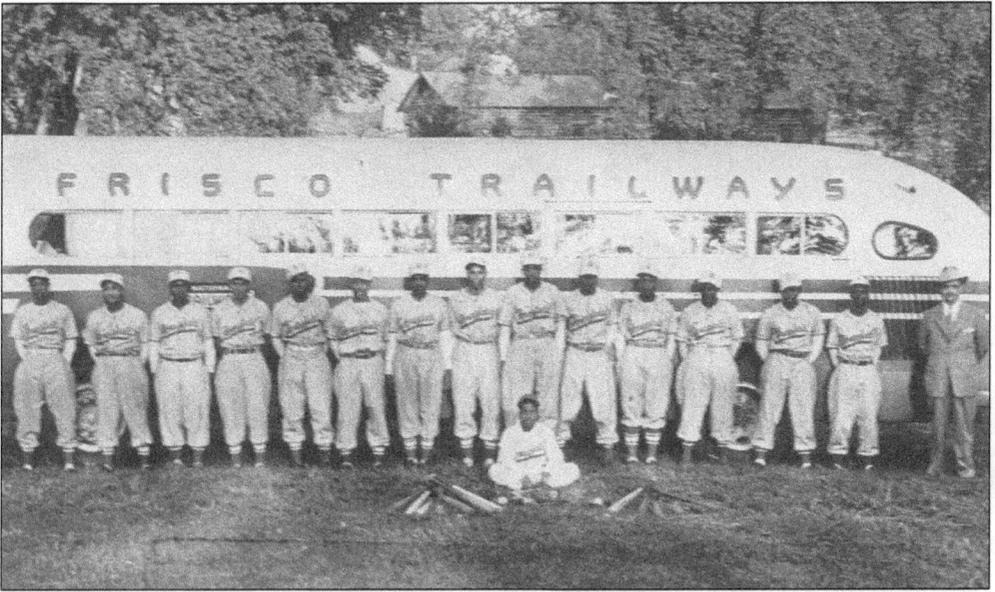

1947 Springfield Stars. By 1947, the Springfield Stars were one of the best teams in a Springfield area booming with good, competitive semi-pro baseball. Despite the constant strain of scheduling limitations imposed by Springfield's segregation standard, the Stars prospered behind the leadership of Thompson and the sponsorship of beer distributorship owner Carl Harlow. (Courtesy of Katherine Lederer.)

1948 Thompson-Mang Park. With semi-pro baseball reaching an extraordinary level of popularity in terms of players and teams, local team sponsors John Thompson and Ray Mang collaborated in 1948 on construction of an 800-seat semi-pro diamond near the southeast corner of Glenstone Avenue and Sunshine Street. The ballpark sat right behind the newly constructed Plaza Shopping Center and became widely know as Sunshine Park, even though its official name was Thompson-Mang Park. (Courtesy of Hank Billings/*Springfield News-Leader*.)

1948 Springfield Creamers. Springfield creamery owner John Thompson caught the semi-pro fever in 1946, after his club battled to the city league championship and competed in the state tournament. In 1947, the Patton Creamers weathered a tough challenge by the Springfield Generals to capture the city crown, but failed to beat out their city rivals in a district tournament held at Mang Park in Branson, Missouri. The Generals went to the state tournament in Sedalia, making it the only season from 1946 to 1950 in which the Creamers did not represent Springfield at state. By 1948, the Creamers reached their peak, led by core players Charley Talley (third from left), Joe and Fred Gott (middle two), Jack Hamlin (fourth from right), Max McCandless (third from right), and Bus Harless (second from right). They won 30 games that season en route to capturing their third straight city championship, and finishing third at the state tournament.

1948 Springfield Stars. Overall, the team won an estimated 85 percent of its 200 games played over six years. In 1948, the Stars competed in the city's semi-pro league for the first time and lost the championship game to the Springfield (Patton) Creamers. (Courtesy of Katherine Lederer.)

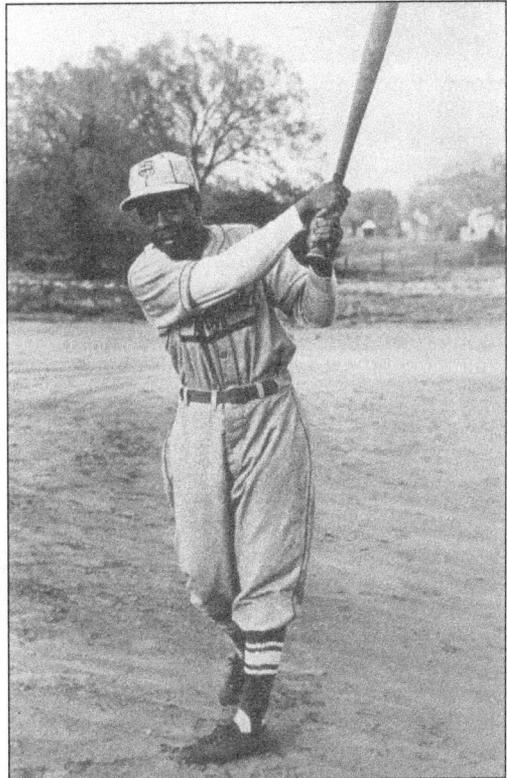

Carlston Looney. Just one of five athletic and gifted Looney brothers to play for the Stars, and for several other black semi-pro teams over a nearly 15-year span, Carlston Looney started in left field for the Stars. With his short, husky frame, he usually hit for power, batted in the middle of the lineup, and remained with the team the entire time they were together. (Courtesy of Katherine Lederer.)

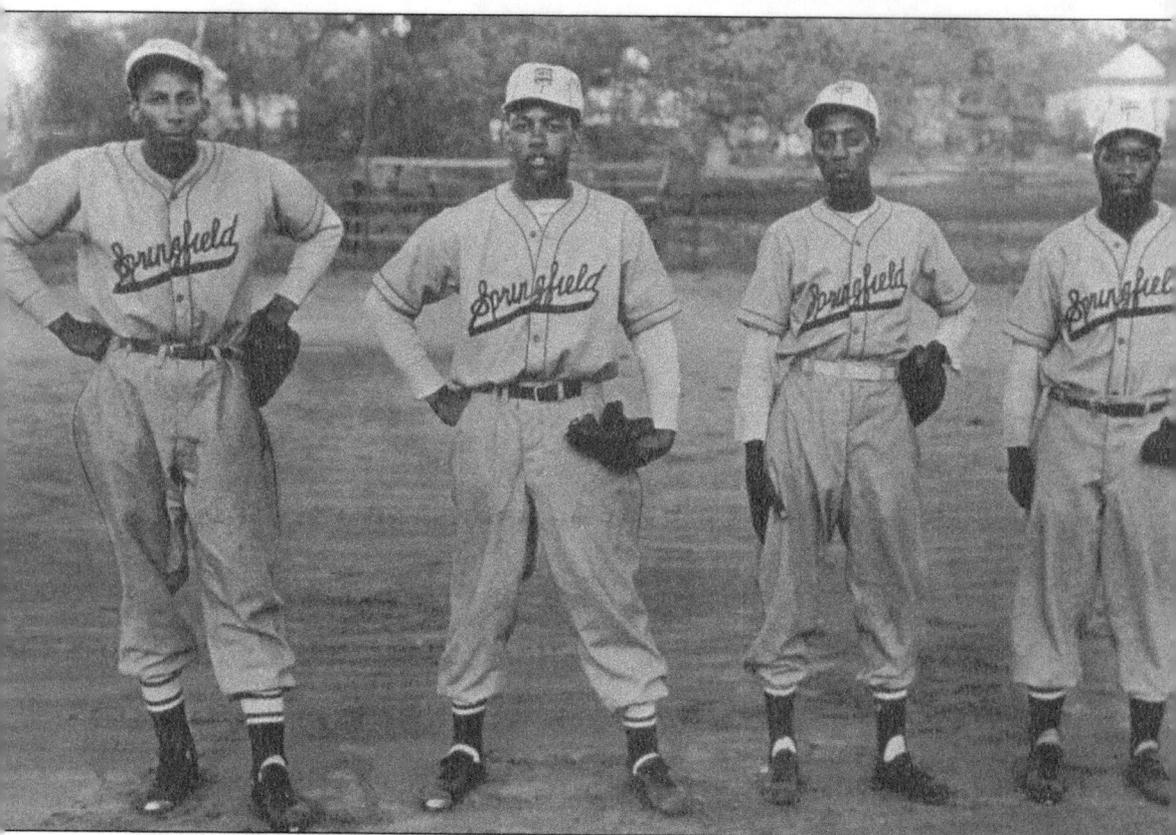

Horn, Patterson, Warren, and E. Looney. These four staple players for the Stars each contributed to the team's vast success in the mid- to late 1940s. Herman "Doc" Horn (far left) primarily pitched for the Stars but became one of only two Stars players (and by far the most successful) to make the transition to professional baseball, when he signed as an outfielder with the Kansas City Monarchs of the Negro American League in 1949. The left handed hitter played five seasons for the Negro Leagues' most storied team, batting as high as .349, and once hit four homeruns in a game, before a brief stint with Monterey of the Mexican League in 1953. Horn returned for one last season with the Monarchs in 1954 before retiring from professional baseball. Pete Patterson (second from left) began playing for the team as a 16-year-old in 1946. The right handed pitcher threw exceptionally hard but never developed a breaking ball and, therefore, survived with only a fastball. As a result, Patterson was used by Stars' manager Carl Thompson primarily out of the bullpen. Teammates joked that Stars' relief pitcher, Paul Warren (second from right), "couldn't break an egg" with his fastball. The skinny right handed junkballer, who bore a striking resemblance to latter day St. Louis Cardinals outfielder Willie McGee, was an effective short relief man over the team's six-year existence. Edwin Looney (far right) was the fastest of the Looney brothers and primarily played center for the Hyde Park team. Due to the sporadic reporting of "negro" games by the Springfield news papers, individual statistics for black semi-pro teams remain nearly unobtainable. Ultimately, the lack of attention given to black teams resulted in good players, like the Looneys, remaining confined to the semi-pro ranks. (Courtesy of Katherine Lederer.)

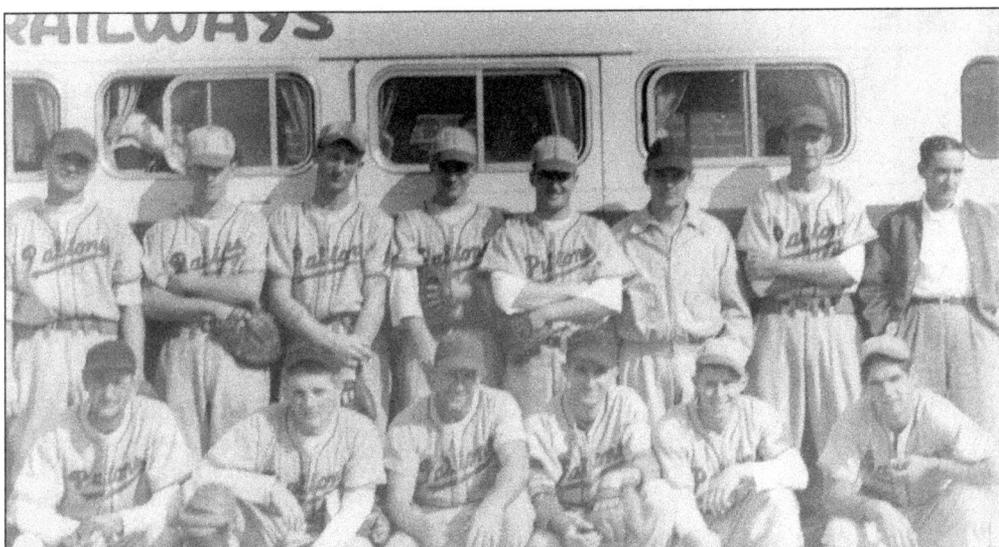

1949 Springfield Creamers. A year after losing in the semi-finals of the state tournament, the Patton club appeared to be headed toward an uncharacteristic year when their 1948 second baseman, Joe Sumners, formed the Riley Redbirds and relegated the Creamers to second place in Sunshine League. By the time the Creamers also lost in the title game of the district tournament at Sunshine Park, an at-large bid to the state tournament was considered a gift. Surprisingly, the Creamers fell to the Holcomb Cardinals in the championship game, behind the all-state pitching of Tom Kilburn and the hitting of right fielder E. Patchum.

1950 Thompson-Mang (Sunshine) Park. The semi-pro league operated out of Thompson-Mang Park in 1948 and 1949 became such a huge success for co-owner John Thompson that he selected former Brooklyn farm hand and Creamers player Joe Sumners (pictured lower right corner) as grounds keeper. Sumners instituted numerous small improvements to the park, including grading of the infield, improved lighting, and remodeling of the club house. Thompson-Mang Park continued to be the main semi-pro playing field until the 1952 season, when the new and better-lit Nichols Park opened.

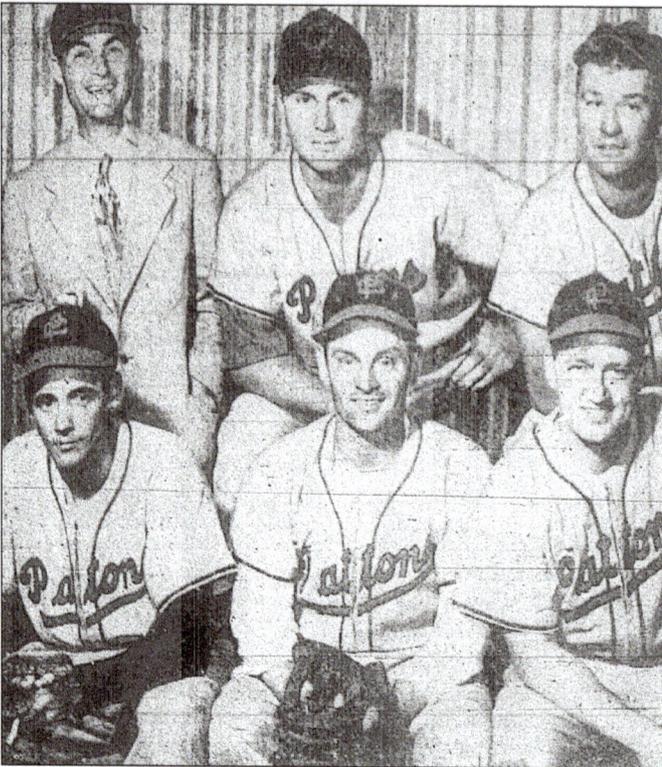

1950 Springfield Creamers. The Patton Creamers celebrated the team's tenth year of sponsorship under John Thompson (top row, far left) in 1950. On-and-off players led the team that year to qualify for a third straight state semi-pro tournament. They are as follows: (bottom row, left to right) Harold Gibbard, Sammy Richesin, and Max McCandless; (top row, middle) George Reed Nixon; and (top right) Fred Gott . Outfielder Jim Hamlin made the state all-tournament team, but for the fourth time in five years, the Creamers failed to win it all. Sponsor John Thompson threw in the towel and effectively ended his tenure in Springfield semi-pro baseball.

1951 Springfield Generals. From the time he formed his first team in 1945, Springfield Generals sponsor C.E. Russell made wining his main priority. However, between 1946 and 1950, Russell's Generals semi-pro teams largely played second fiddle to several other teams, most notably John Thompson's Creamers' clubs. That all changed in 1951, when Thompson eased from the local baseball scene and Russell commenced his often times wild spending on baseball. Russell reassembled his core players from the original team in 1945 and added several Creamers players, most notably, greatly traveled shortstop Bus Harless. Much to Russell's delight, the team won 17 of their first 20 games and cruised to their first city championship.

114

1953 Webster's Oil. When the Hyde Park Stars broke apart, Webster's Oil owner JMK Webster scooped up many of the Stars' remaining players and formed a solid team. The group, pictured from left to right, included as follows: (front row) B. Starks, Edwin Looney, George Whitcomb, Lord Yokum, M. Manier, Robert Spencer, and J. Webster; (back row) Junior Thompson, F. Harlem, Clarence Looney, K. Johnson, Robert Duncan, Carlston Looney, R. Pasley, and F. Mccall. Just like their predecessors, Webster's never broke through to beat the Generals for the city championship. (Courtesy of Historic Museum of Springfield-Greene County.)

***SPRINGFIELD GENERALS—1953 Missouri Champions**

Back row: C. E. Russel (official), Geo. Robinson (u), Harold Means (of), Phil Kemp (p) Bill Davis (p), Carl Swenson (p), and Jerry Lowther (mgr). Center: Buster Harliss (if) Frank Brown (of), Hansen Taylor .(c), Bill Buehler (p), and Sam Richesin (of). Front: Joe Marks (p), Al Billingsley (lf), and Jack Hamlin (of). Mascot: Dude Tussel. *Springfield finished in a tie for seventh place in the National Tournament at Wichita with three wins and two losses.

1953 Springfield Generals. Following two straight city championships, and great excitement for 1000 fans who watched the team lose a close game that year to Doc Horn and the Kansas City Monarchs, in 1953, the Generals accomplished something that no other Springfield team had, winning the state tournament. The addition to the roster of outfielders Frank (F.A.) Brown, Sam Richesin, and catcher Hanson Taylor gave the Generals an extra offensive boost, while at the same time the team rode the splendid pitching of Phil Kemp and Carl Swenson.

115

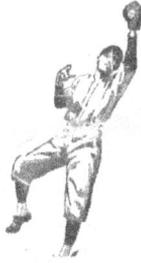

1954 Missouri State Semi-Pro Tournament. The Springfield Generals entered the 1954 Missouri State Semi-Pro Tournament as the defending champions, and became only the second team in 19 years of the tournament to claim back-to-back titles when they defeated the Holden Chiefs, 4-3, in the championship game. By winning the state tournament, the Generals again qualified for the National Baseball Congress Semi-Pro National Championship, a tournament in which the team had, in 1953, won three games and finished in seventh place.

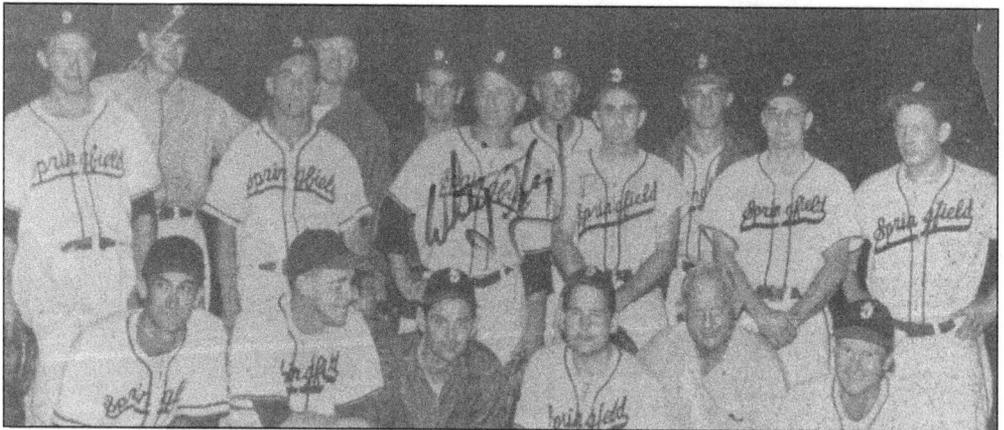

1954 Springfield Generals. Despite a respectable showing in 1953, the Generals returned to Wichita, Kansas for the National Baseball Congress' Semi-Pro National Championships as major underdogs. The Wichita press gave the Generals little chance at getting past several traditionally strong early-round opponents. However, Generals sponsor C.E. Russell bolstered the team's one glaring weakness of the previous year, pitching, by adding former Detroit Tigers right hander Bill Black, along with his four talented teammates—Whitey Herzog, Jerry Lumpe, Ed Stabb, and Vince Magi—from the 1953 national tournament champion, Fort Leonard Wood, Missouri Hilltoppers.

NINE

Coming Around Again

For much of the 1960s, '70s, and '80s, baseball remained stagnant in Springfield, at least above the college level. Besides diminished interest, the problem centered primarily on field availability issues. For years Springfield High School routinely played baseball on the football stadium without as much as a formal infield or pitchers mound. Even though all that changed with the construction of Nichols Park in 1952, the addition of multiple high schools to the Springfield Public Schools system in the late 1950s further complicated matters. Not until 1966, when the Meador Park diamond began on south side Springfield-Greene County Park Board land, did an additional field become available for widespread use by high school aged and older players.

Despite Southwest Missouri State hosting the first four NCAA Division II World Series at Meador Park from 1968 to 1971 (with SMSU national runner-up in 1969), a much needed face lift for Meador waited 20 years. Veteran baseball player, coach, and enthusiast Hook Brown ran a small and unimpressive adult summer baseball league at Meador Park for the better part of 1970s and into the early 1980s. Failing health caused Brown to cease operation in the years just preceding his 1984 death. Inevitably, it would be another ten years before an adult oriented league of even that lower caliber sprang up south of Springfield in Nixa and nearly another ten years after that before semi-pro baseball teams returned in the form of the Springfield Slashers and resurrected Springfield Generals.

By the early 1990s, baseball fervor showed a marked shift towards taking professional baseball serious again. Doug Greene, Allen Casey, Dave Agee and Dick Birmingham of the Springfield Professional Baseball Association (SPBA) started a drive in 1989 for minor league baseball to return. The SPBA explored the possibility of an expansion team for Springfield in the Class AA Texas League, something that appeared a remote possibility when the group sold 500 season tickets for an essentially imaginary team. However, Texas League officials stated unequivocally the need for a stadium before serious consideration of Springfield could occur. The SPBA and the city of Springfield reviewed modifying Meador Park or Barnhouse Field between Springfield and Republic, but neither proved feasible. Eventually, construction of a proposed city-owned stadium at the corner of Chestnut Expressway and Boonville Avenue fell apart when a one-

eighth sales tax levy failed in August 1990. All other attempts to secure stadium funding for a Texas League team failed by 1992, forcing the SPBA to turn their attention toward the Class AA Southern League.

Efforts to bring a Southern League team to Springfield involved coordination with Dennis Bastien, owner of that league's Nashville franchise. Relocation of the Nashville team shifted stadium funding towards a joint public-private venture. Prospects appeared good by 1994, when Springfield businessman Larry Lipscomb offered to donate one million dollars and land at the corner of Republic Road and Kansas Expressway (near newly developing Chesterfield Village) to facilitate stadium construction. The Southern League then gave tentative consent for Bastien's Nashville franchise to move to Springfield for the 1997 season, pending adequate season tickets sales and completed stadium construction. The SPBA oversaw sufficient sale of 2,700 season tickets, as approval for three-level government funding progressed. Crucial state funding covering half of construction advanced into early 1995, as securing local funding remained the only perceived stumbling block. After some persuading, Greene County passed a funding measure, which cleared the way for the state to rationalize including the project on their 1995–1996 budget. Then, in a move that reeked of politics and special interest, Greene County Associate Commissioner Darrell Decker killed the bill by lobbying state legislatures to vote in opposition of stadium funding. Without ever acknowledging to state legislators that he was out-voted two to one on the Greene County Commission, the all-important state funding vanished. Although Decker refused to acknowledge the true motive for his actions, speculation loomed that downtown developer John Q. Hammons acted to kill the project because he secretly wanted a stadium as a part of his center city realm.

On the coat tails of that near miss in Springfield, the SPBA compromised on city location and supported Bastien, when he tried to have a stadium built just south of Springfield in Ozark, Missouri. Even after another promising season ticket sales drive that effort also crumbled when a one-half percent sale tax levy failed in 1996, prompting Bastien and most members of the SPBA to give up. In June 1996, Larry Lipscomb regrouped, bringing in business partner Ron Herschend and would-be operations manager David Reid and worked to secure an expansion team in Texas League, to be called the Springfield Twisters. The new ownership group continued plans for an enhanced yet privately funded Chesterfield Village area, 6,800 chair back seat stadium, with additional seating for 1,500. Lipscomb and Herschend's plan included a tentative agreement for Southwest Missouri State University's baseball program to utilize the facility but hinged mostly on the increased minor league requirements for Major League Baseball's expansion into Arizona and Tampa Bay. With the December meeting of the National Association looming in New Orleans, only two million dollars stood in the way of construction of the 9.8 million dollar stadium (with 4.5 million for the Texas League franchise addition). In a private meeting between Lipscomb, Herschend, and Springfield mayor Lee Ganaway, the stadium and 2.8 million dollars in land was offered to the city as debt service in exchange for allocating the two million dollars needed for construction. Essentially, the city received the stadium for free, while state appropriated money for Springfield allowed an addition 13 million dollars for construction of a Chesterfield Park ice rink. Ganaway rejected the offer, however, claiming insufficient funds. Realizing that the deck was stacked against them and that their window of opportunity for a Texas League expansion franchise had passed, Lipscomb and Herschend formally ended their quest in 1997.

With four recent failed attempts at returning professional baseball to the Springfield area, but evident interest in light of the several thousand season tickets sold in the 1995–1996 attempts in Springfield and Ozark, Chicago businessman Horn Chen stepped up to the plate in 1998. Chen, owner of the entire independent Texas-Louisiana Professional Baseball League, negotiated a suitable agreement through the city of Ozark for a long-term land lease near the corner of 65 Highway and Highway CC in northern Christian County. Chen's approximately 4,000-seat ballpark went up in less than five months at a cost of three million dollars, gaining the name Price Cutter Park through licensing rights purchased by a local supermarket. The

Ozark Mountain Ducks opened their inaugural season in 1999 as an expansion franchise in the Texas-Louisiana League.

That first season the Mountain Ducks led the league in attendance and instantly became the mediocre Texas-Louisiana League's shining star. In 2000, the Ducks again led the league in attendance, hosted the league's All-Star game and made the league playoffs in their second season under former Atlanta Braves farm hand, Barry Jones. Jones remained as Ozark's player manager through the 2001 season, before the club made what was categorized as a financial move in naming North Arkansas College head coach Phil Wilson as manager for 2002. Although Wilson had previously coached at the NCAA Division I level, he possessed no professional experience and, according to players, it showed in his two seasons as manager. Ozark remained in the Texas-Louisiana League through the 2001 season when the league changed names to the Central League. Realizing that the newness had worn off and enthusiasm had began to wane, the club sought broader appeal from its Springfield fan base by changing names that same year to Springfield-Ozark. By the time the Springfield-Ozark franchise of the Central League was sold to a group in Pensacola, Florida following the 2003 season, season victories and, therefore, attendance had steadily declined.

For the 2004 season, Mike Hayes, owner of a franchise in the independent Frontier League, moved his team from Kenosha, Wisconsin, to Ozark, leased Price Cutter Park, and called his team the Ducks, dropping "Mountain" from the name. The new Springfield-Ozark Ducks of the western division of the more competitive and well respected Frontier League performed better than any Duck's team since the 2000 season. Still, with a shiny new stadium in Springfield by then awaiting a Class AA affiliated minor league team, enthusiasm and support for the improved Ducks team never materialized. The club posted a 52-44 record and remained in the playoff hunt until late in the season, but drew even fewer fans to Price Cutter Park than the year before. Thus, in the fall of 2004, Hayes pulled up his Frontier League team, as had been expected. With no professional team interested in using Price Cutter Park in 2005 and Southwest Missouri State (who used the field for many home games from 2000 to 2004) no longer needing it, the ballpark, once described by a *Springfield News-Leader* columnist as Ozark's "Field of Dreams," relegated to rental status.

The downturn for the Ozark team and ballpark corresponded entirely with the upswing those same years in Springfield. The construction in downtown Springfield of the 8,056-seat Hammons Field, at a cost of 32 million dollars, created a buzz around town in anticipation of affiliated professional baseball's return. The large brick and green roofed ballpark featured the most state-of-the-art all-around facilities in the nation at the time of its construction. Besides a $650,000 drainage system, the lighting system featured six poles with 24 to 32 bulbs each at 1,000 watts, creating a far cry from what old-timers remembered struggling under at White City Park. Off the field, club houses and training amenities located just beyond the right field fence exceeded most college or minor league facilities. The two sided clubhouse building split between a 10,000 square foot side for Southwest Missouri State University and a slightly larger 11,500 square foot side for the professional team. Visiting teams and the umpires dressed in a 3,000 square foot clubhouse behind the stands on the third base side. The training facility adjacent to the home clubhouses featured 14,500 square feet of plush, soft FieldTurf brand artificial grass, large enough with the 30 foot ceilings to use as a complete indoor infield during unfavorable weather. Twin motorized drop-down indoor batting cages rounded out what designers billed as the countries best such complex for these two levels of play.

Springfield fans spent 2004 satisfying their curiosity over the new ballpark, by taking in games of the soon-to-be professional team's Hammons Field co-tenant, Southwest Missouri State University. SMSU, coming off their first College World Series trip the season before, christened Hammons field on April 2, 2004, before 9,017 spectators; one of the top attendance totals for a baseball game in the history of Springfield.

Throughout the spring and summer of 2004, rumors swirled over what—if any—Class AA team would fill the vacant ballpark sitting at the corner of John Q. Hammons Parkway and

Trafficway. Stadium developer, financier and namesake, John Q. Hammons, had reassured the public for months that a deal for a Texas League franchise was imminent and would be announced upon conclusion of that club's current season. Finally, in late-August, a press conference disclosed that the deal involved purchase by the St. Louis Cardinal organization of the El Paso club of the Texas League. The St. Louis National League club paid a reported 9.8 million dollars (nearly twice what the El Paso owners had paid just five years before) to secure the franchise, then relocated their Southern League farm team in Tennessee to the Queen City of the Ozarks; again reviving the name, Springfield Cardinals. Thirty-one-year-old Matt Gilford took over as general manager/vice president of the new Springfield club.

With the Springfield Cardinals opening play in the spring of 2005, management duplicated Branch Rickey's actions of 74 years before, casually assuring Springfieldians of an appealing club by pledging superior management and ample veteran players, as well as bringing in the big league club for exhibition games. With strong expectations for success in Springfield, long term operation requires more than promises or contemporary marketing plans or even nostalgia, but also acknowledgment of the city's past and what it indicates. For baseball to succeed in the Springfield area all the factors present in that most successful period of the early 1930s must converge: extensive promotion, a reasonable economy combined with fair ticket pricing, the opportunity to consistently see future major leaguers, an appealing and accessible ballpark, and most importantly a championship winning team. When one or several of these factors is missing, the economic viability of any Springfield area team becomes an issue, risking the future of the ball club. In the end, Springfieldians have always longed for professional baseball until it arrived and failed to meet expectations. Then after a period of five to six years fan interest has historically always fallen off.

Although the future again seems bright for Springfield professional baseball, only time will tell whether the second generation of Springfield Cardinals outlive the up and down 12-year run of their predecessor; or if two aces in the hole like Al Eckert and Branch Rickey are in the *cards* again for Springfield. And most importantly, if pennants fly over Hammons Field, just as they did at White City Park under St. Louis' watch during the 1930s.

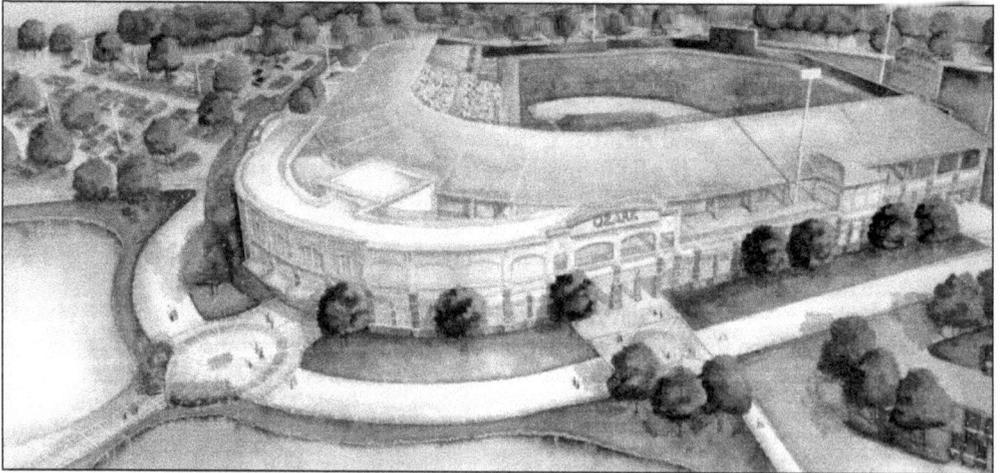

Ozark Double-A Stadium. After a failed 1990 attempt at bring a Texas League team to a proposed stadium at Chestnut Expressway and Boonville Avenue, Dennis Bastien, owner of the Nashville franchise of the Class AA Southern League, entered the picture with intentions of relocating his team. Bastien first tried to construct a stadium near Chesterfield Village, before turning his attention toward stadium construction just south in Ozark, Missouri. In June 1996, an Ozark sales tax levy failed, ending hopes for the nearly 20 million dollar project, and thereby prospects for Bastien's team. (Courtesy of Allen Casey.)

Springfield Twisters. In 1994, Springfield businessman Larry Lipscomb joined the group attempting to build a baseball stadium in southwest Springfield and bring back minor league baseball. When politics derailed that public-private funded ballpark early in 1995, and shifting focus to Ozark, Missouri, in 1996 failed too, Lipscomb organized a new group in mid-1996, aimed at funding a stadium privately and luring a Texas League franchise to Springfield. Lipscomb's proposal called for the new Texas League expansion team to be called the Springfield Twisters. (Courtesy of Larry Lipscomb.)

Chesterfield Park. With other avenues for building a stadium near Chesterfield Village seemingly dead by May of 1996, Larry Lipscomb pulled together an investment group to invigorate the Chesterfield project and shift funding from public to private. Redesigned of the 6,800-plus-seat ballpark headlined a high-tech, multimedia presentation created for Texas League officials. As the December deadline approached for pleading their case for a Texas League franchise at the winter meetings in New Orleans, Lipscomb's group fell two million short of the needed 9.8 million dollars. (Courtesy of Allen Casey.)

Price Cutter Park Entrance. Chicago businessman Horn Chen financed Ozark, Missouri's new ballpark, constructed in the first five months of 1999 at an economical-for-the-day cost of three million dollars. Situated near the corner of Highway 65 and CC Highway, "The Pond," as it was nicknamed, faced Highway 65 and was officially named Price Cutter Park in June of 1999, for the sponsoring supermarket chain. (Courtesy of Mike Campbell.)

PCP Playing Field. Recessed into a man-made valley and often cool on otherwise warm summer nights, the spacious, pitcher-friendly Price Cutter Park rarely served up the gopher ball. Price Cutter Park came into the Texas-Louisiana League as the nicest field in the circuit, seating around four thousand people with all chair back seating and a picnic and burm area down the left field line. Additional use came from Southwest Missouri State during the 2000–2004 spring college seasons, plus further use by high school, junior college, and semi-pro teams, like this 2004 game between the Springfield Slashers and Springfield Generals. (Courtesy of Campbell Photo Works/ Mike Campbell.)

Ozark Mountain Ducks. The Ozark Mountain Ducks began play in the Texas-Louisiana League in the 1999 season and, utilizing a family friendly atmosphere and various promotions, instantly became a popular summertime activity for Springfield area residents. Slowly things changed for the team from Ozark, starting with a name change to "Springfield-Ozark," in 2001; to the league changing its name to the Central League in 2002; and finally to the Mountain Ducks franchise in the Central League moving to Pensacola, Florida, and a franchise of the independent Frontier League moving to Ozark and becoming the Springfield-Ozark Ducks for the 2004 season.

"Homer" the Duck. For fans young and old, "Homer" the Duck became a staple of Mountain Ducks games during the team's six-year existence. Homer entertained on the field, on top of the dugouts, and in the stands, mingling with fans.

Barry Jones. Barry Jones became the Ozark Mountain Ducks' first manager and remained in that position through the 2001 season. A former outfielder in the Atlanta Braves organization, the left handed hitting Jones continued playing for Ozark, leading the team to their only playoff appearance in 2000.

Eddie Deckard. Springfield-Hillcrest high school graduate Eddie Deckard joined the Mountain Ducks for the 1999 and 2000 seasons. Deckard, a right handed pitcher, had spent three seasons in the Tampa Bay Devil Rays farm system before joining Ozark for their inaugural season. Unfortunately, arm problems seemingly caused 2000 to be Deckard's last season in professional baseball.

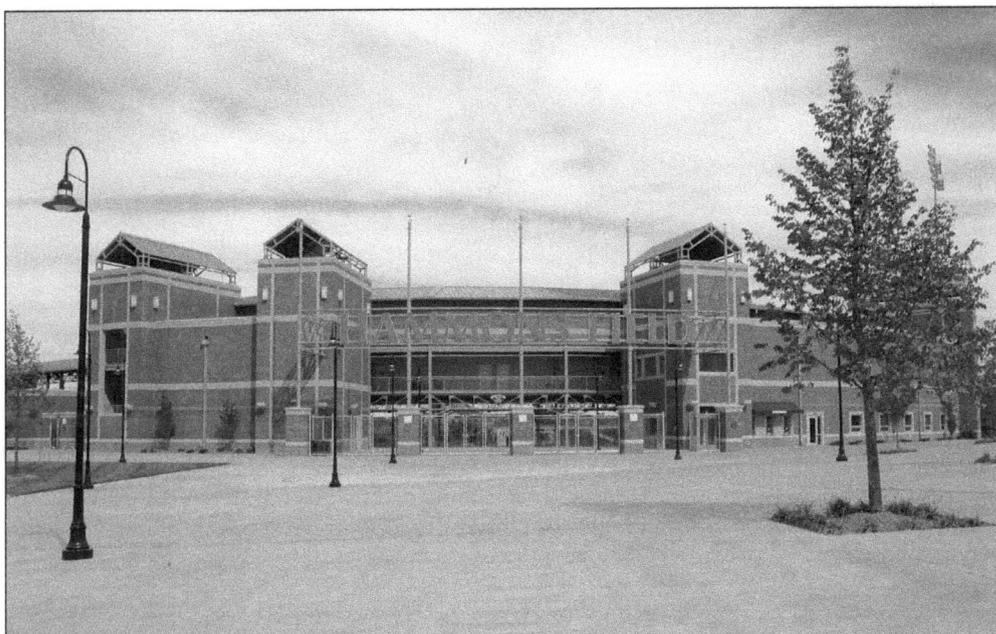

Hammons Field Entrance. The entrance to the 32 million dollar, 8,056-seat, Class-AA-quality Hammons Field faces the corner of Trafficway and John Q. Hammons Parkway. The stadium complex, called "the crown jewel of Jordan Valley Park" forms a triangle with two other properties held by ballpark owner John Q. Hammons. (Courtesy of Campbell Photo Works/ Mike Campbell.)

Opening Night Ceremony at Hammons Field. Similar to the mayoral oriented season opening ceremonies of Springfield's pro teams of past, Springfield mayor Tom Carlson, presented stadium builder, John Q. Hammons, with a plaque commemorating the April 2, 2004 opening night game at Hammons Field . (Courtesy of SMSU Photo Services/ Kevin White.)

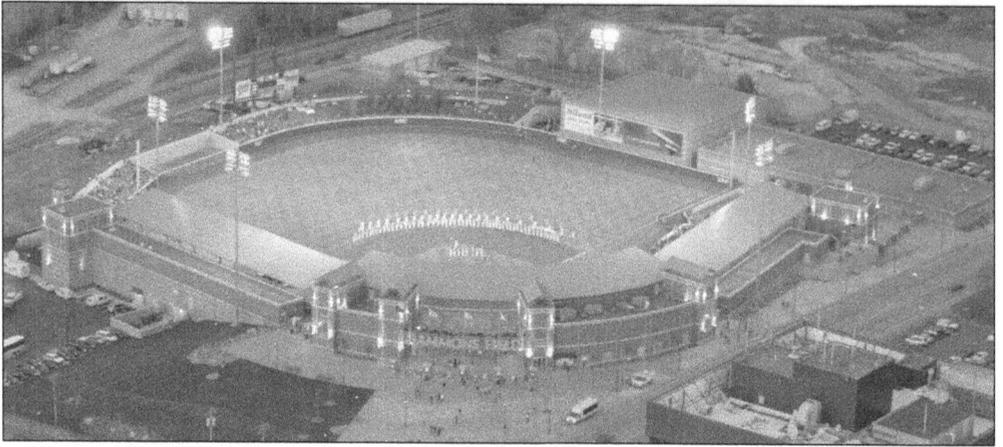

Sky Shot of Hammons Field. An overflow throng of 9,017, one of the largest crowds to ever see a baseball game in Springfield, pack into Hammons Field to watch Southwest Missouri State University take on Southern Illinois University. (Courtesy of SMSU Photo Services/ Kevin White.)

Field View of Hammons Field. The mystique of Hammons Field, illuminated on opening night, April 2, 2004, brought out baseball hungry fans that rooted on the Bears that night, but clearly looked forward to the new Springfield Cardinals professional team in 2005. Southwest Missouri State University's outstanding attendance while playing on what several baseball publications declared as the "best college baseball field in the country," allowed the Bears program to place in the top ten in the nation in NCAA Division I attendance. (Courtesy of SMSU Photo Services/ Kevin White.)

Clubhouses at Hammons Field. The clubhouse building for Hammons Field, located just beyond the right field wall, features separate areas for both Southwest Missouri State and the Springfield Cardinals. The Cardinals received the larger side, with 11,500 total square feet of space that included a locker room pre-installed with lockers and little more. The SMSU clubhouse (pictured), at 10,000 square feet, was slightly smaller and unfurnished. SMSU installed their own lockers and completely furnished their side, done primarily through donations from former players. (Courtesy of Campbell Photo Works/ Mike Campbell.)

Weight Rooms at Hammons Field. Besides similar sized locker rooms, each of the two clubhouses included a team meeting room, trainer area, player lounge, and identical small weight room. (Courtesy of Campbell Photo Works/ Mike Campbell.)

Indoor Training Facilities at Hammons Field. A big part of the Hammons Field baseball complex is the indoor training facility adjacent to the clubhouse. Measuring 14,500 square feet, with a 30-foot-tall ceiling and an all-FieldTurf artificial grass floor, the climate controlled building provides all-season baseball workout options. This included space for layout of bases on a full size infield, arranging of portable pitching mounds, and twin rising batting cages. (Courtesy of Campbell Photo Works/ Mike Campbell.)

2005 Springfield Cardinals. Affiliated professional baseball returns to the Queen City of the Ozarks in 2005 in the form of the Springfield Cardinals, the St. Louis Cardinals' Class AA farm team in the Texas League. At two steps below the major leagues, playing in the Texas League marks the highest level of professional baseball ever achieved by a Springfield team. Although the old Springfield Cardinals played one season in the Class A Western League, at which point the old five-class system (AA, A, B, C, and D) placed them two steps below the majors, the more competitive modern system rarely allows for the number of rookies present on the 1933 team. The team's 2005 logos, with the sleeve patch (left), jersey logo (center), and hat logo (right) are featured above.